BADGLEY MISCHKA

AMERICAN GLAMOUR

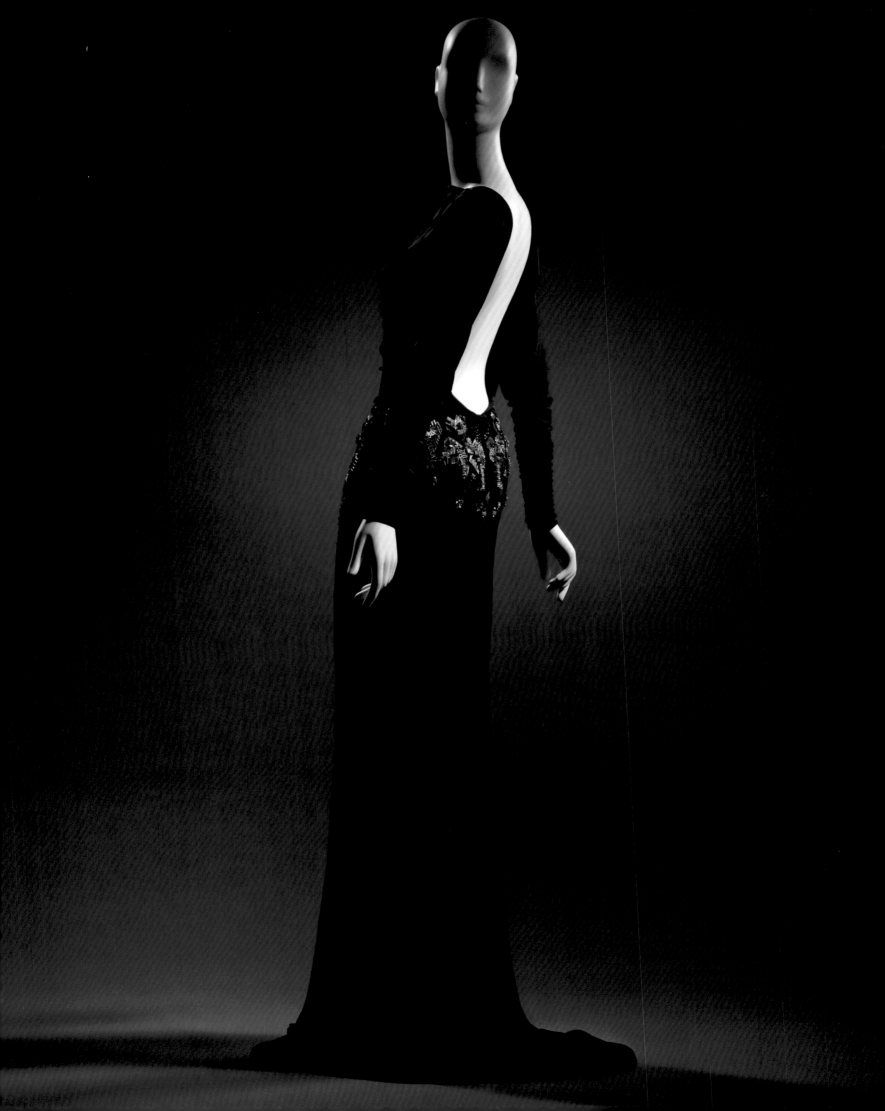

BADGLEY MISCHKA

AMERICAN GLAMOUR

Foreword by
André Leon Talley

RIZZOLI
NEW YORK

New York · Paris · London · Milan

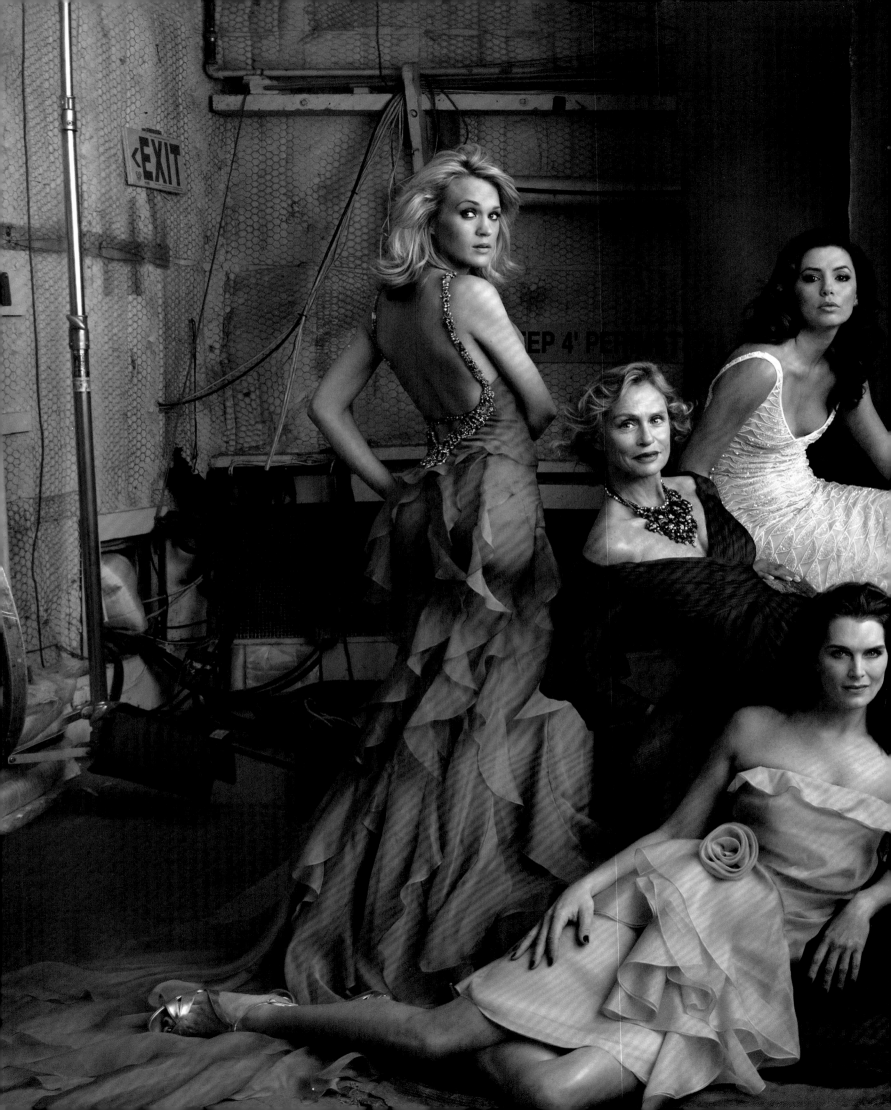

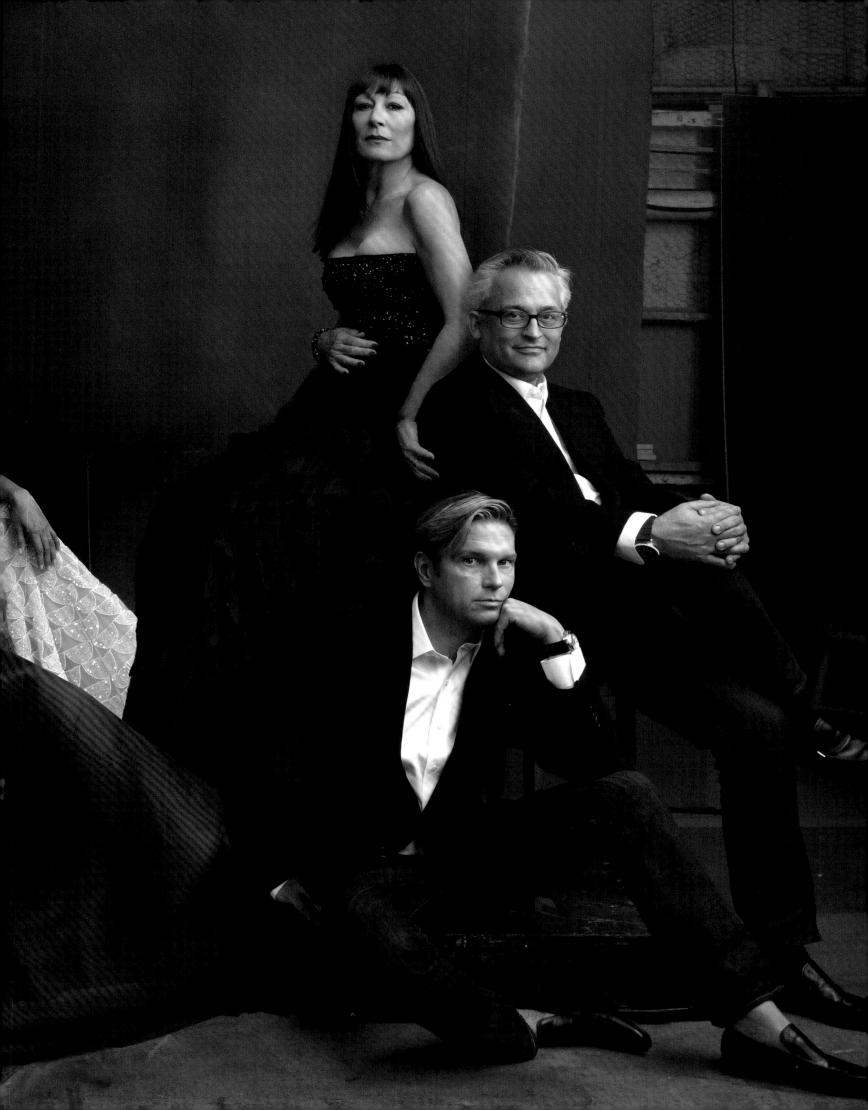

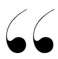

I've worn Badgley Mischka as long as they've been making dresses. They have a wicked sense of glamour and the times that I've chosen to wear their gowns have all been highlights. I was honored to be a part of their 20th anniversary campaign and will always be a great fan. —ANJELICA HUSTON *Mark and James. James and Mark. Gowns, gowns, gowns. Glorious gowns. Certain elements of my life as an actor certify the movie star experience. Hotel Cap D'Antibes during Cannes. The green room at the Oscars. The quiet moment, when the last delicate button has been threaded through its silk loop, and the sum of gown and gems and beautiful hair and make-up by equally great artists takes our breath away. Badgley Mischka has provided scores of these special moments, when for a few magical hours that elusive state of actually <u>feeling</u> like a movie star blooms. Since the early nineties, when I discovered their glamour, I've worn their gowns for premieres such as "Insurgent" and iconic events such as the White House Correspondents' Dinner, and their utter loveliness, incredible creativity, and fabulous quality have made my body relish physical beauty that is moving art. Mark and James' gowns have a glorious balance for me: drop dead glamorous, creative and interpretive, and both in always just the right amount.* —ASHLEY JUDD *I adore Mark and James not only for the designers they are but also for their spirit and kindness. I remember them dressing me for the 2002 Oscars in this glamorous red gown. I felt radiant walking down the red carpet in one of their creations.* —HEIDI KLUM *It was a lucky day in my life when I was introduced to the talents of Mark and James. I found designers who loved the female shape, imagination, and spirit and whose designs reflected that. The miracle for me was that I would put on one of their dresses and zip it up and everything was where it should be. They are magicians. You start with the fit, and then progress to the beautiful detail, the elements of design that reflect a total understanding of aesthetic, using fabric and embellishment in such an imaginative and elegant way. I have a Badgley Mischka dress in my wardrobe that is a jewel, and will appear in my will. I have worn their dresses to the Oscars, to the Emmys, to the Golden Globes, and always felt not only glorious, but totally comfortable too, a divine coming together heaven and earth!* —HELEN MIRREN *You can tell Badgley Mischka loves designing for women and understands all kinds of women's bodies. They do mine proud.* —OPRAH WINFREY *One of my all time favorite red carpets moments was at the Emmy Awards when I wore a gorgeous fuchsia Badgley Mischka gown. I have never felt more beautiful.* —BROOKE SHIELDS *Badgley Mischka is the ultimate in glamour for the red carpet. Mark and James designed a gown for me for my first ever Golden Globe Awards, and it was a true highlight in our wonderful relationship that I'll always remember. Every time I wear Badgley Mischka, I immediately feel sexy and confident, and there is no greater gift when I want to feel beautiful for a special night!* —CARRIE UNDERWOOD

CONTENTS

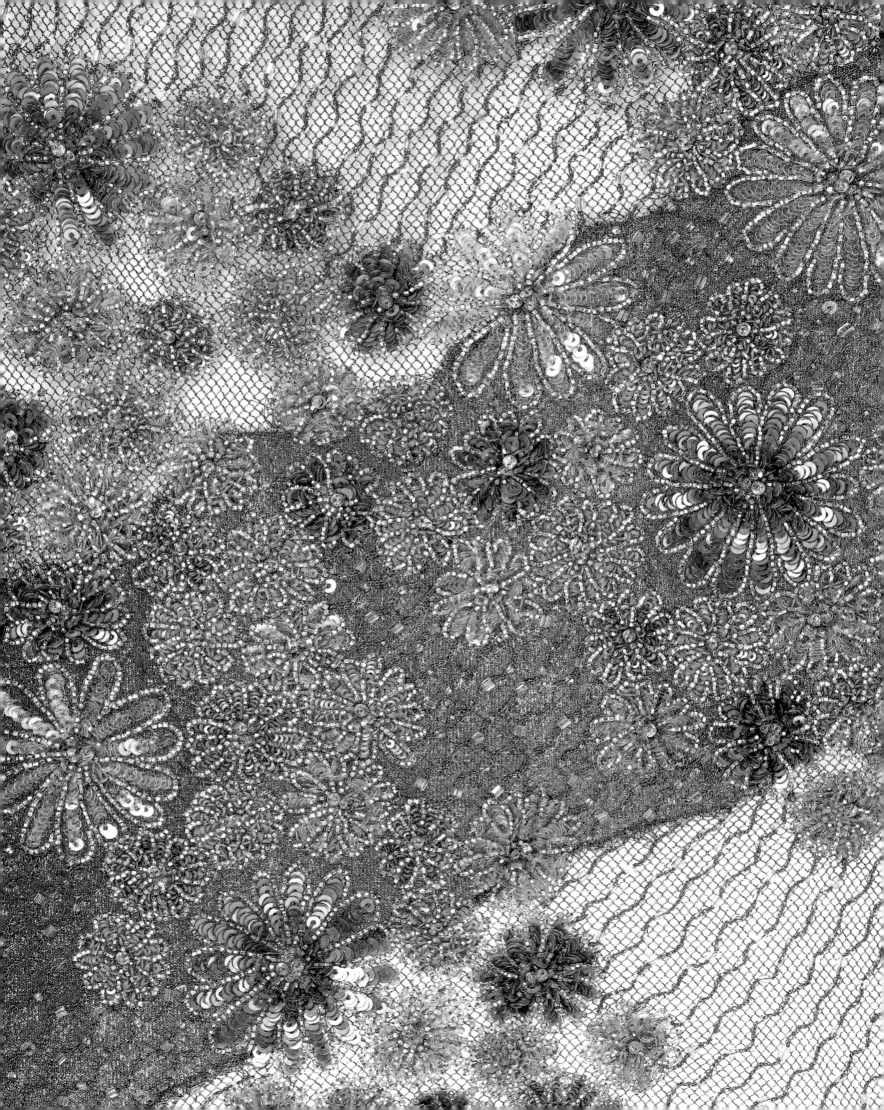

FOREWORD

André Leon Talley

Each time I am in Hollywood for the Golden Globes, the Oscars, or SAG awards, one of my favorite pastimes is to drive by the Badgley Mischka store at 477 North Rodeo Drive and Santa Monica Boulevard in Beverly Hills, California. Especially in the evening, I love window-shopping after-hours, on the way back to the hotel after dinner. Sometimes I get out of the town car and walk over to the windows to gaze at the dazzling elegance of Mark and James' designs, in the windows of this unassuming yet elegant, small jewel box of a store. I am always amazed at the shimmering brilliance of the team of Mark Badgley and James Mischka, who launched their fashion brand in 1988.

To celebrate this moment—the twenty-fifth anniversary of their company—it is a great pleasure to congratulate them on their successes. Along Rodeo Drive, the mega stores and brands sparkle, yet Badgley Mischka's store is outstanding. It is there that one sees one special mannequin, displayed in the window, that illuminates the splendid significance of this dynamic team, which *Vogue* has claimed as one of the ten most important designer names in fashion.

The two designers, who met in fashion school and quickly rose to the top, are known for elegant, beautiful clothes that give to the wearer the drama of big moments—dressing up with style, opening nights at the ballet, or opera, or theatre, shimmering Scheherazade embellishments, as well as quiet, understated fireworks that women love. Throughout their career, the essence of glamor, as well as a timeless, classical modernity has been the solid and firm foundation of their work.

Badgley Mischka coats, wedding dresses, cocktail or grand evening gowns are born from a tradition of symbolic splendor, and yet they are steeped in an American style of clean, understated silhouettes, often fused with klieg-watt, red-carpet drama. Mark and James are—like their designs—elegant, with throwback, old school manners, deportment. and faultless grooming. I remember one great show, held in the Fountain Room at the Four Season's Restaurant in New York, where the shimmering embroideries on chiffon, the gold light and incandescent

allure of their crystals and sequin beads were as powerful as a Cartier pendant, yet in fabric.

They have many fashion muses, from model Gisele Bündchen to Brooke Shields, as well as their good friend, Cornelia Guest, daughter of the late C. Z. Guest, one of the great American style icons. I've often been a dinner guest in Cornelia's former estate in Old Westbury, when Mark and James were also guests. Cornelia is from a dynasty of style; as a muse she gives the team a sense of American elegance, which she inherits from her mother, who was one of my good friends.

Anjelica Huston, one of the most elegant and beautiful women in the world and a great Oscar award-winning actress, is also a muse to Badgley Mischka. She comes from a European background, yet when she was young, she modeled not only for Halston, but also for Valentino and was constantly in *Vogue*. To this day, Ms. Huston is a person to watch for her incredible style—be she in jeans on a horse or walking in to a black tie party.

"You are a queen, remember that," Marlon Brando once told Anjelica Huston, and she carries that with her, in her heart. In her memoir, she recalls how she arrived at the studio to be in an Annie Leibovitz portrait for an advertising campaign with Badgley Mischka. She asked to be photographed in her black strapless dress then hurried back to the hospital bed of her late husband, the sculptor Robert Graham. In this photo, she is aligned with Lauren Hutton, Eva Longoria, Brooke Shields, and Carrie Underwood. It's a beautiful portrait by Leibovitz, created by the legendary photographer to give an illusion of the special sparkle and sense of beauty a Badgley Mishcka evening dress conveys to the wearer.

They give to their countless clients, fans, and admirers the kind of clothes that Worth gave to the rich American clients at the turn of the century in Paris, the essence of dazzle and opulent surfaces that the Callot Soeurs gave at the beginning of the last century, and the level of refinement Norell, the great American designer, was known for. They design clothes that give to each individual, a "queenly" moment or experience.

They give the individual—be it Oprah Winfrey, Halle Berry, Jennifer Lopez, Jane Fonda, or Dame Helen Mirren—the special privilege and ability to feel as if they are like a queen for that night, who has thrilled not only her audience, her family, her loved ones, her lover, but also herself in full-on, unabashed spectacular dressing. But it is not always about fireworks: Mark Badgley and James Mischka are talented enough to offer simple, straightforward silhouettes—a go-to in every woman's wardrobe.

Luxury is something that affords dreams and desire. Badgley Mischka's fashion world is filled with lyrical sonatas in the fine gossamer threads of beautifully crafted style. If their dresses were songbooks, they would range from Cole Porter to the Beatles to Taylor Swift. "Fashion is just a touch of the marvelous," Christian Dior, once said. Mark and James are fashion princes who offer the magic of illusion—that marvelous illusion that women love when they wear a Badgley Mischka design.

Mark and James, congratulations on your first quarter century, and glide forward into the next. This book celebrates your sustained, elusive touch of brilliance in your wonderful life together as formidable masters of elegance.

INTRODUCTION

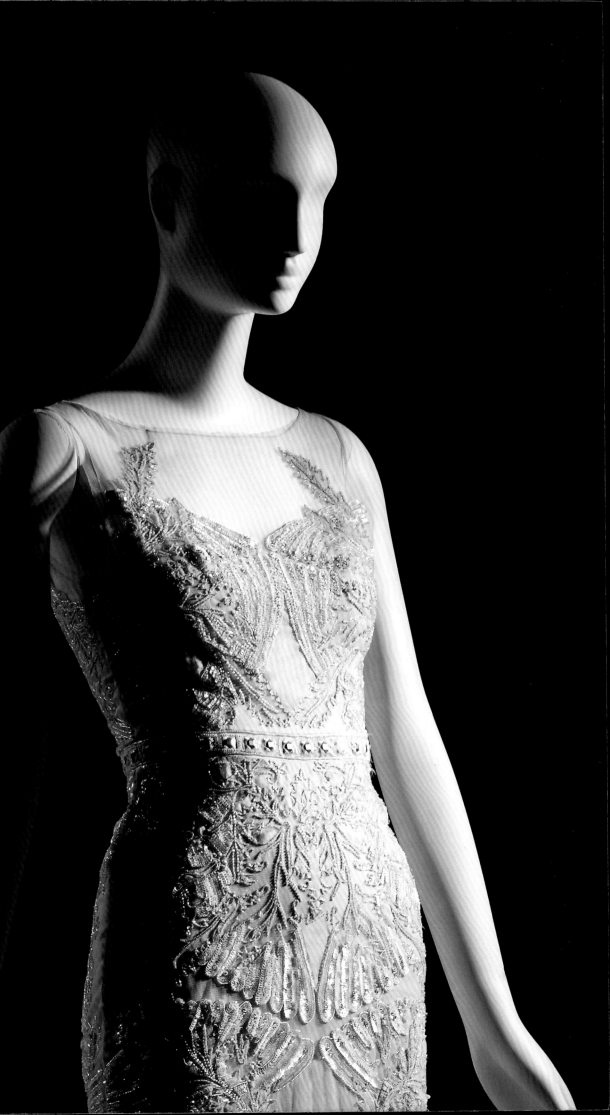

A LITTLE HISTORY

Body-conscious, embellished, modern evening gowns imbued with the dreamy feeling of Hollywood's golden age have been Badgley Mischka's signature for more than twenty-five years, cultivating a revival of American glamour on the red carpet. Since joining forces in 1988, Mark Badgley and James Mischka have established a place in the arc of American fashion, concentrating on social dressing in the style made legendary by designers Bill Blass, Oscar de la Renta, Christian Dior, and Adrian. Like their predecessors, Mark Badgley and James Mischka's personal charm is reflected in the relaxed, elegant beauty of their clothes.

Their process of working as a creative pair is unique. With sensibilities that are so complementary, they have developed a mental shorthand between them. Badgley grew up in Portland, Oregon. His father was chairman of a May Company department store, but Badgley developed his love of clothes by watching hours of TV as a kid, sketching Lucille Ball, Bette Davis, and other glamorous stars. He studied at the University of Oregon and USC before transferring to Parsons School of Design in New York, where the two met. Mischka was born in Wisconsin and grew up in Malibu and Princeton; he studied biomedical engineering at Rice University but dreamed of a fantasy inspired by the sixties

Opposite Mark Badgley and James Mischka on the runway, 2013. *Previous pages* Sea foam tulle gown with beading and organza appliqué from the Spring/Summer 2013 collection.

sixties suburban glamour of his mother, who wore designer dresses by Paco Rabanne among others. After graduating from Parsons in 1985, they both worked in the industry—Badgley for Jackie Rogers and Donna Karan, and Mischka for Willi Smith—before starting their company. Mischka's background in tailored menswear famously melded with Badgley's love of ruffles, beading, and embroidery. Badgley's twin sister, O'Hara, was their muse and constant inspiration.

From the beginning, in their loft in Hell's Kitchen, they worked together with a singular voice. "Nothing is sacred. We take each other's sketches and draw over them," says Mischka. "There's absolutely no competition," agrees Badgley. Having similar tastes and sharing a passion for the creative process, the two men split the work of the company between them, completely trusting each other's decisions and judgments—even when working apart. One might be in Italy working on shoes while the other is in Paris or New York working with fabrics or the patternmaker, yet when the components are brought together, they seamlessly create a unified whole. The designers' distinct qualities have become intertwined to create a unique style of modern, streamlined glamour that has been key to the pair's success.

Season after season, their collections are based on a few favorite, deceptively simple silhouettes, such as the mermaid fishtail gown, which serve as the foundation for their couture-style workmanship, detailed beading, and embellishment. "We like what we like—and that has been consistent over the years. We have never tried to be everything for everybody," Badgley explains. "We have never tried to be trendy, and we feel that this has been the reason we have earned the loyalty of our clientele. We've always just tried to make beautiful clothes." Reflecting their one-zip-and-you're-dressed philosophy, their gowns impart high glamour with an uncomplicated, modern-day

Mark Badgley and James Mischka after the Fall 2000 runway show with models, Frankie Rayder, Alex Wek, Maggie Rizer, and Caroline Ribeiro.

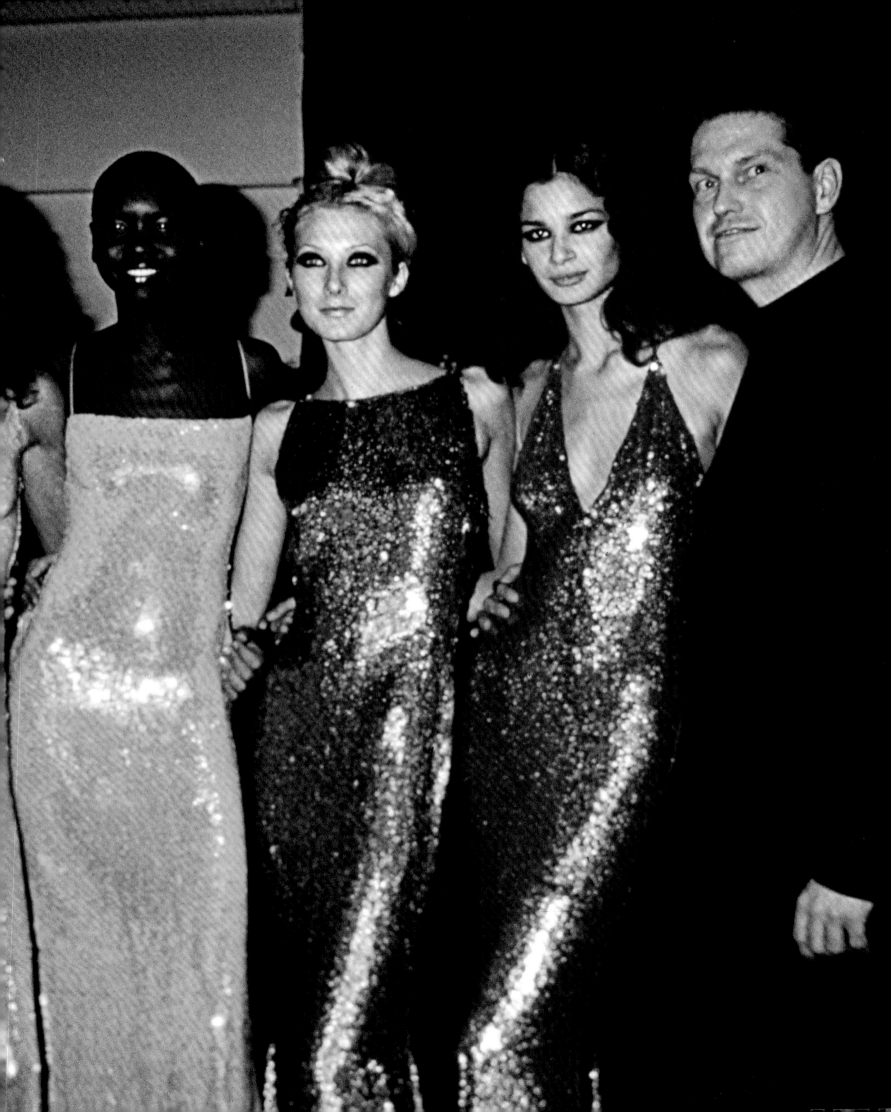

simplicity—the beaded dress, in fact, acting as its own jewelry. "Life today is so streamlined and mechanical, so processed. Our clothes hark back to when people had time to pay attention," Mischka explains. "Today, the ultimate luxury is to have time. We try to package a sense of the charm and grace of that golden era for people."

Their signature muted colors—blush, misty gray, lavender, bisque, champagne, and platinum—are selected to highlight a woman's complexion and to evoke an old-world atmosphere. These ethereal, antique colors paired with the texture of custom beadwork create an understated, shimmering luminescence. The remarkably fluid gowns made from delicate feather-light fabrics, such as chiffon and silk crepe, embrace the body because of the weight of the beads.

Badgley Mischka played a leading role in the rise of celebrity dressing in the 1990s, garnering accolades from *Vogue* magazine, which deemed the duo among America's top ten designers. Already specializing in eveningwear inspired by the Hollywood studio look of the 1940s, Badgley Mischka was a natural fit when it came to dressing modern-day actresses for award events, bringing back a classic sense of elegance and glamour. It all started in 1995 when Teri Hatcher wore a Badgley Mischka dress to the Emmys and, six months later, in 1996, when Winona Ryder wore a Badgley Mischka dress to the Academy Awards. Ever since, their gowns have been in demand, worn by Kate Winslet, Jennifer Lopez, Sharon Stone, Halle Berry, and Brooke Shields, to name but a few. "That gorgeous old-world glamour is at our core," Badgley explains. "I love the aura of Hollywood movies and the photography of the 1940s. Photos by Horst, Avedon, and Hurrell are a constant source of inspiration. The liquid fabrics, the sheen, and the glamour are always a source of inspiration." *Gentleman Prefer Blondes, Gilda, The Women, Breakfast at Tiffany's, Vertigo,* and *Now, Voyager* are movies that they watch again and again and never tire of.

Sharon Stone, Cannes, late 1990s.

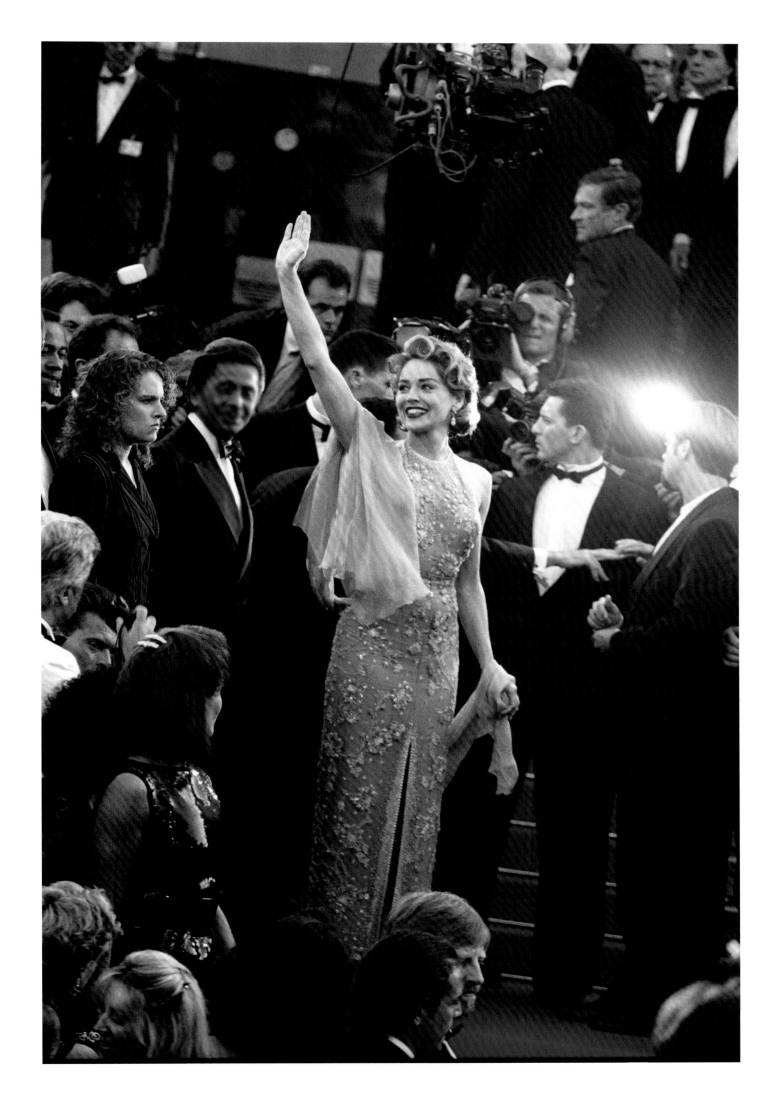

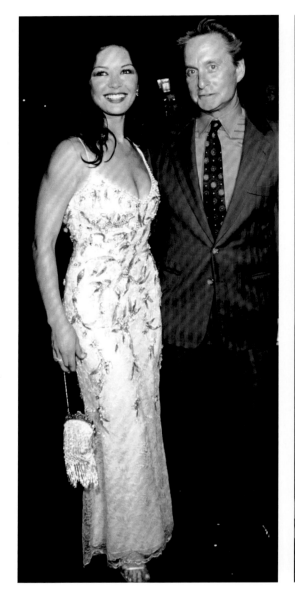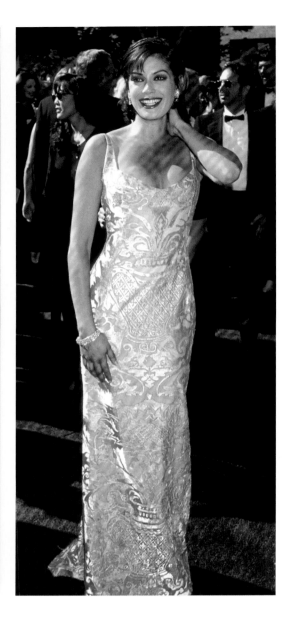

Above Specializing in eveningwear with an aura of old Hollywood glamour made Badgley Mischka a favorite among awards ceremony–bound celebrities. Left to right: Catherine Zeta-Jones and Michael Douglas share a joint birthday at Club 151, 1999; Winona Ryder at the Academy Awards, 1996; Teri Hatcher at the Primetime Emmy Awards, 1995. *Opposite* Fall/Winter 1999 collection.

Badgley Mischka is sold in the most prestigious stores in the world, including Bergdorf Goodman, Neiman Marcus, Saks Fifth Avenue, Holt Renfrew, and Harrod's. In 2000 Badgley Mischka opened a flagship store on Rodeo Drive in Los Angeles, and in 2013 a store in New York City. In the spirit of the silver screen, the stores are decorated in muted, warm gray tones; gold and other metallics are used as accent colors and for lacquered surfaces. The stores provide an exclusive atmosphere in which customers can fully experience the nuances of the luxury brand. Even as the business expanded, Badgley Mischka has adhered to its founders' signature style of glamour.

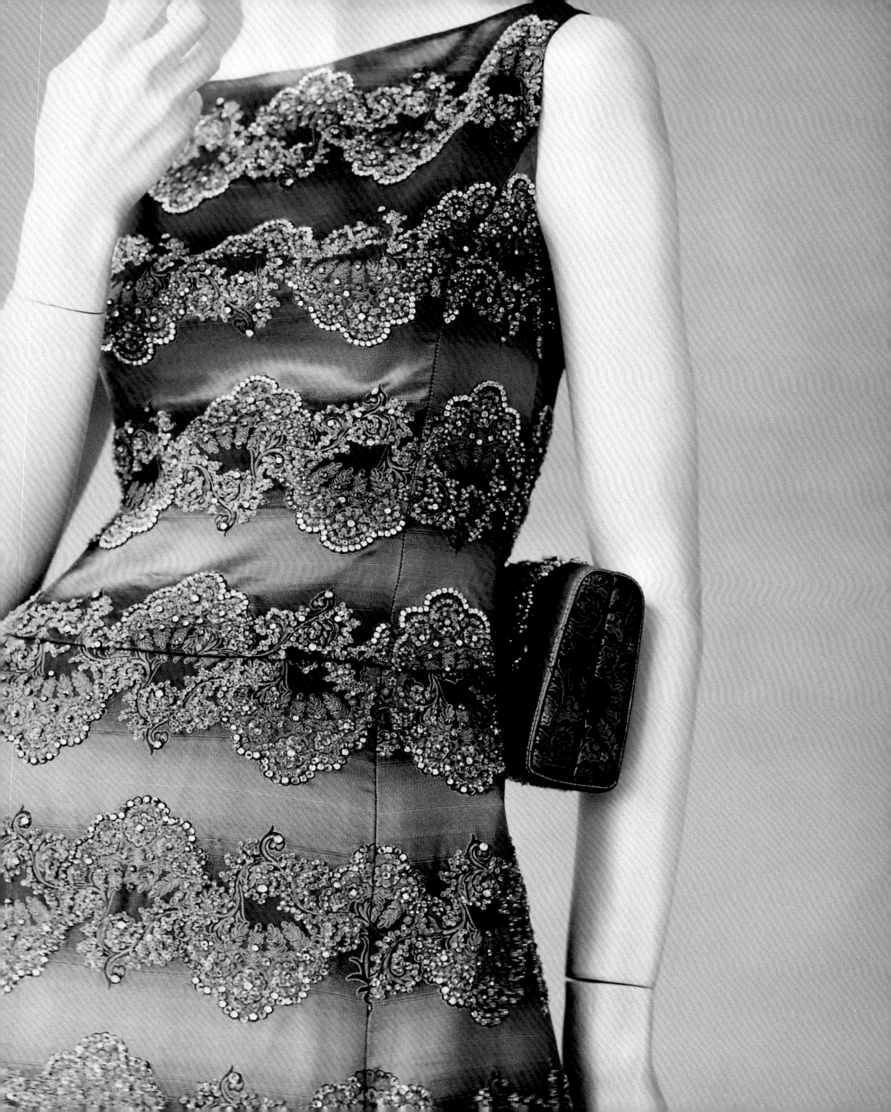

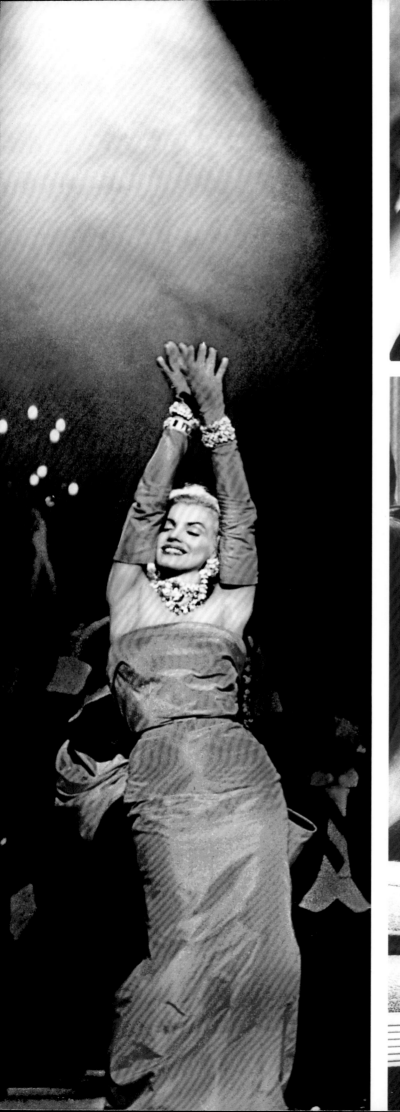
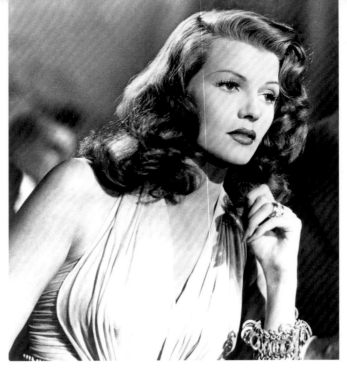
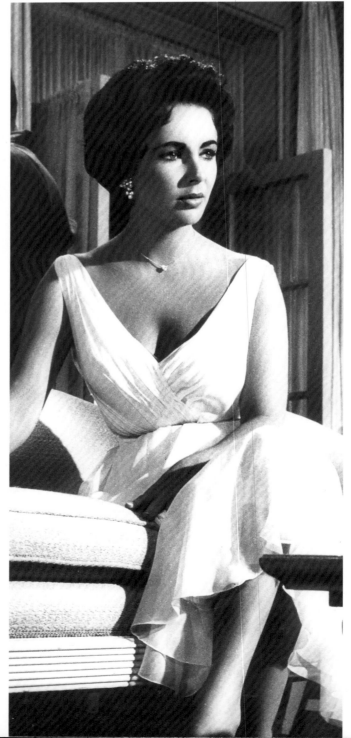

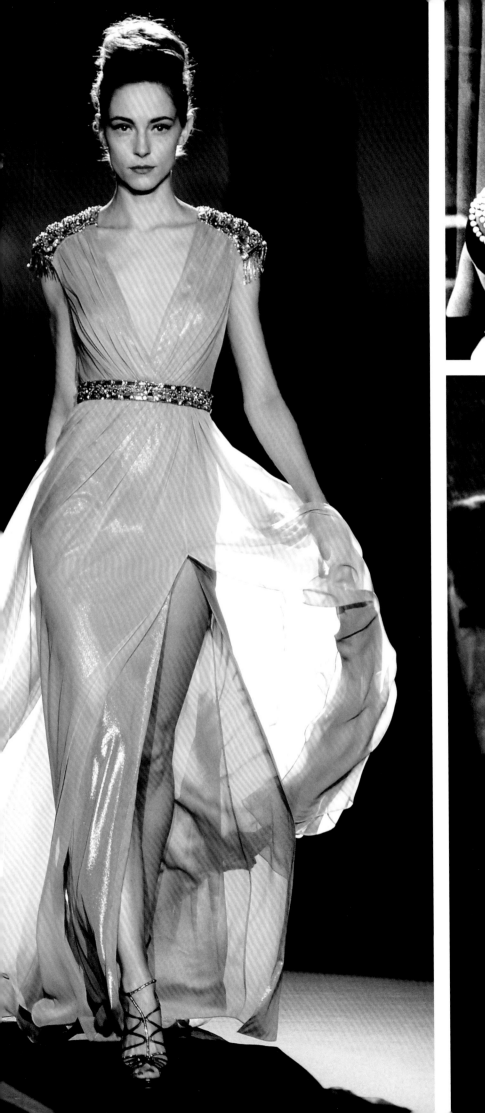

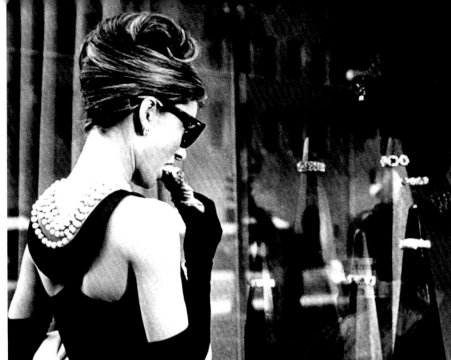

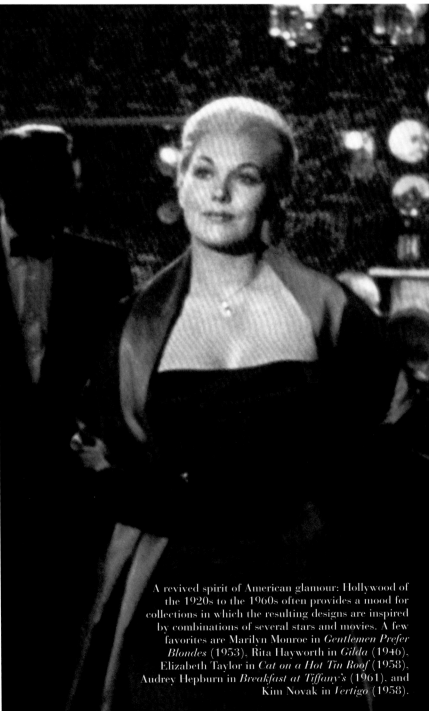

A revived spirit of American glamour: Hollywood of the 1920s to the 1960s often provides a mood for collections in which the resulting designs are inspired by combinations of several stars and movies. A few favorites are Marilyn Monroe in *Gentlemen Prefer Blondes* (1953), Rita Hayworth in *Gilda* (1946), Elizabeth Taylor in *Cat on a Hot Tin Roof* (1958), Audrey Hepburn in *Breakfast at Tiffany's* (1961), and Kim Novak in *Vertigo* (1958).

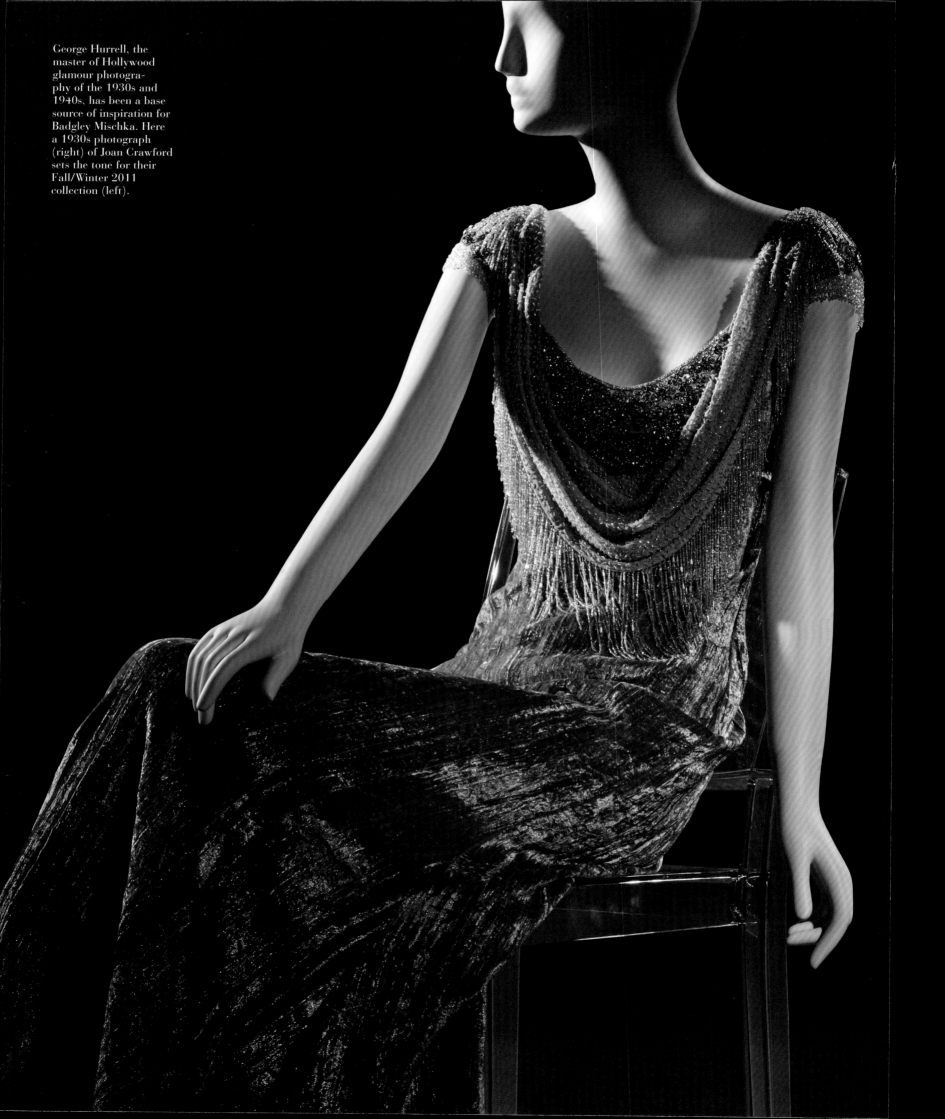

George Hurrell, the master of Hollywood glamour photography of the 1930s and 1940s, has been a base source of inspiration for Badgley Mischka. Here a 1930s photograph (right) of Joan Crawford sets the tone for their Fall/Winter 2011 collection (left).

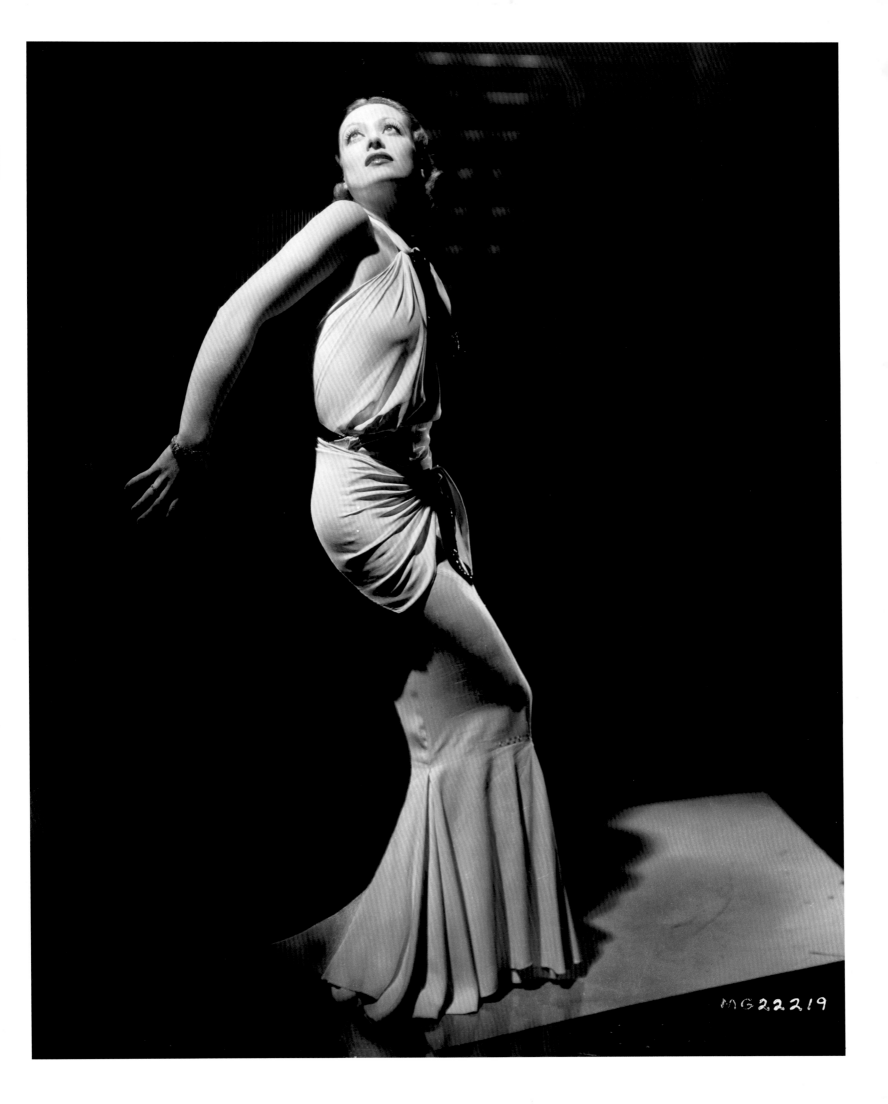

MG22219

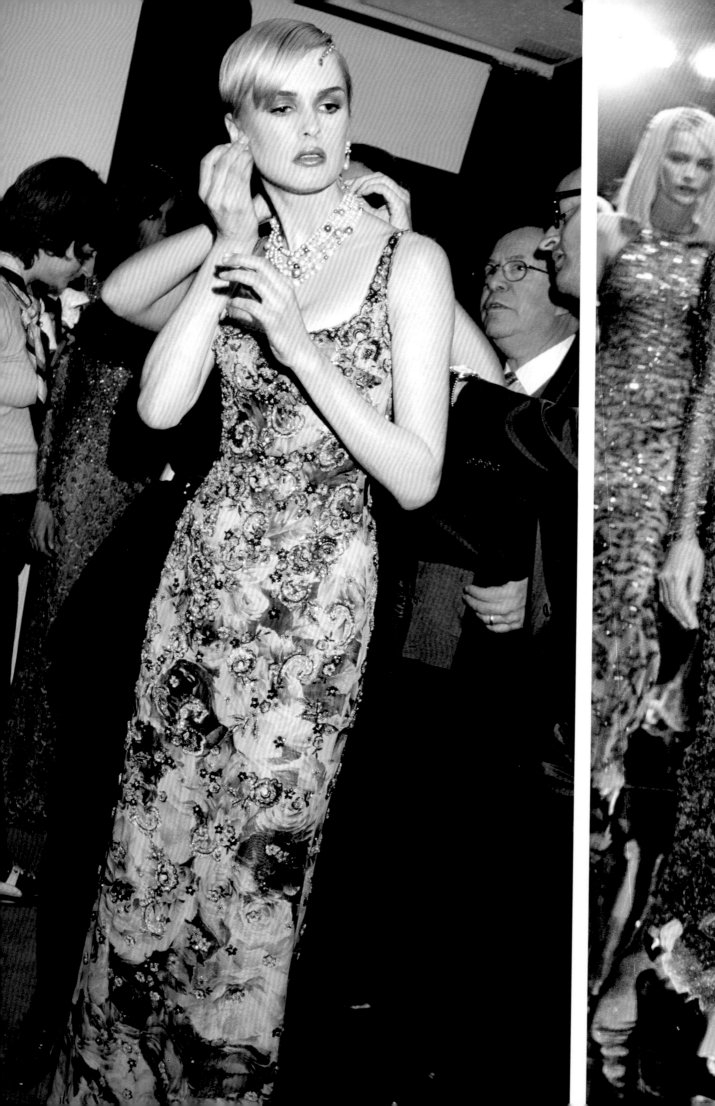
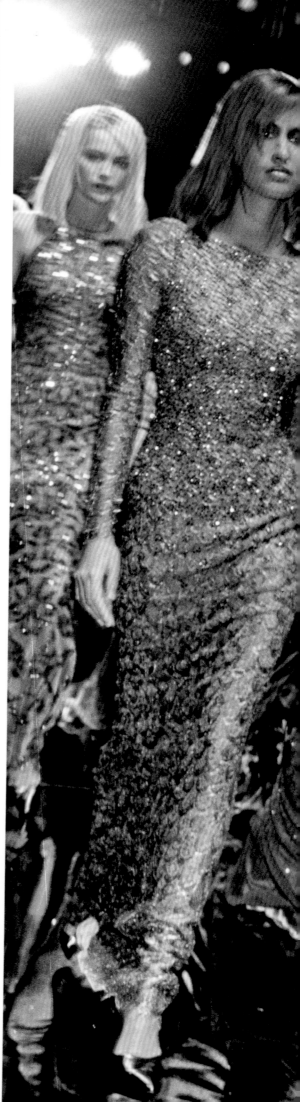

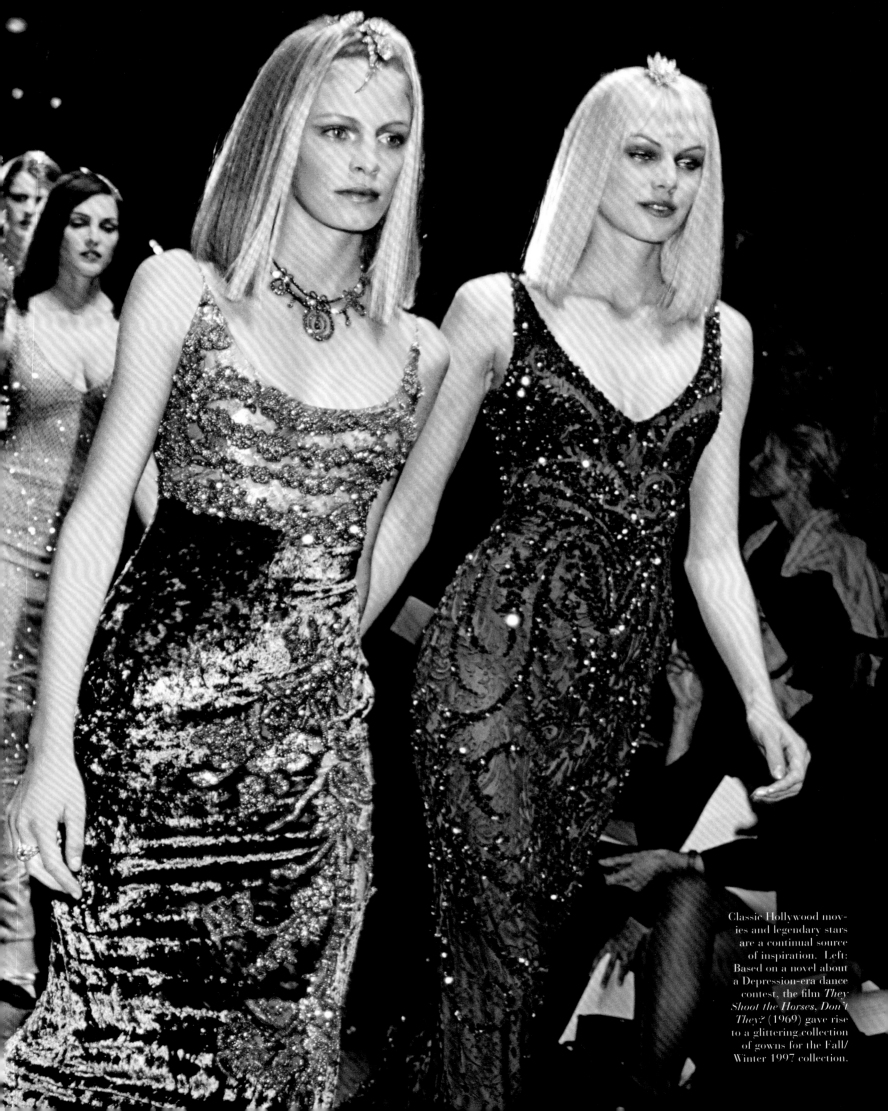

Classic Hollywood movies and legendary stars are a continual source of inspiration. Left: Based on a novel about a Depression-era dance contest, the film *They Shoot the Horses, Don't They?* (1969) gave rise to a glittering collection of gowns for the Fall/Winter 1997 collection.

PROCESS

From a loft in Hell's Kitchen, Badgley and Mischka created their first collections, doing everything from sketches and draping to sales and shipping. From the very beginning of their careers as designers, they had a strong desire for a high level of quality in their craft. Today, with their skilled staff, they create gowns with couture-style workmanship and details, such as hand-stitching, horsehair bindings, weighted hems, and the endless fittings that make their dresses extraordinary.

Although the beading is often the most apparent attribute of a Badgley Mischka gown, the design process starts with the fabrics and colors. Preferring classic fabrics from France and Italy, especially the mills in Como, the designers search the archives of the great mills and select vintage designs, which they adapt—such as by adding a metallic thread for more sheen—to make their own. Swatches of the selected fabrics form the base of an inspiration board for each collection and, from that, the texture and silhouette emerge. Badgley draws the original sketches with Mischka. Then, the sketches are tacked up on a wall to show how the collection works as a whole. They discuss the mood and feeling of the collection with their design team, adjusting and editing to make a final selection. Notes and revisions are made directly on the original sketches. Next, they work with the

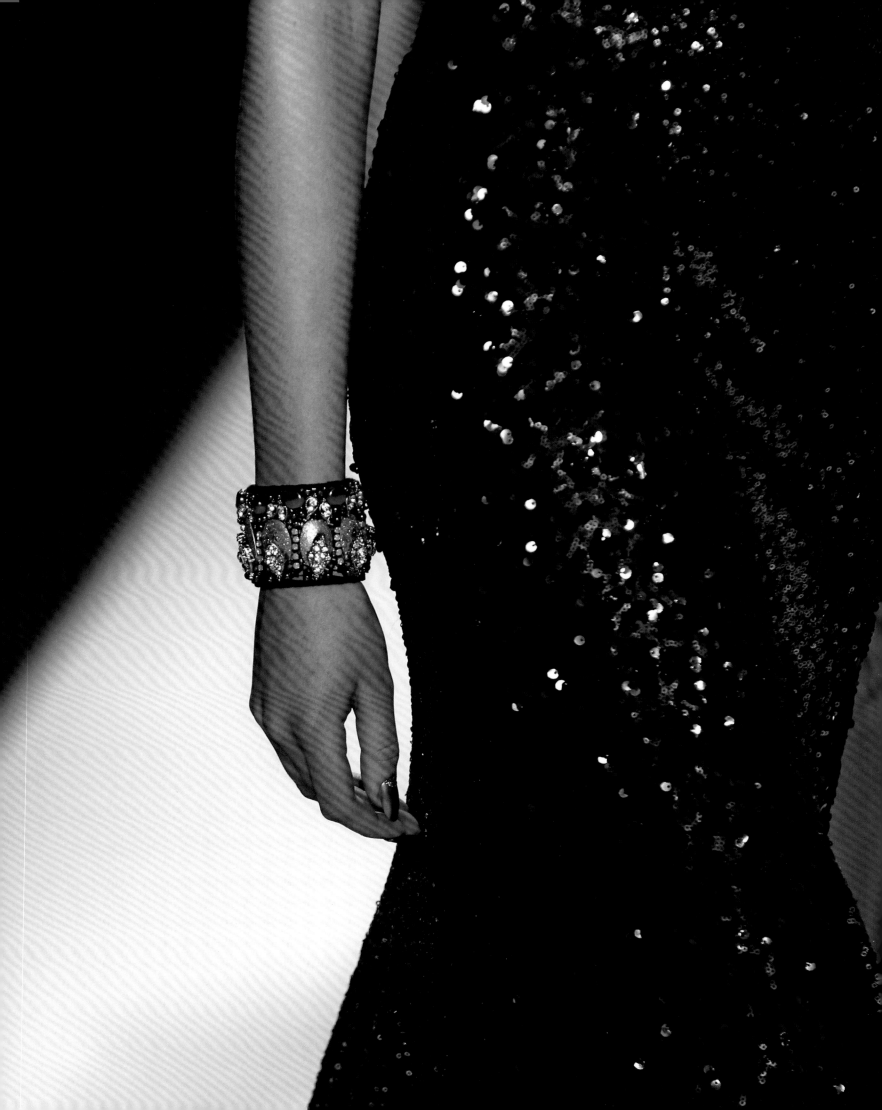

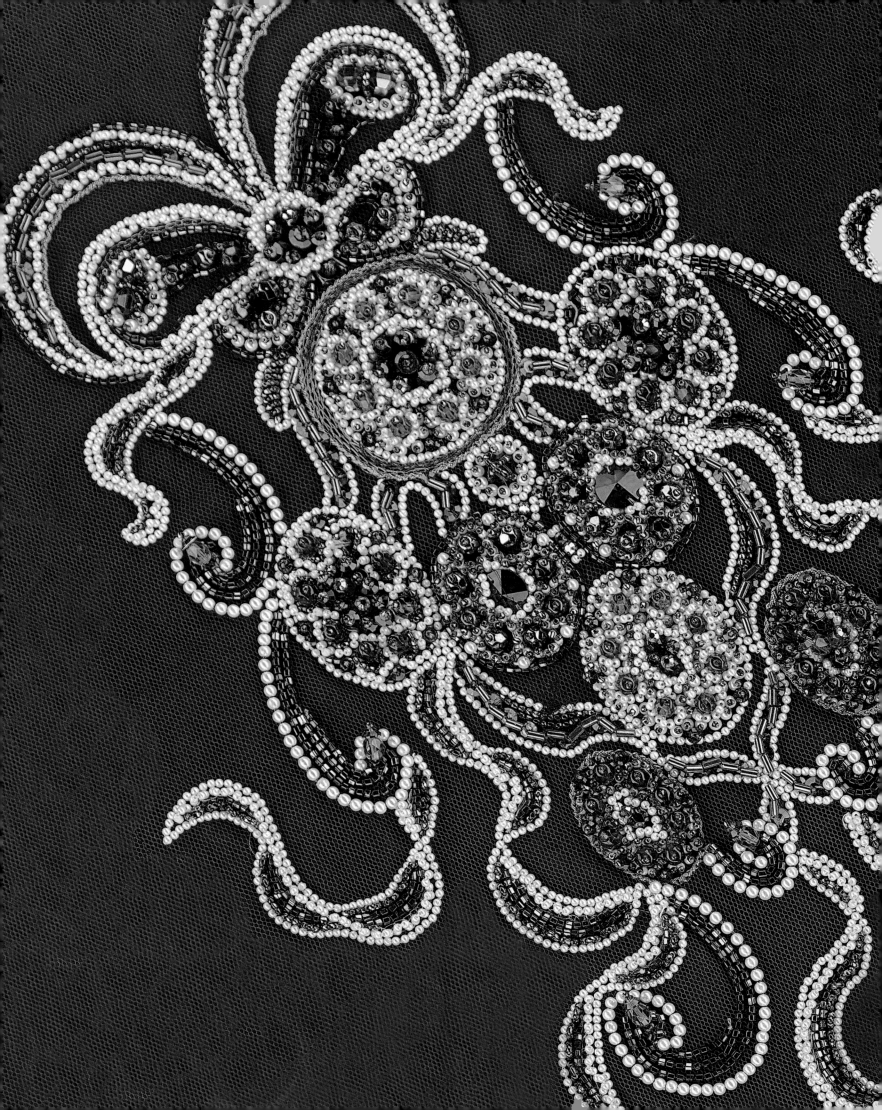

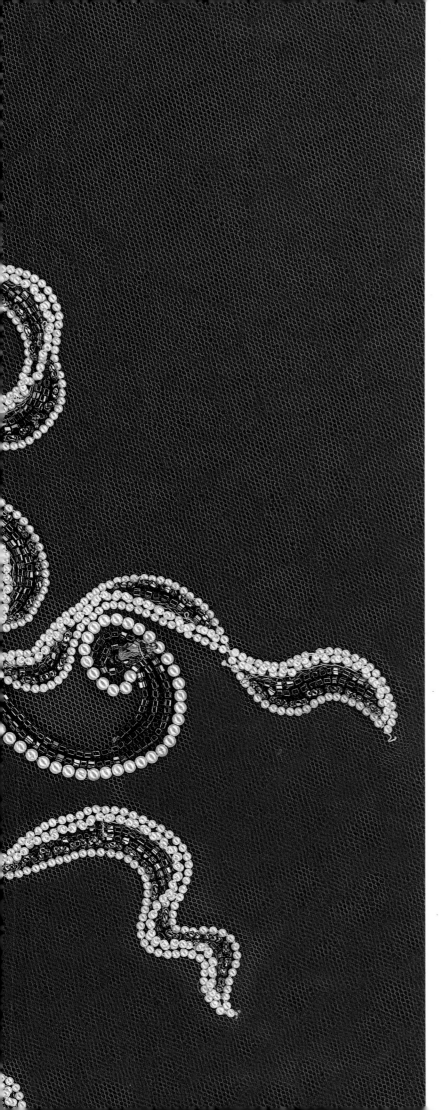

patternmakers, who interpret the sketches and drape the designs in muslin. The three-dimensional form is developed through a series of fittings, further editing, refining, and embellishment.

All of the original samples and custom gowns are made in Badgley Mischka's studio, which is located in New York's landmark 550 Seventh Avenue building. Here, a tangible sense of passion for creativity and craft emanates from the workroom. The lead patternmakers and sewers have worked with the designers for more than twenty years. They play vital roles in creating three-dimensional gowns that stand up to the original concepts and sketches. The head patternmaker has worked closely with Badgley and Mischka over the years, gaining a feeling for how to adapt their exaggerated sketches into shapes on the dress form. "When I get the sketch, I think a lot about how it will work [as a whole]. I think about how each part is made, and one by one it [the gown] becomes what they want," she describes.

Once the muslin is approved, the pattern pieces are thread traced onto the dress fabric and sent to India for beading. When the beaded pieces come back to the workroom, the patterns often have to be adjusted or remade to accommodate the weight of the beads. In the workroom, a great deal of thought goes into the details that make the gowns appear seamless, because the designers' expert patternmakers and seamstresses believe that these little details matter as much as any other part of the process. The process is not an easy one, but the designers insist it is worth all the hard work to make their vision come to life.

Embellishment is for evening, and the many small details at Badgley Mischka make a unique difference.

33

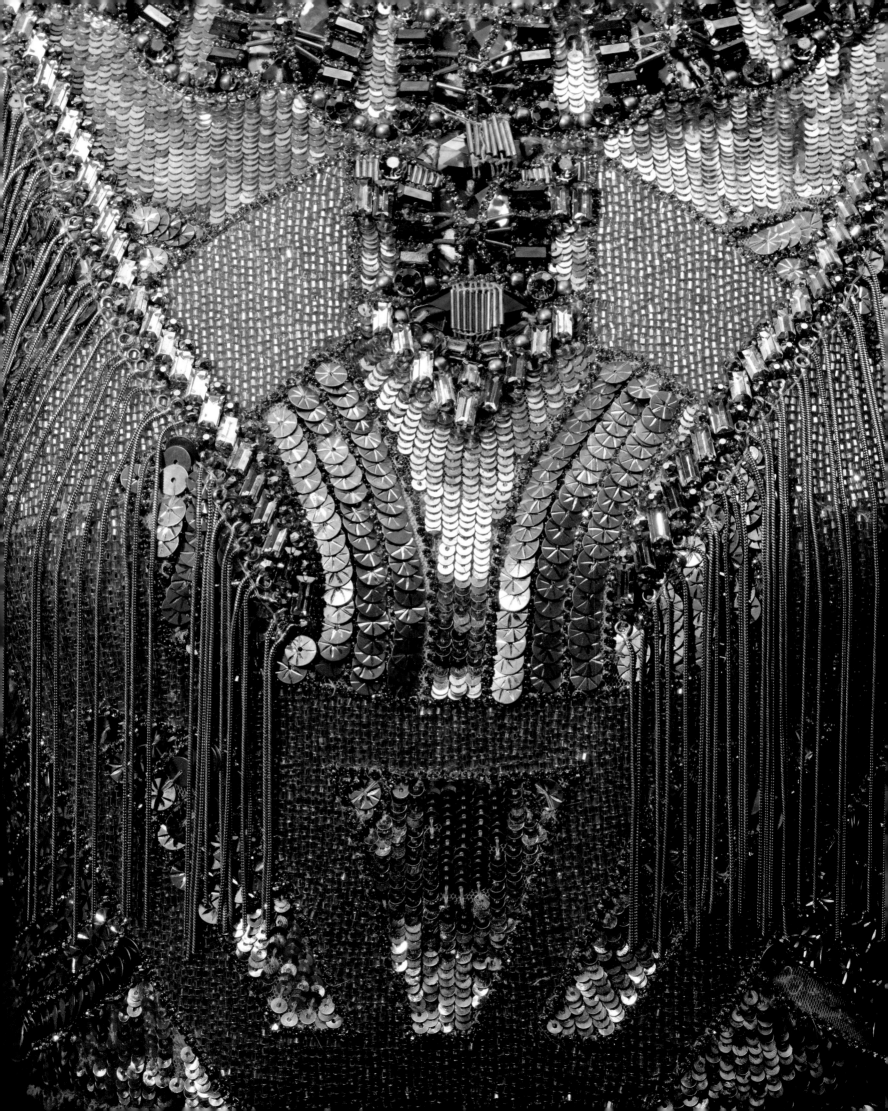

BEADING

To bead one of Badgley Mischka's grand dresses requires four or five people, working twenty-four hours a day in two shifts, typically over the course of three-to-five days. Tens of thousands of beads, each one sewn on individually by hand, might be required to complete the design on one gown. The workers knot the thread constantly to ensure that if one bead falls off, the whole row doesn't follow, a step that gives the wearer confidence and security. The sensation of wearing a beaded gown is unique. "A beaded dress feels different. The weight of the beads chisels and molds a silhouette to the body," Badgley explains.

Beading has been a Badgley Mischka signature for twenty-five years. The designers developed their own distinctive look by manipulating existing beads with unique "aging" processes to impart a lustrous, museum quality to the gowns. Today, 80 percent of the beads used on a Badgley Mischka gown are custom-made using a wide range of techniques and treatments—from hammering, custom dyeing, painting, sandblasting, and fire polishing to hand casting beaded appliqués inside resin. In the early years, they distressed the materials with drain cleaner, bleach, and runs through the dishwasher to create the unique patina. "We sort of have a PhD in beading," Badgley proclaims. "We know

A dozen or more different kinds of hammered, hand-painted, heated, antiqued, or otherwise custom-made beads may go into a single design. In this gown, a jump ring was soldered to each piece of box chain to create the fringe (Fall/Winter 2013 collection).

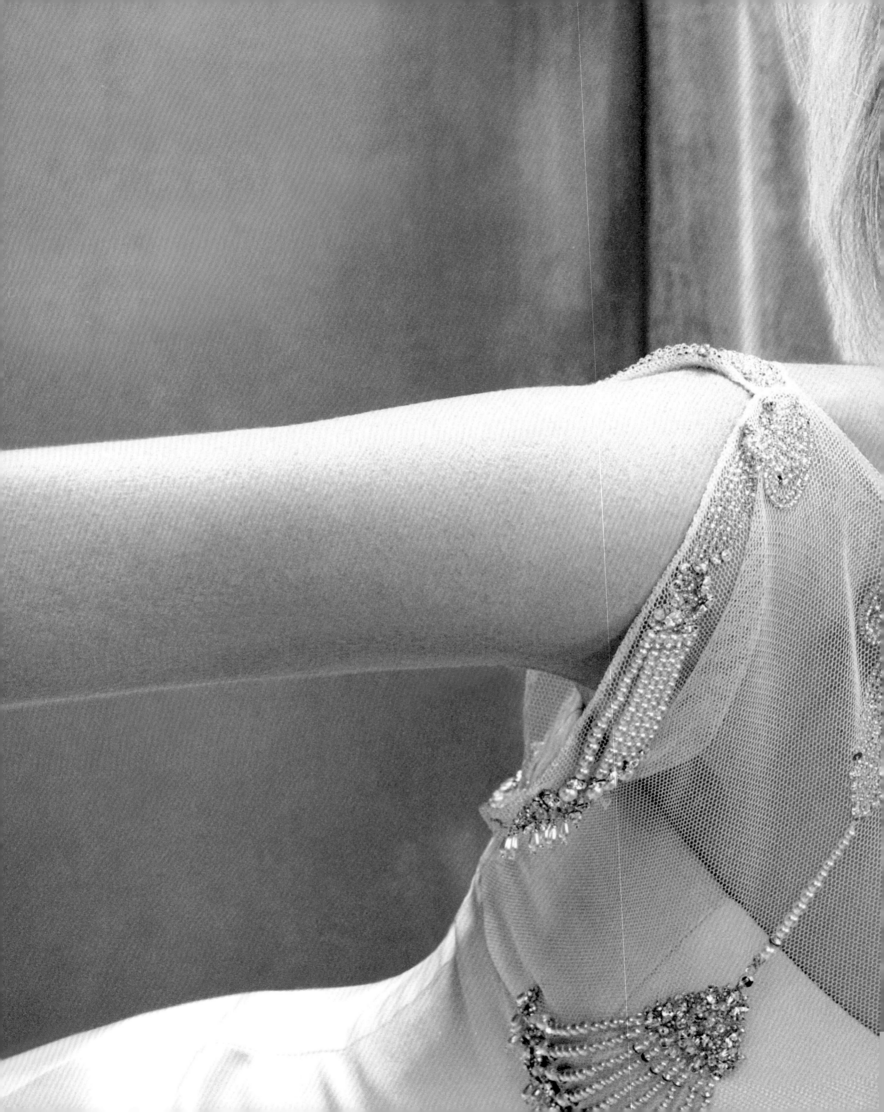

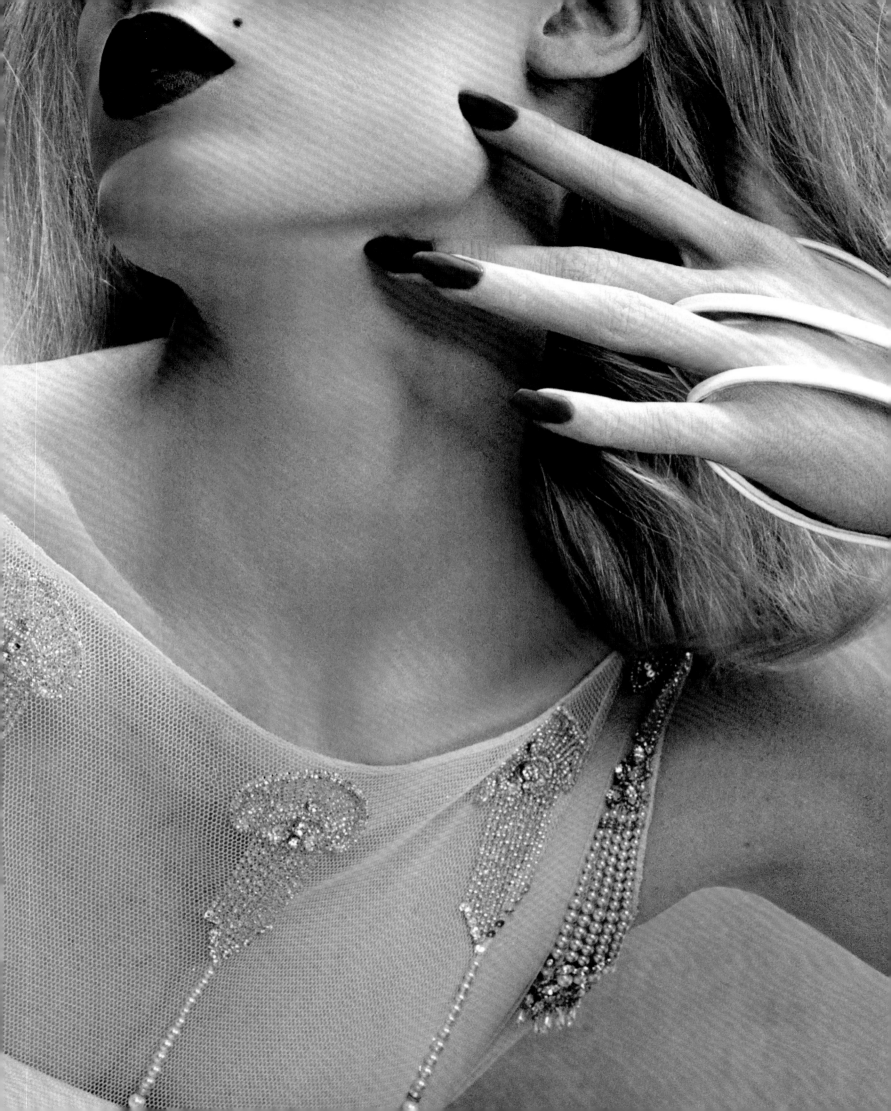

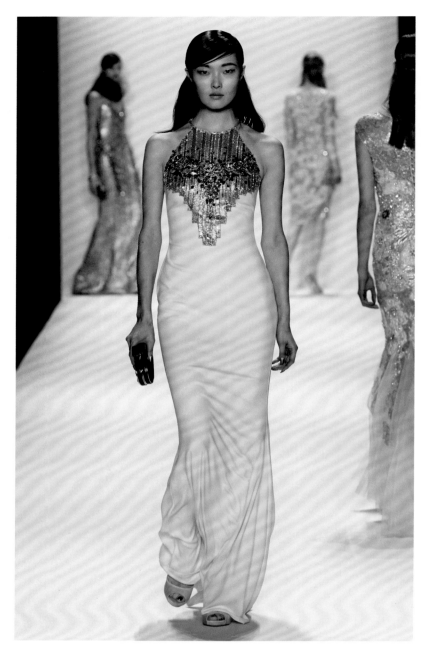

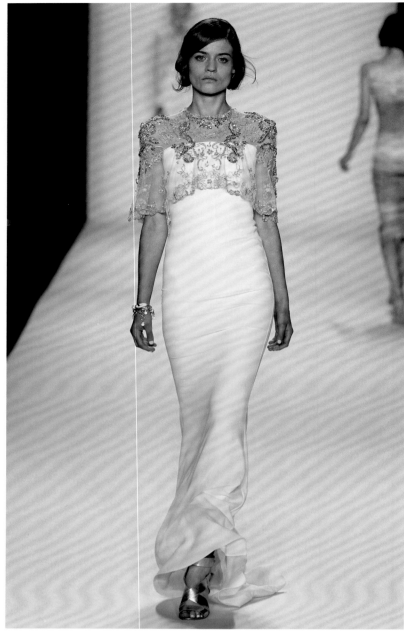

Above Timeless columns of white in which the beading is integrated into the texture of the fabric. Left to right: Gold accents in the form of chain maille and brooches are stacked on white, adding grandeur and dimension (Fall/Winter 2014 collection). Metallic threadwork and cut bugles on tulle mimic metallic lace in this cape (Spring/Summer 2014 collection). Shoulders and necklines are accented with stacked crystals; a bodice of pearlized and frosted sequins, crystals, and strung pearls mixed with antiqued, silver-lined, cut bugles, intertwined with tulle ruffles melt down the skirt, which is a collage of pearls, organza, and tulle cut on the bias and hand-stitched (Spring/Summer 2014 collection). A tulle gown with organza appliqué, and rose opal–stacked crystals, and delicate coiled flowers (Spring/Summer 2014 collection). *Previous pages* Delicate beading brings evening-wear elegance to the bride's special day (Fall 2002 Bridal collection).

where all the cottage industries are. The development of original beads and designs is a really important part of our process and requires a lot of back-and-forth."

All of the beading is done in Bombay, India, where it is a centuries-old male profession often passed down from one generation to the next. Traditional techniques have inspired adaptations that have been refined for couture gowns. Striving for innovation every season, Badgley and Mischka continuously work on new ideas that push the boundaries of beading. For years, they have been selecting beads that blend into the fabric to enhance its texture, blurring the line between bead embroidery and a custom fabric. "We don't just do a beaded gown. We blend everything into the fabric so it's a collage where the fabric begins and the embroidery ends," Badgley explains.

Creating an original bead-embroidered design with custom beads is a labor intensive, detail oriented process. A paper pattern

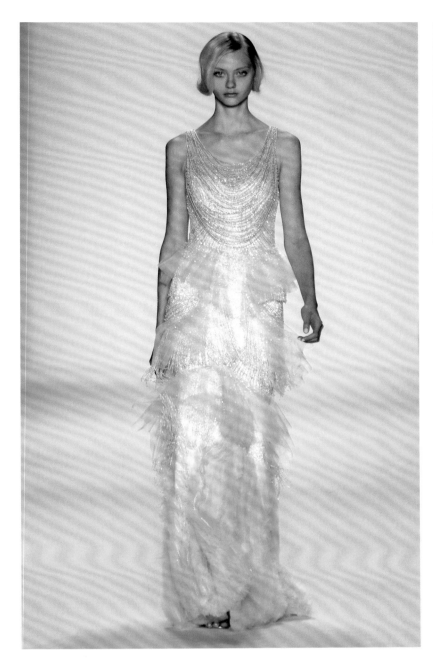
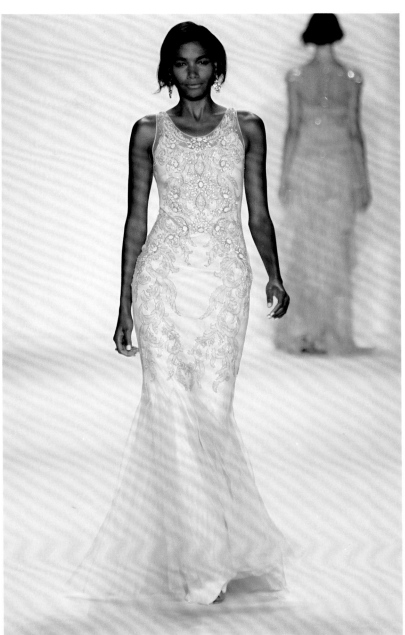

of the dress pieces is used to create the custom-beading artwork. The artwork is drawn, bead by bead, and then color-coded to communicate the type, color, and position of each bead to be used. Each layer of the dress must be drawn separately. Outlines of the pattern pieces are thread traced onto the fabric to show where the embroidery should be placed. Then the artwork, a material key, a detailed letter, and the uncut fabric panels are sent to India, where the fabric is stretched tautly on wooden frames. Because the beading shrinks the fabric, a back-and-forth process is required to refine the final pattern. The piece is taken on and off the frame over and over again, and a dress may log several thousand air miles back and forth from New York to India before it is completed.

Since the inception of the brand, Badgley and Mischka have collaborated with extraordinary artisans and craftspeople to realize their signature style. Working from the designer's sketches, their staff and suppliers attend to the many details needed to realize the finished embroideries and garments, guiding them through a complex process that is susceptible to the changing forces of weather and international politics. The high level of specialization and attention to quality and detail add the nuances to Badgley Mischka's gowns that make them unique in our own time and in the history of fashion. Their extraordinary talents, and those of many, others are brought together with the singular goal of making women look beautiful.

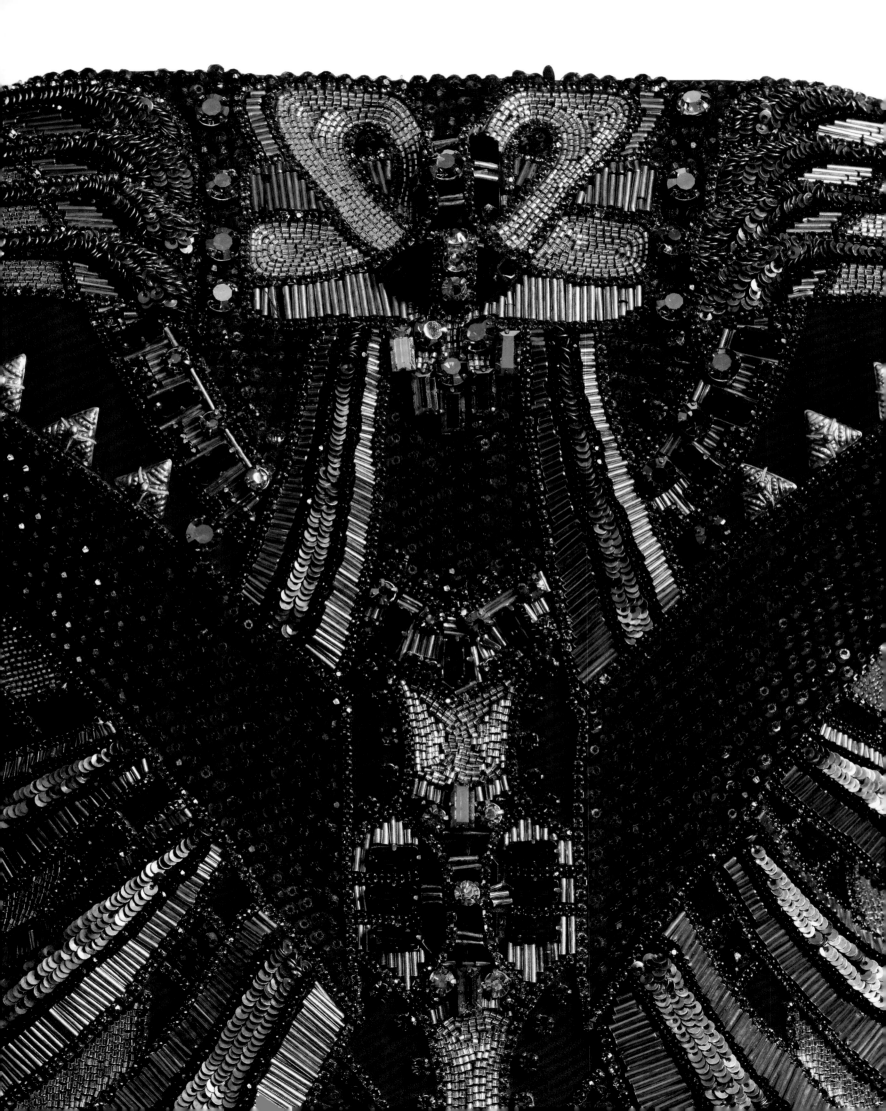

Right A collage of brooches layered with custom-cut sequins and crystals on a fabric of chain maille separated by rows of crystal chainette. Both faces of the chain maille were used for added dimension (Fall/Winter 2014 collection). *Opposite* A design of stacked bugle beads, custom-cut glass stones, and etched-metal sequins paired with ruby-colored Lochrosen crystals that have been acid-treated to look antique (pre-Fall 2013 collection). *Following pages* Organza appliqué and chiffon reverse appliqué on tulle with cut bugle and sequin trimming create more of a texture than embroidery. The resulting fabric is engineered around the body in what appears to be a seamless form (Spring/Summer 2013 collection).

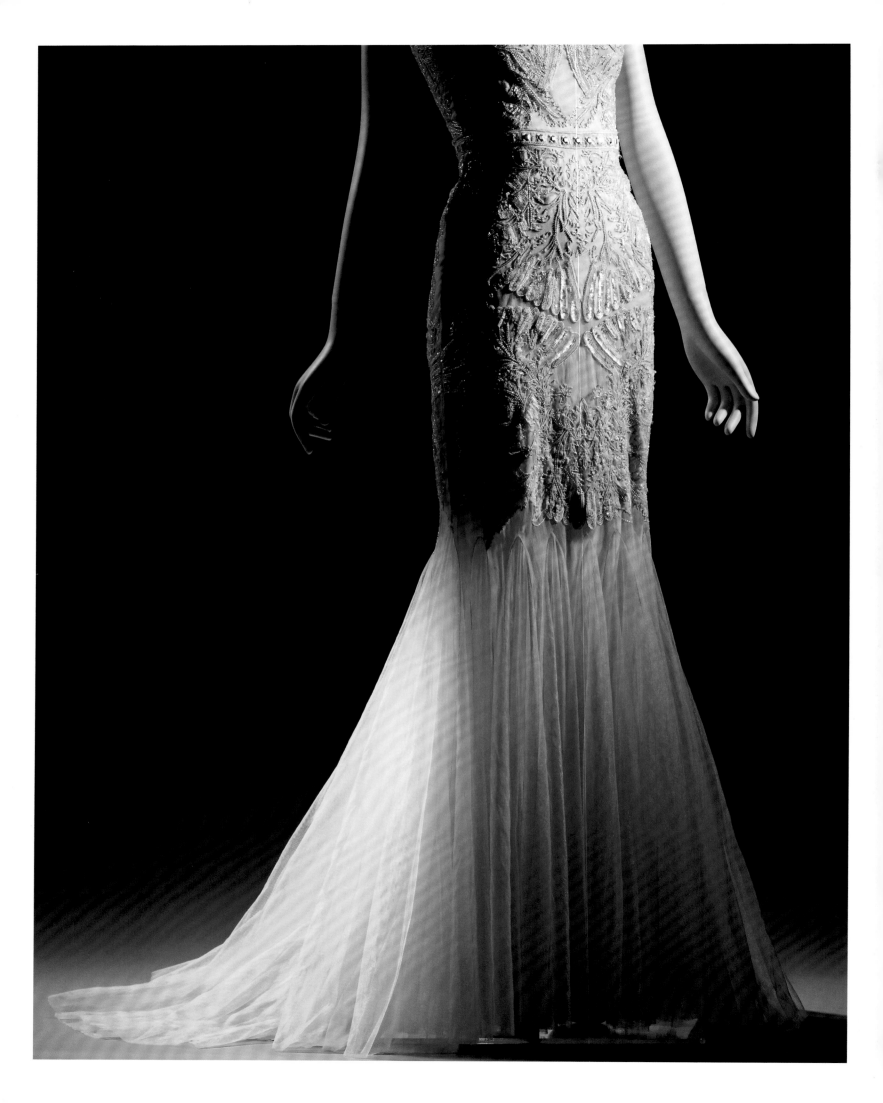

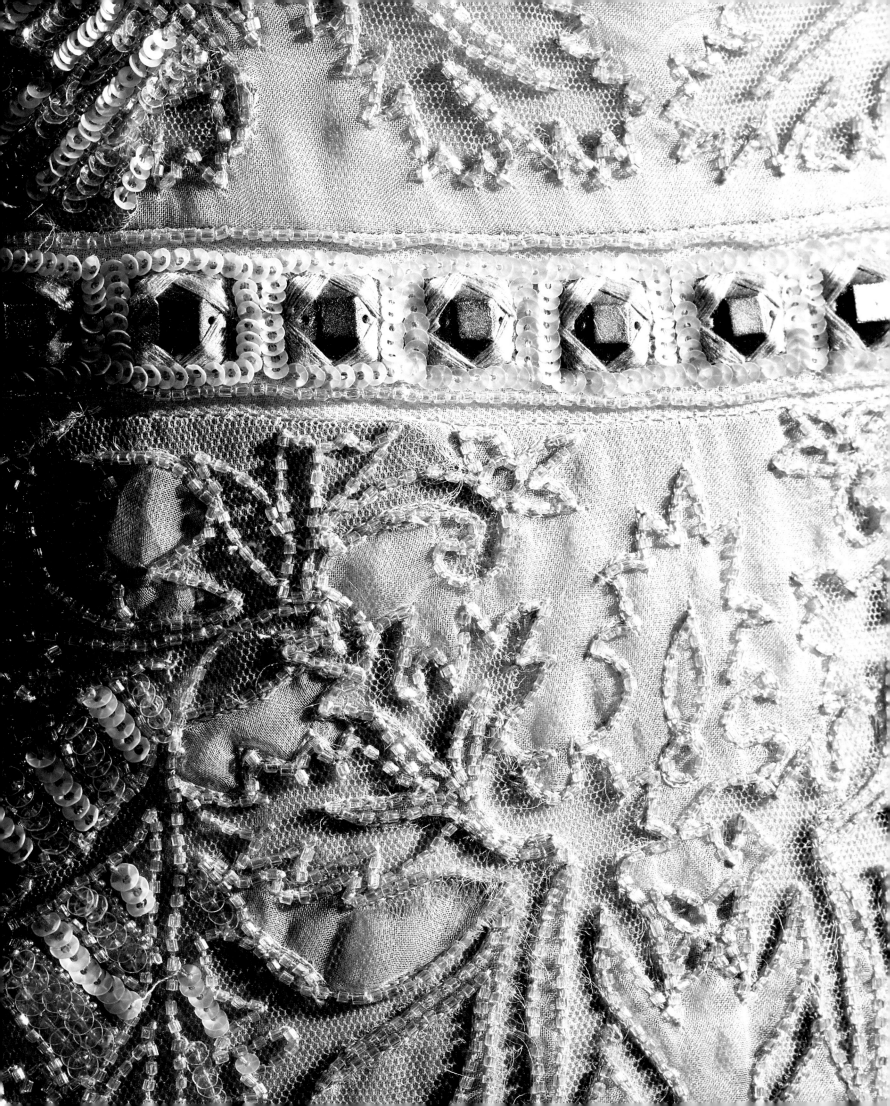

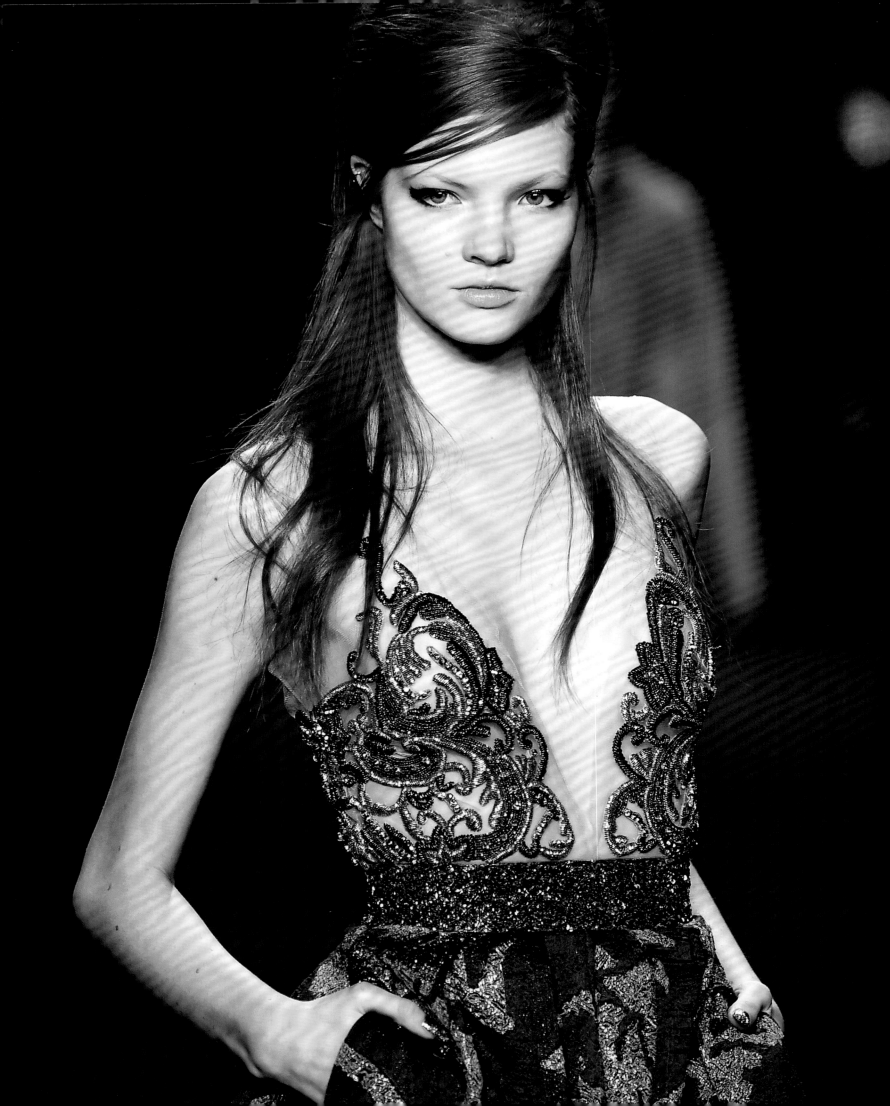

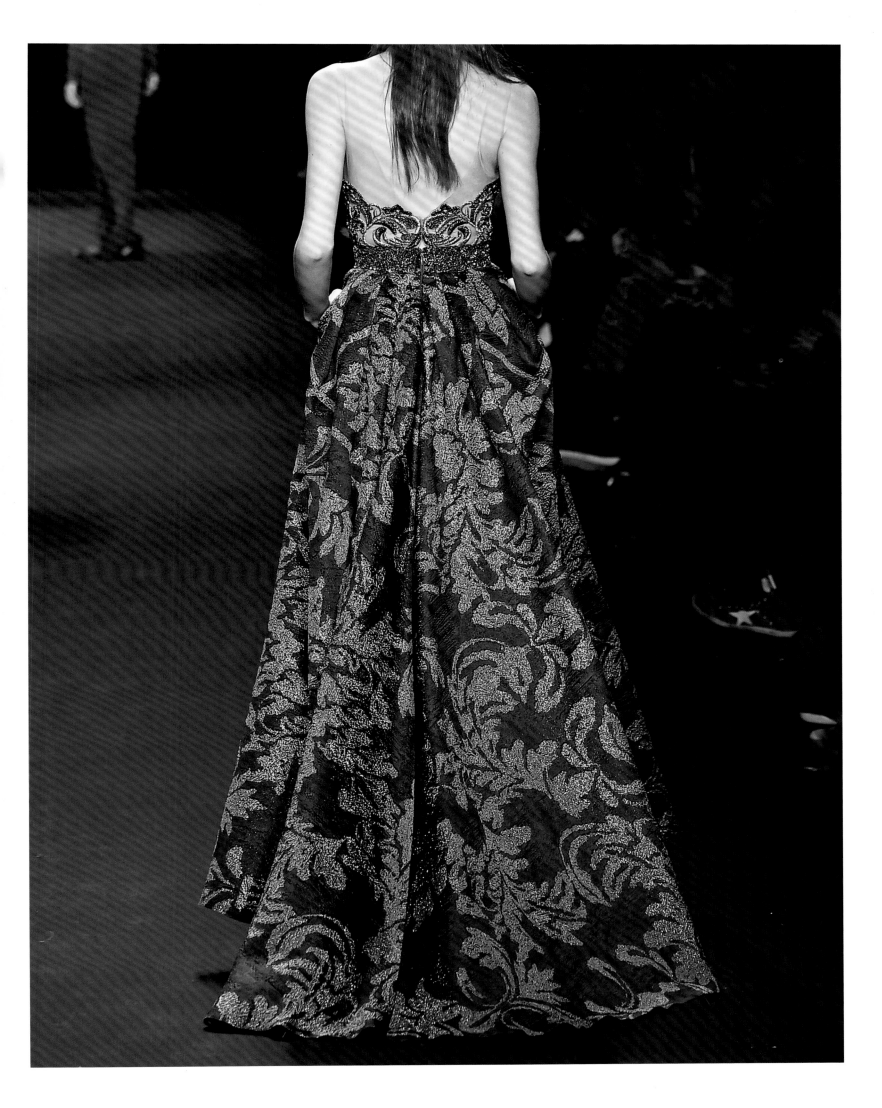

Opposite A collage of net, beads, and lamé evoke the textures of a Gustav Klimt painting, the inspiration for the Fall/Winter 2014 collection. *Previous pages* The patterns and textures of Spanish brocades inspired by the silent film *Blood and Sand* (1922) are mimicked in beading, giving the Fall 2015 collection a baroque elegance. *Following pages* A gown of metallic lace adorned with micro bugles and crystals in soft vintage hues with fluttering "beads" of handmade, hand-painted vintage petals purchased from a Parisian silk-flower dealer (Spring/Summer 2013 collection).

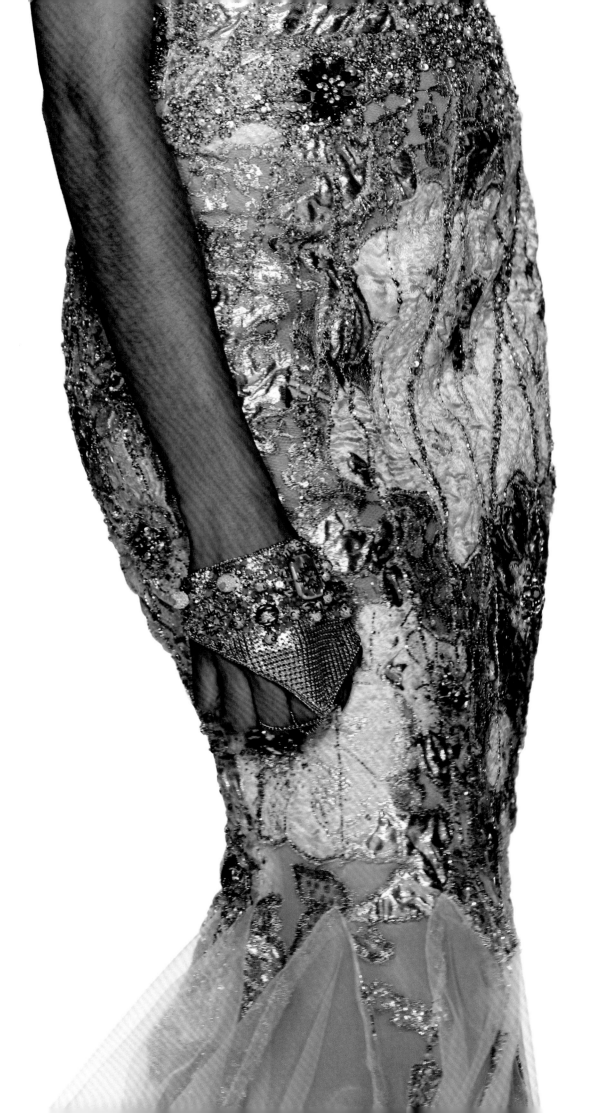

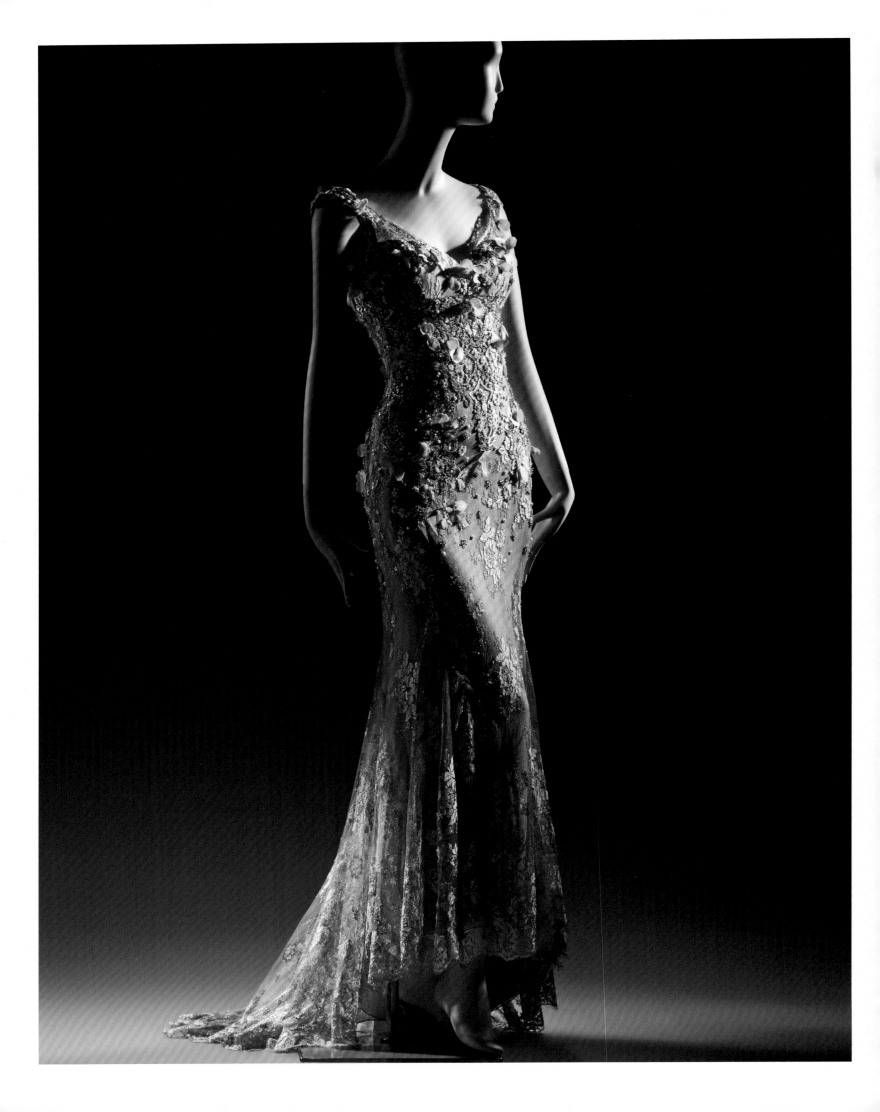

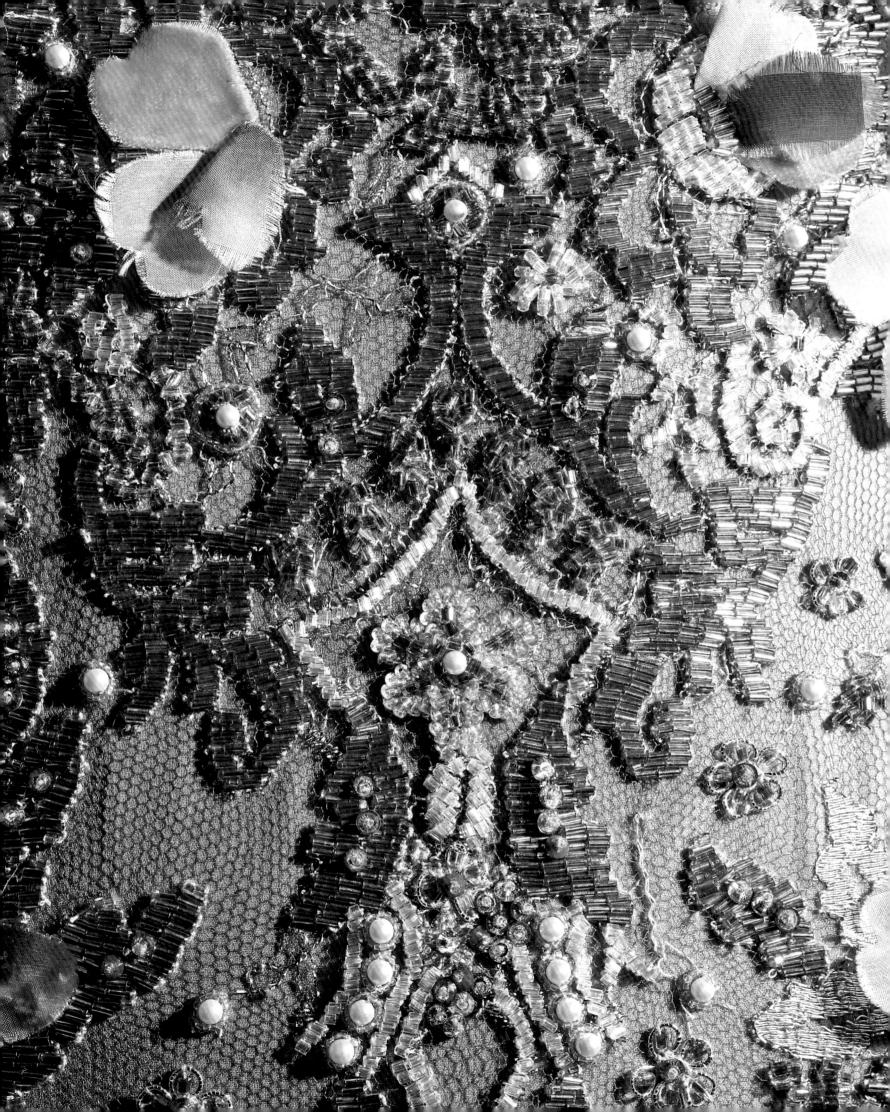

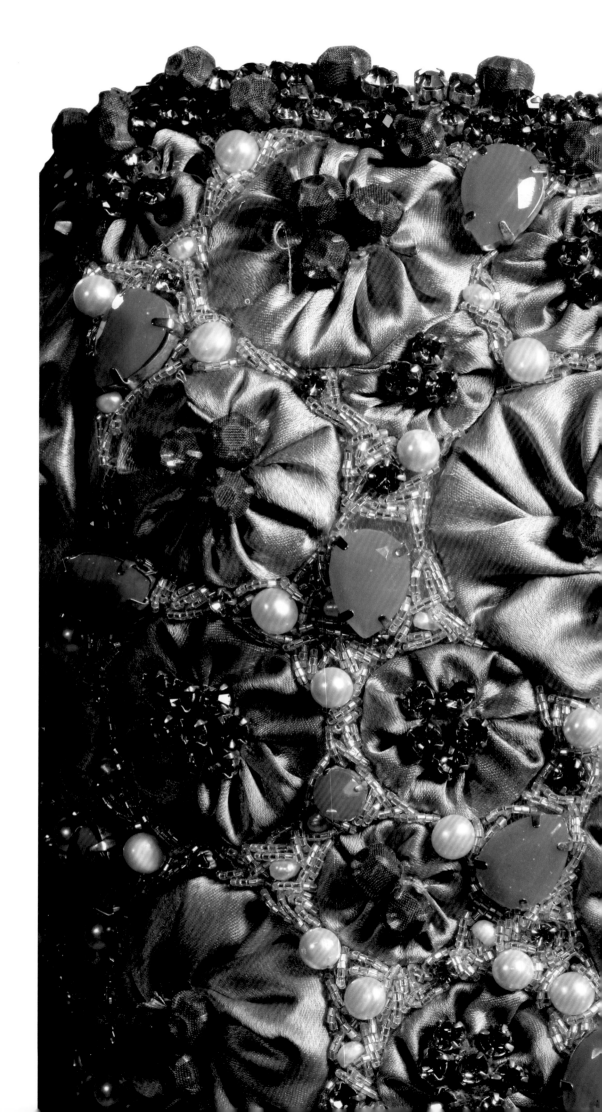

A feminine expression
of silk-satin rosettes,
pearls, and a lacework
of beads (pre-Fall 2009
collection).

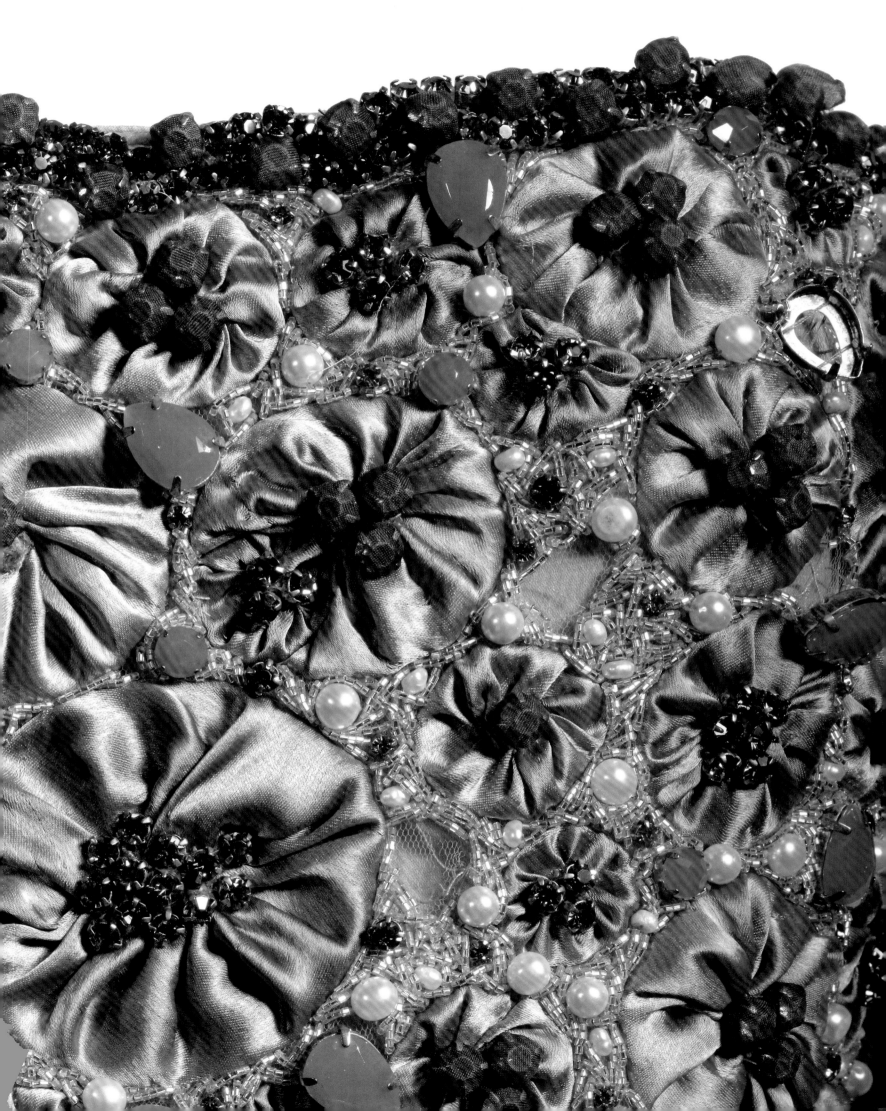

Opposite Dramatic
custom beads, scaled
for a grand entrance
(Spring/Summer 2009
collection). *Following
pages* Delicate beaded
lace evokes feminine
allure (Fall/Winter 2002
collection).

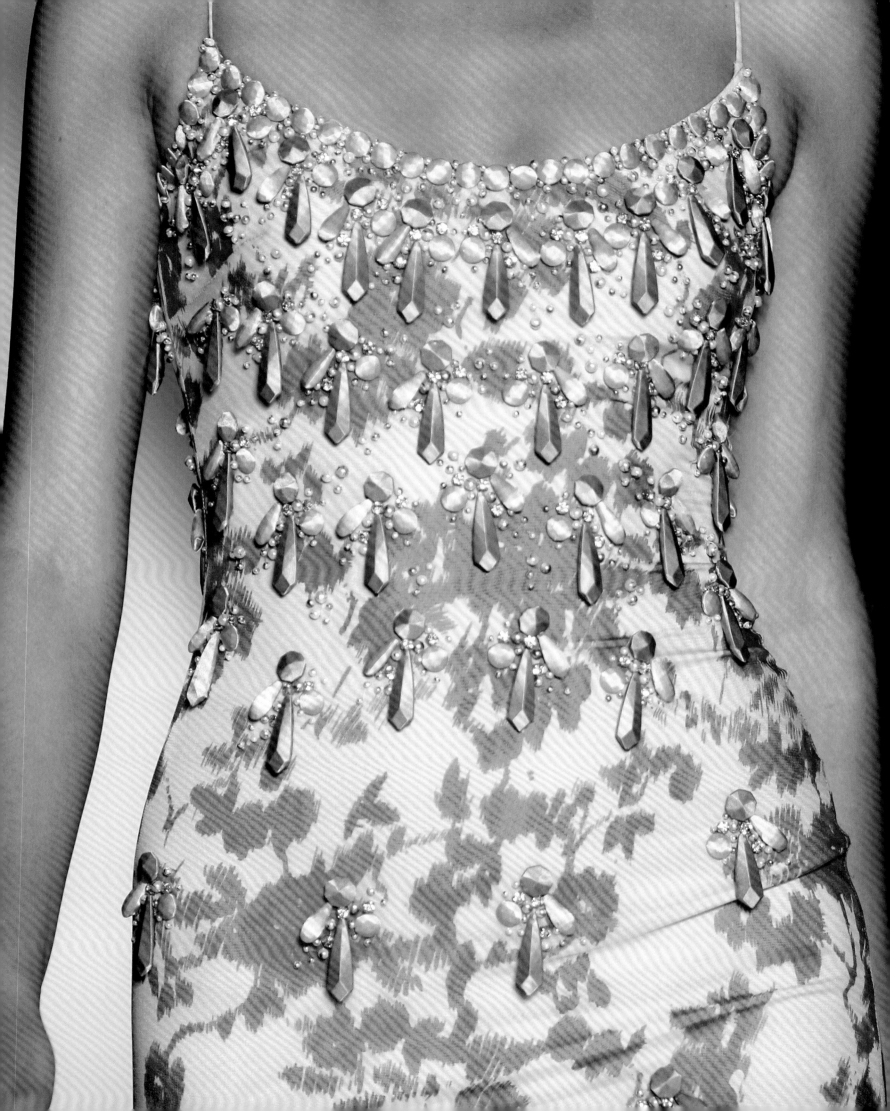

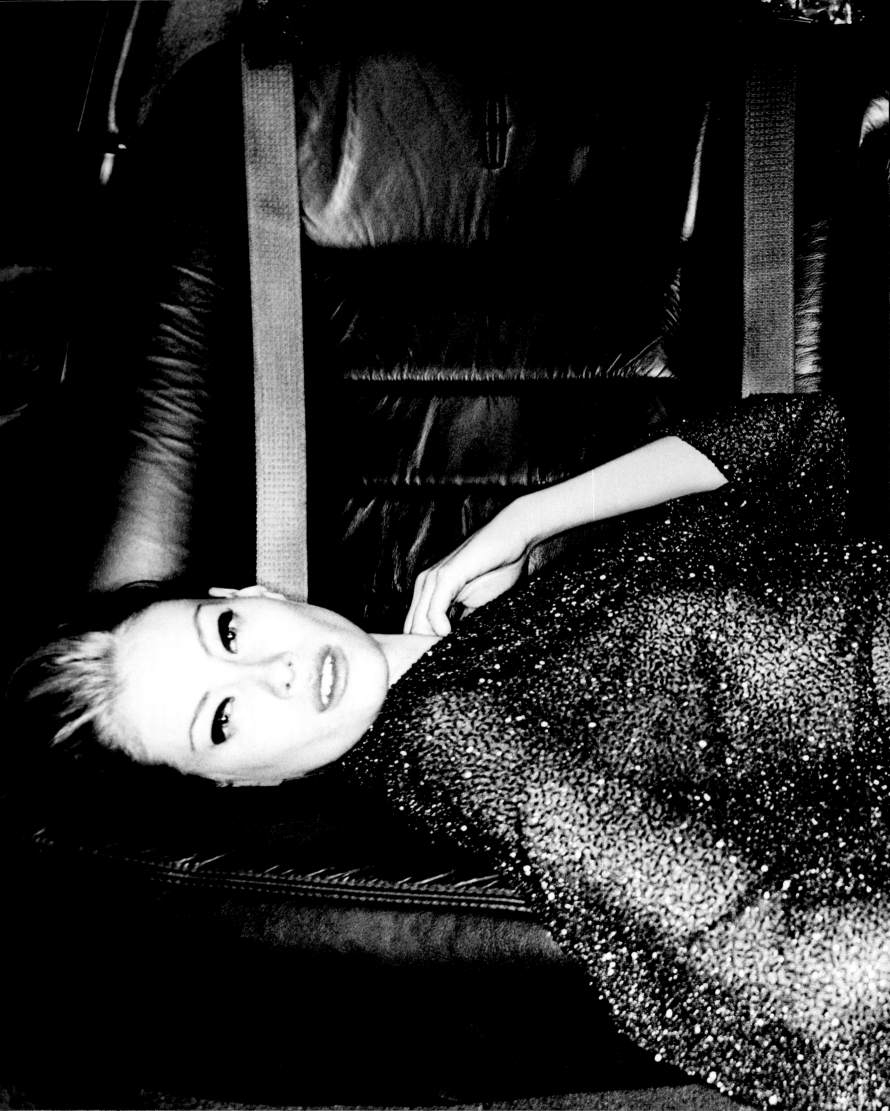

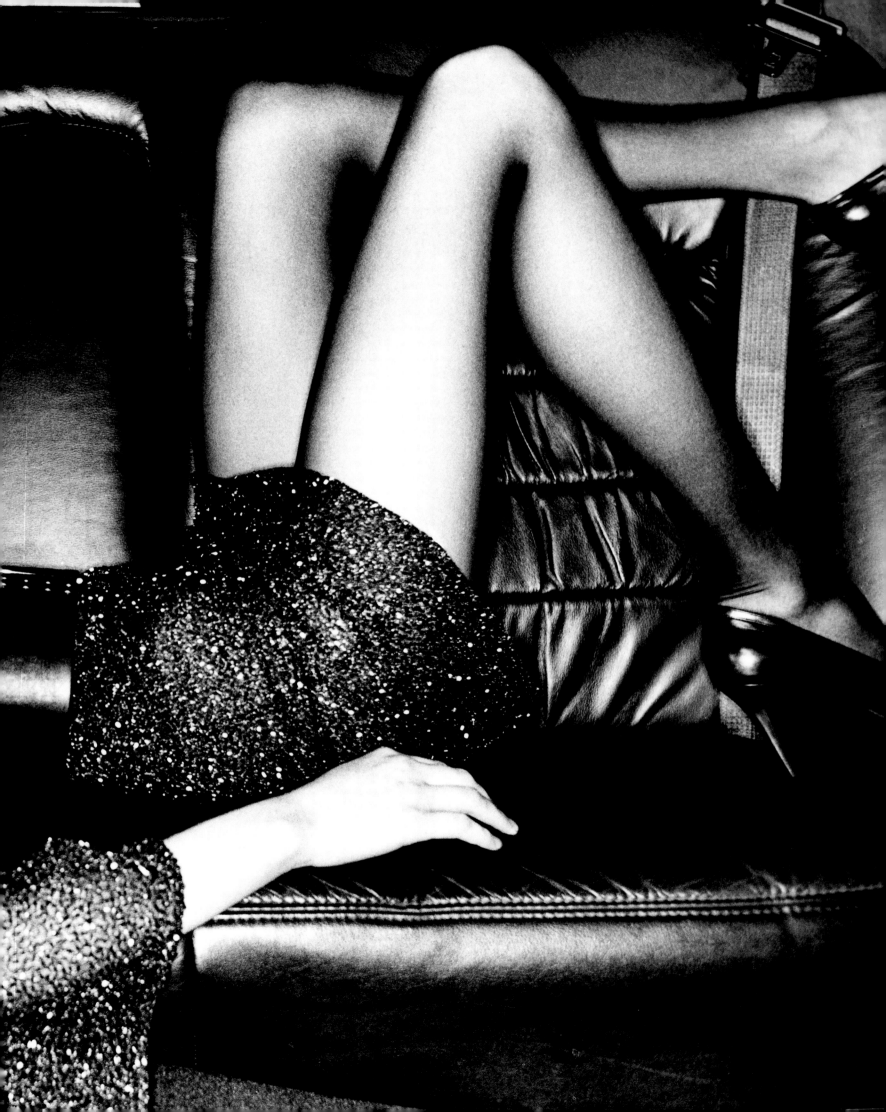

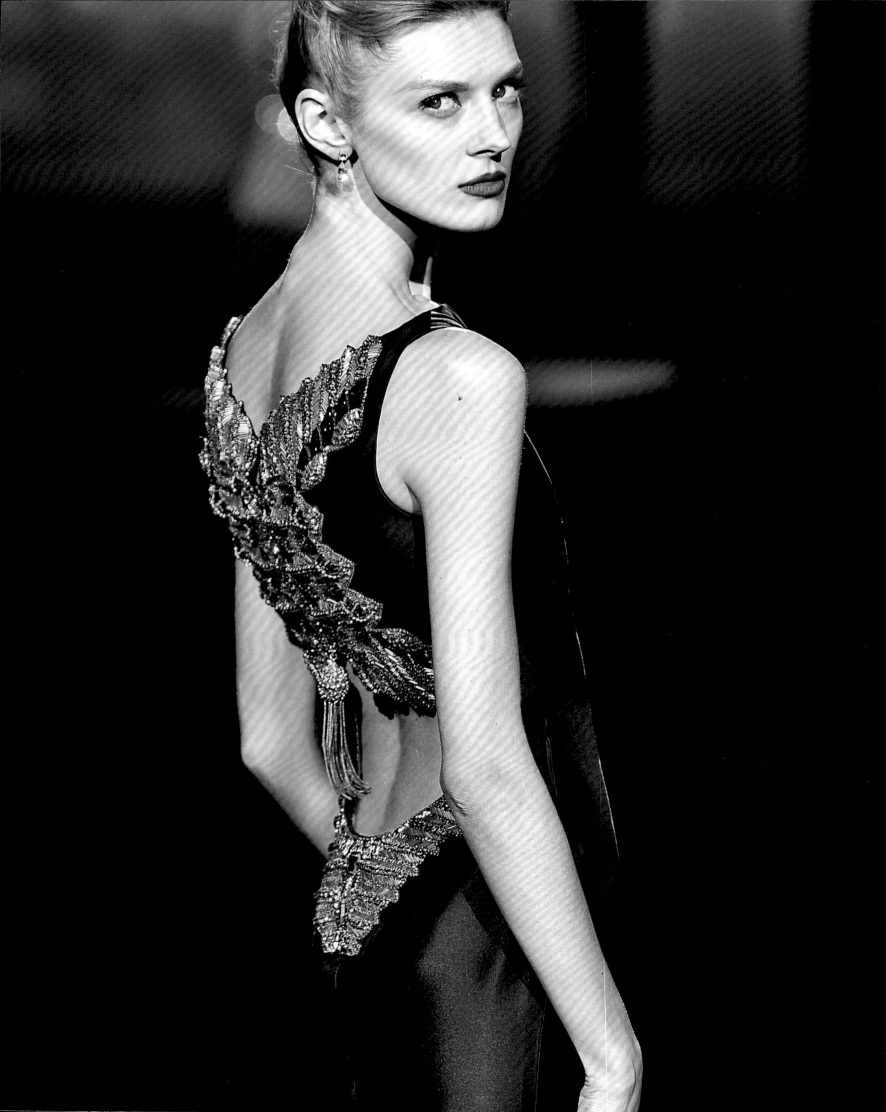

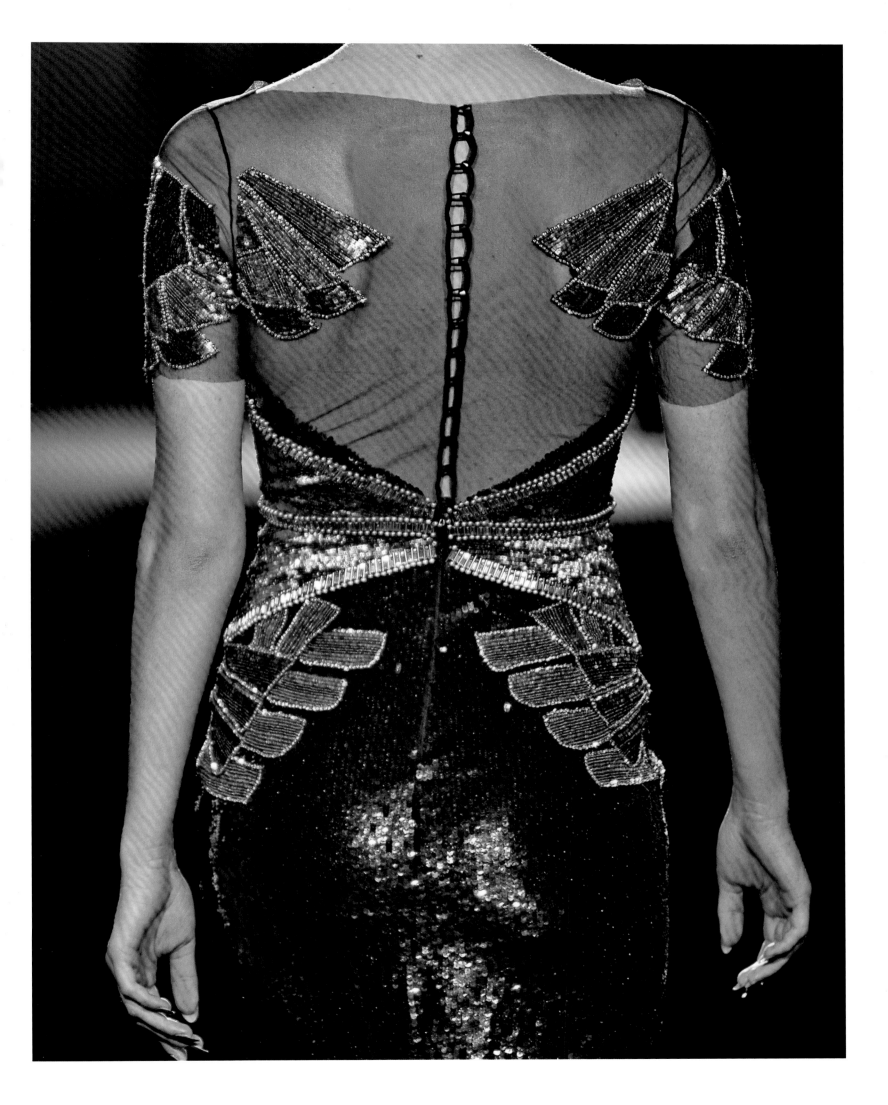

*Opposite and following
pages* Beading on the
shoulders brings the
focus of attention to the
wearer's face. *Previous
pages* Bold Aztec- and
Mayan-themed embroi-
deries emblazon the
finale gowns of the Fall/
Winter 2013 collection.

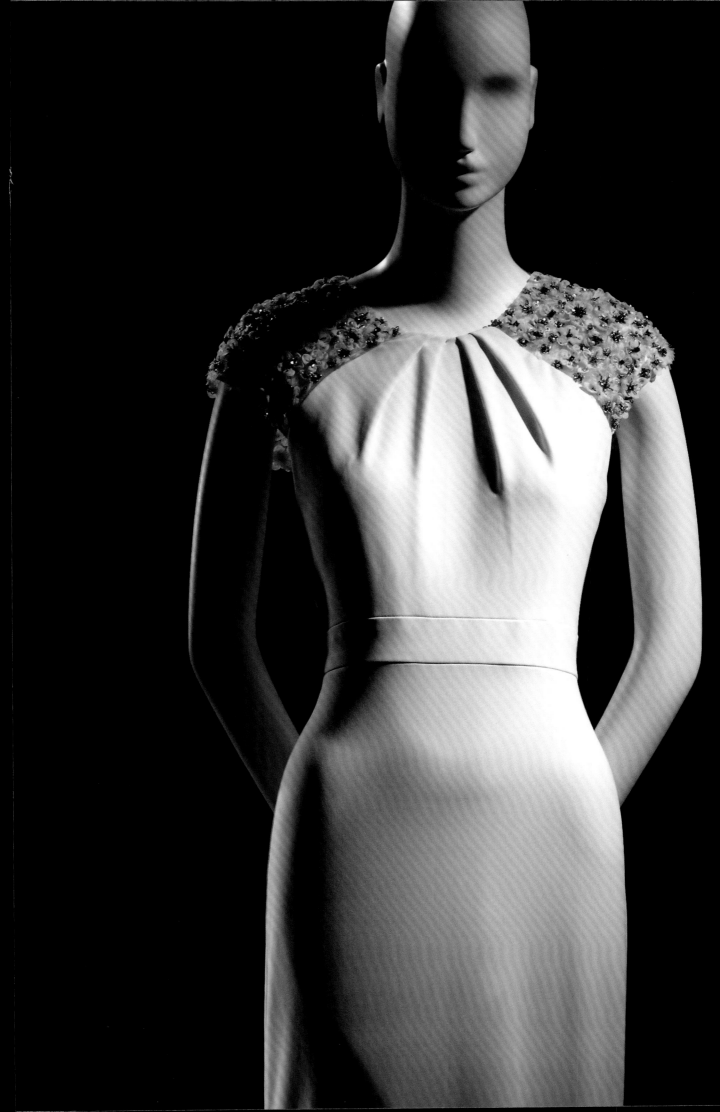

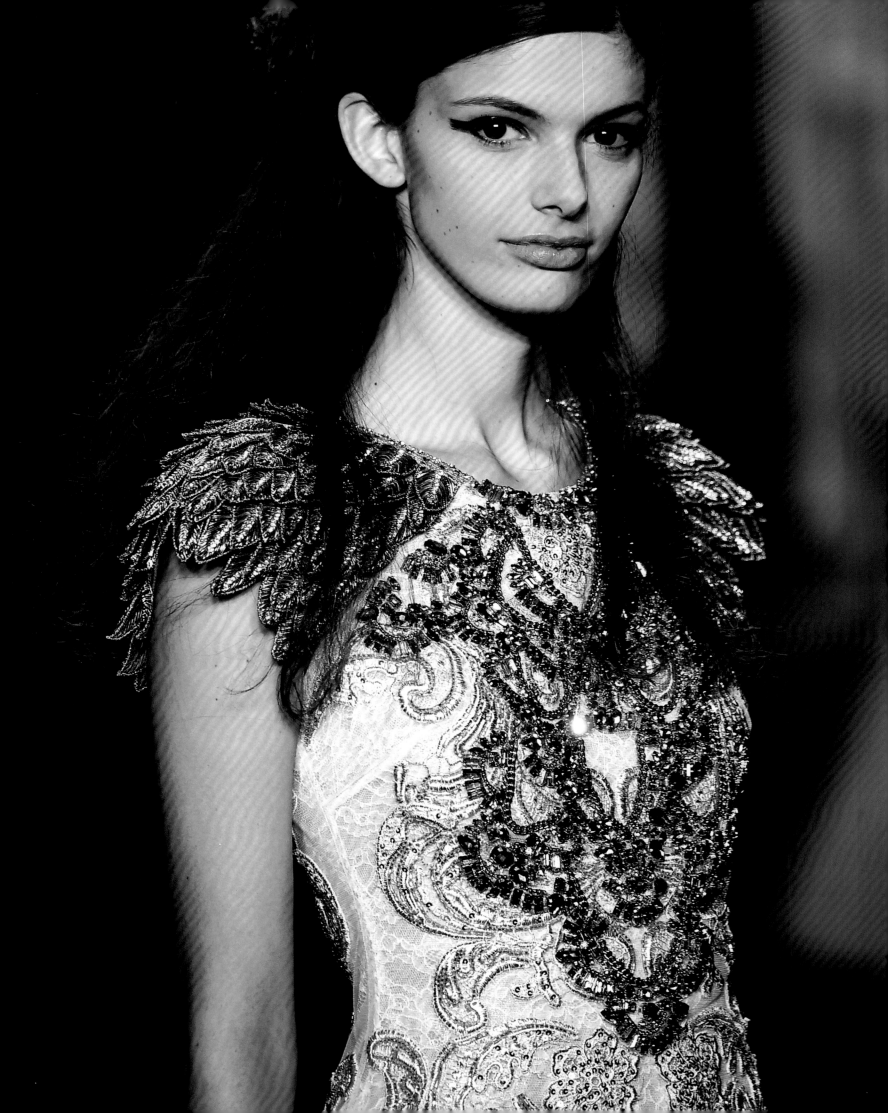

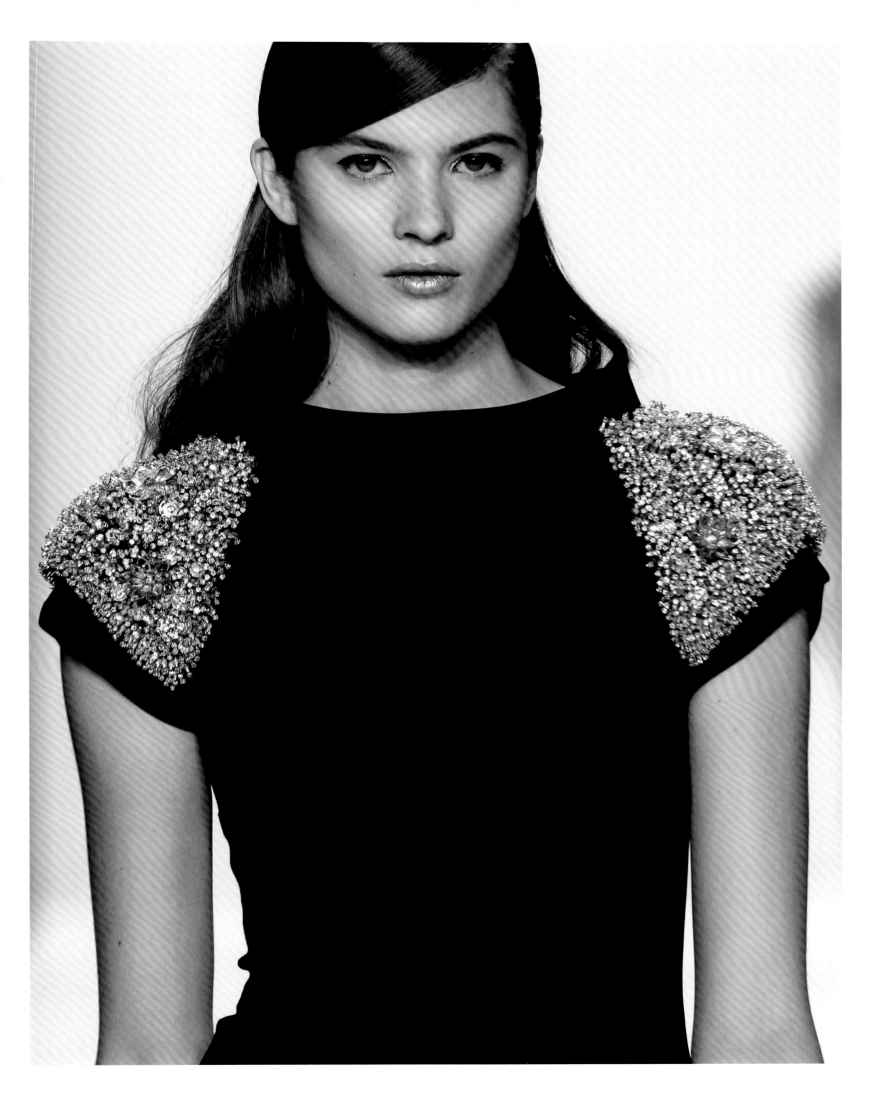

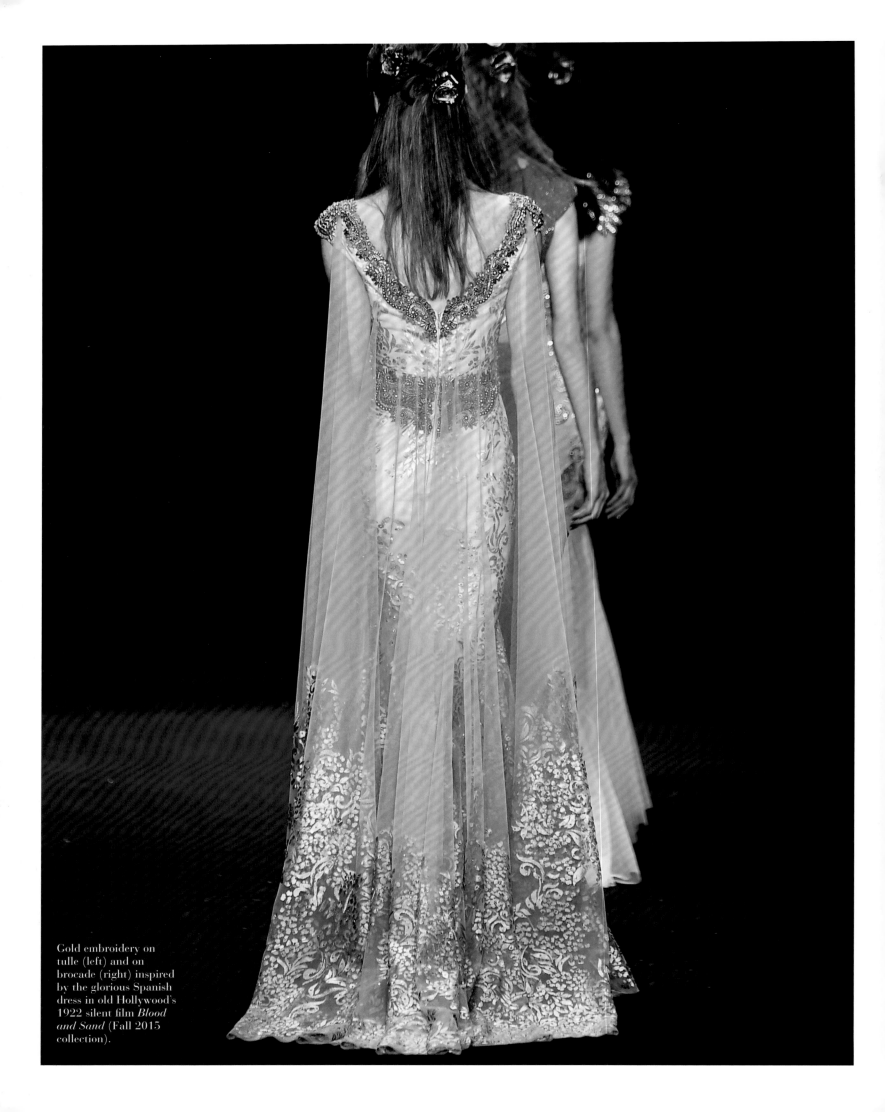

Gold embroidery on tulle (left) and on brocade (right) inspired by the glorious Spanish dress in old Hollywood's 1922 silent film *Blood and Sand* (Fall 2015 collection).

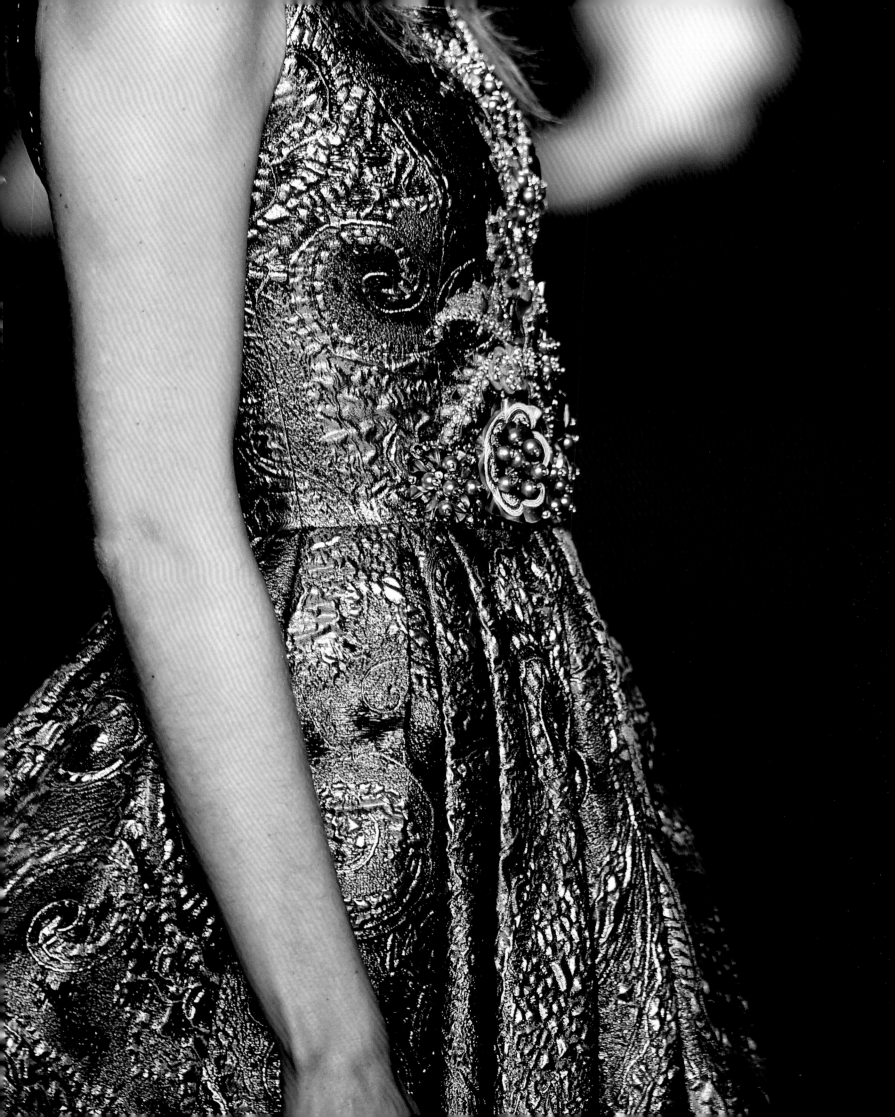

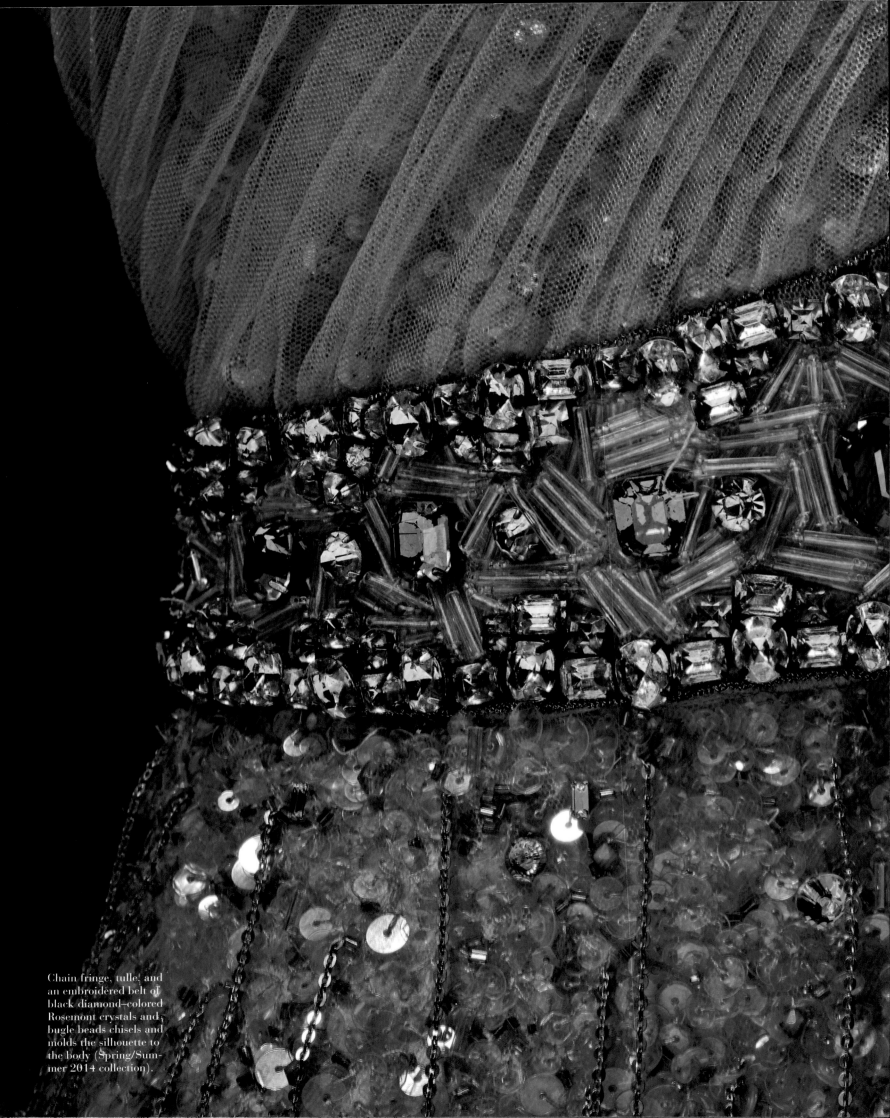

Chain fringe, tulle, and
an embroidered belt of
black diamond–colored
Rosemont crystals and
bugle beads chisels and
molds the silhouette to
the body (Spring/Sum-
mer 2014 collection).

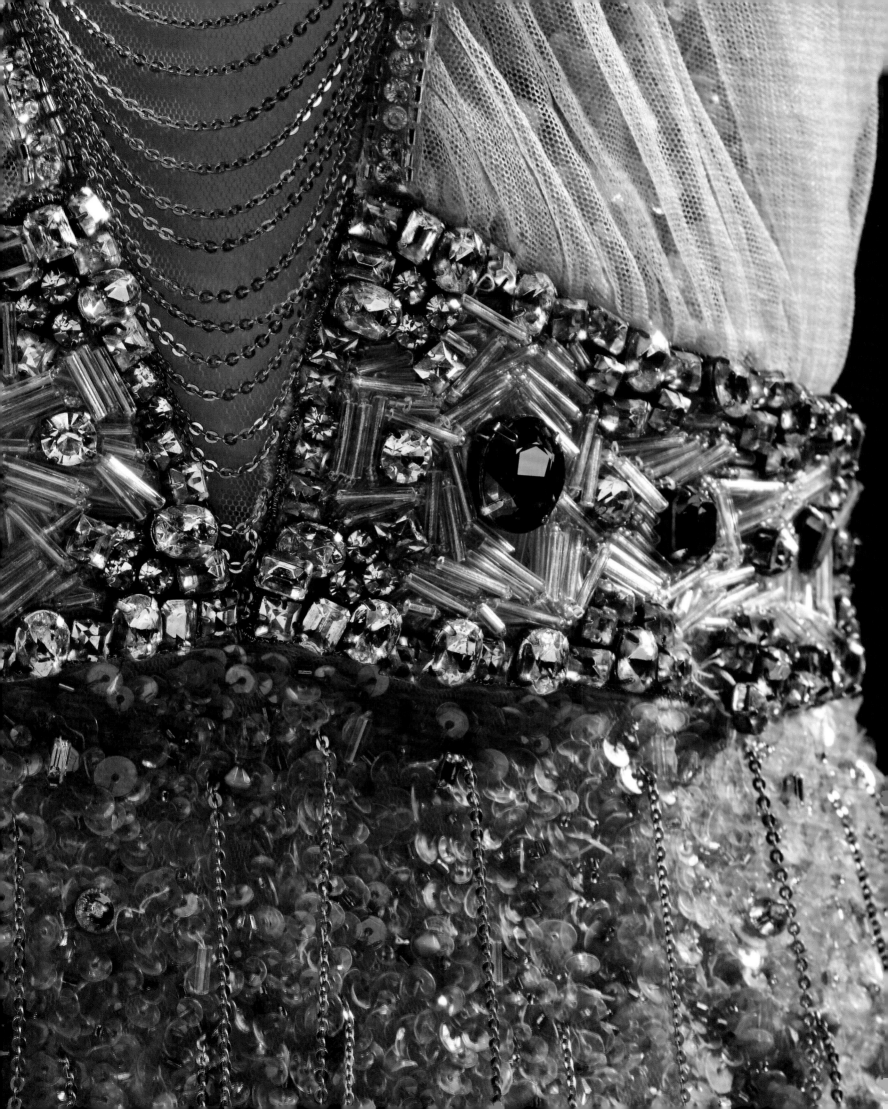

HOLLYWOOD GLAMOUR

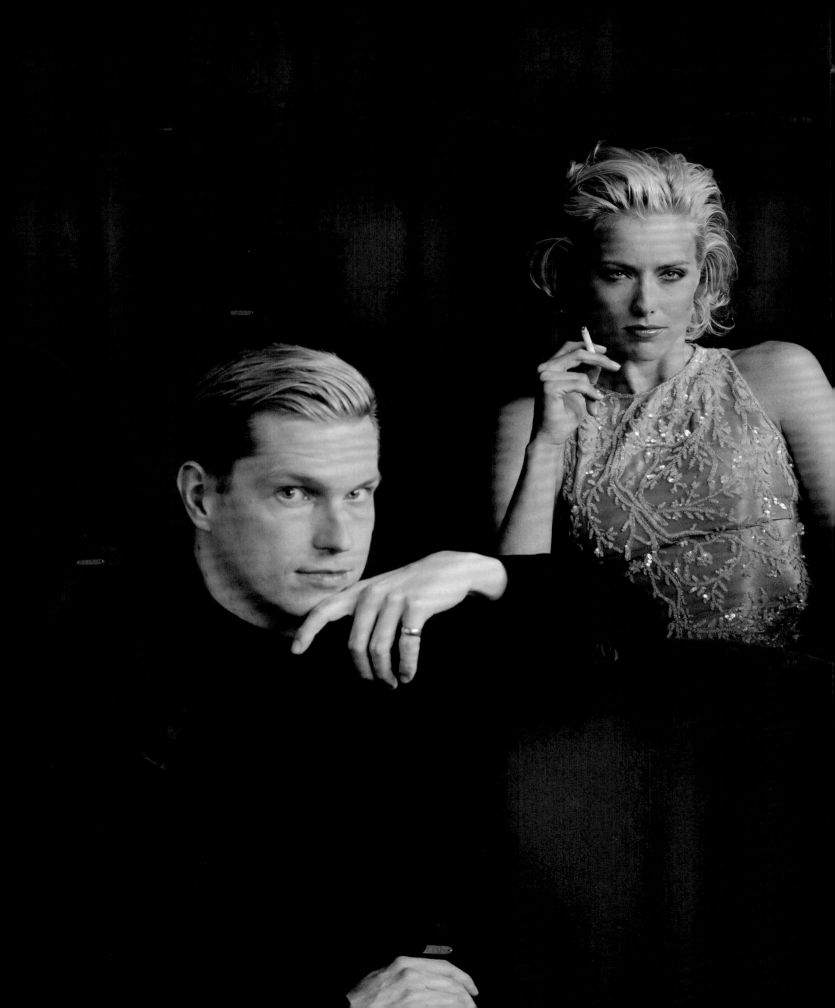

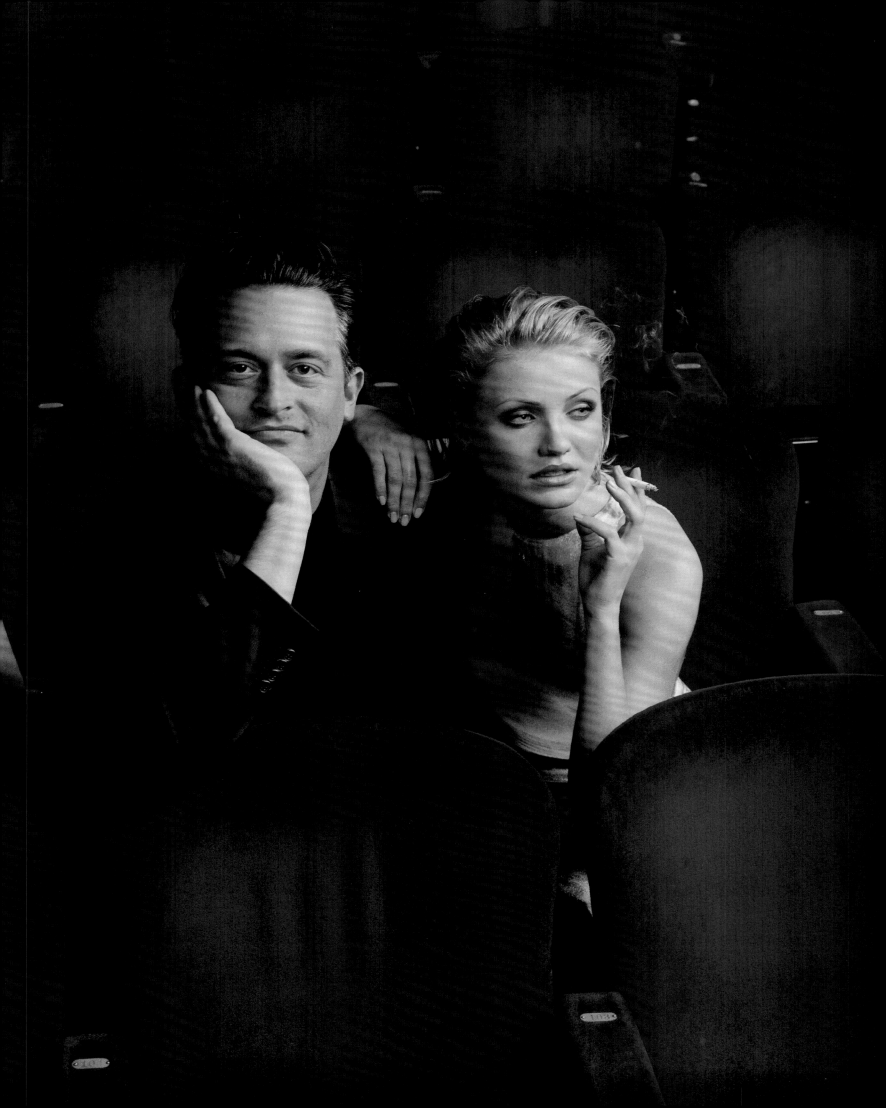

HOLLYWOOD GLAMOUR

Hal Rubenstein

Certain designers love to intellectualize fashion. Perhaps it's an overre-action to a lingering anxiety that a career making clothes is a clear indi-cation that one has never outgrown the desire to play dress-up. They are formidably represented by my collection of overwrought press releases from past ready-to-wear collections that claim to owe a season's spark of creativity to the paintings of Mark Rothko, carvings on the walls of Ang-kor Wat, or the poems of Sylvia Plath (now doesn't that lift the spirit?).

So what are we to make of Mark Badgley and James Mischka when they unhesitatingly admit that the glorious designs for which they are best known—the ones that stride across Oscar and Emmy red carpets and climb the grand staircases that lead up to New York's annual Met Ball or to the nightly stars-aplenty premieres at the Cannes Film Festival—are inspired by "the Golden Age of Hollywood when stars like Rita Hayworth, Lauren Bacall, and Ava Gardner looked absolutely stunning, sensual, and amazing." Why, that's just so, well, obvious.

You bet your bugle beads it is. And maybe that's why so many stars, both veterans and bright new lights, as well as the millions of women who watch them in wonder tinged with envy adore what

Opposite Brooke Shields at the Emmy Awards, 2008. *Previous pages* Mark and James with Téa Leoni and Cameron Diaz. Leoni wears their gold trellis beaded organza gown while Diaz dons one of silk panne velvet.

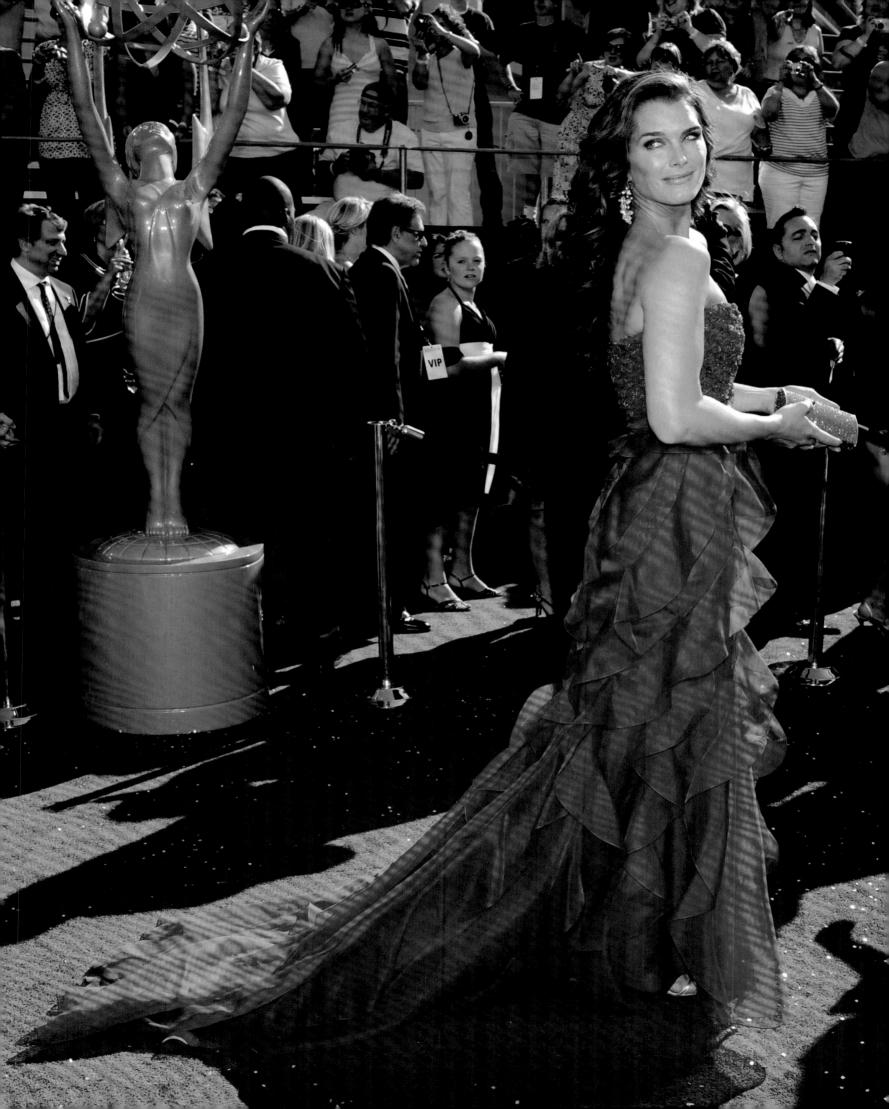

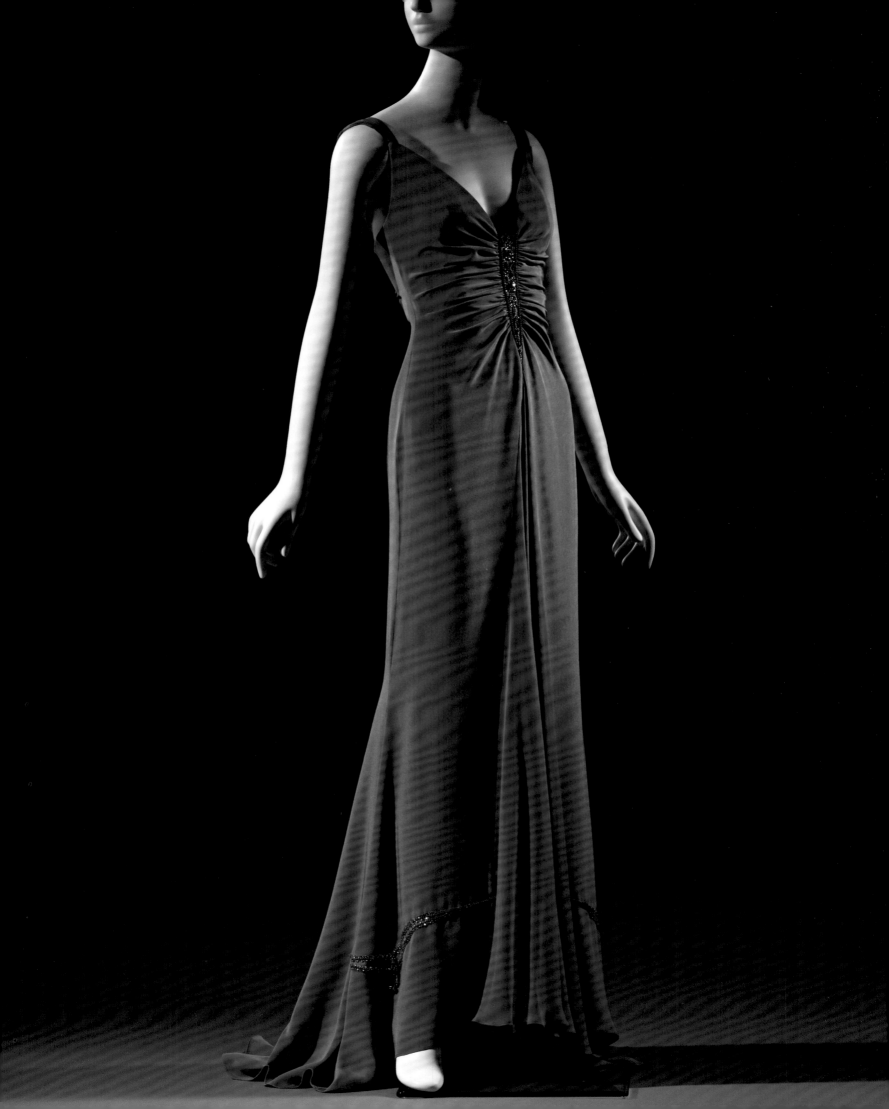

Badgley Mischka do. What's so refreshing is that the pair's undiminished fascination with the legacy of great beauties of the silver screen isn't in any way cerebral. Rather, it's wide- and bright-eyed, visceral, dreamy. We need no theories to swoon and smile at their adroit interactions of curves and sparkle, to get a rush from that whoosh of taffeta or the shine of shantung, or to marvel at the ethereal weightlessness of hand-beaded tulle when they allow them to glide with grace along the female form.

Just because pensive rumination and obscure cultural references are not required to appreciate the appeal of ruffles, lace, and Swarovski crystals, crafting them to celebrate beauty in all its permutations requires keen eyes, deft hands, a fanciful imagination, and a rare and enchanting power to make a women look sensational, photograph like an icon, and to feel both as regal as if it was her coronation day and yet as desirable as if she's unlocked the secret of happiness.

The women Badgley Mischka celebrate in this section cannot be contained in a single category. Some have basked in fame for years. Others have been a little overwhelmed by all the attention at the time. Some cited are voluptuous, others are waiflike, bombshells, tomboys, diminutive, statuesque; one is a near-sainted cultural deity and another has played a royal so often that others probably curtsy in her presence as a reflex. But what all of these women share is an ecstatic willingness to give themselves over to the sweeping romanticism that helps to transform each of them into paradigms of what happily ever after looks like if only for one night.

No one, either on the silver screen or sitting in the audience, can exist in a world of glamour forever. But when that moment comes along, and it's starlight a woman wishes to capture, how lucky for her that Badgley Mischka has managed, time after time, to capture the sartorial equivalent of fireflies in a bottle. Just as celluloid frames flickering for milliseconds created the memorable cinema that continues to inspire them, Mark and James are savvy enough to know that although fashion may be forever, the excitement we crave and remember most, and best, happens in a flash. And that's why their only goal is to blind us with delight. Works for me.

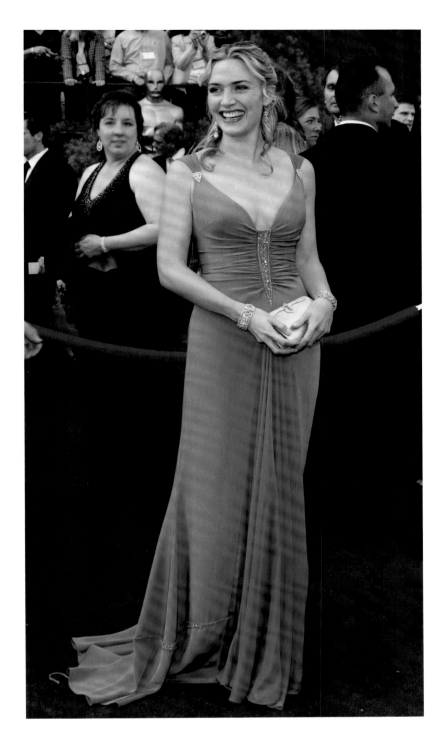

Kate Winslet in a custom
gown at the 77th
Academy Awards, 2005.

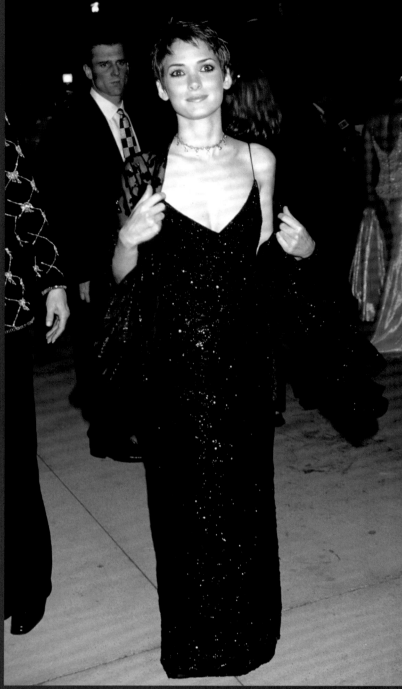

Calista Flockhart
at the 75th Academy Awards, 2003.

Winona Ryder
at the *Vanity Fair* Oscar Party, 1998.

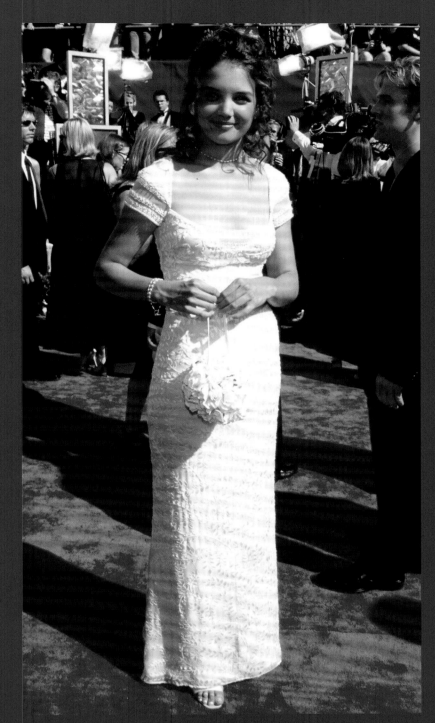

Katie Holmes
at the Emmy Awards, 1998

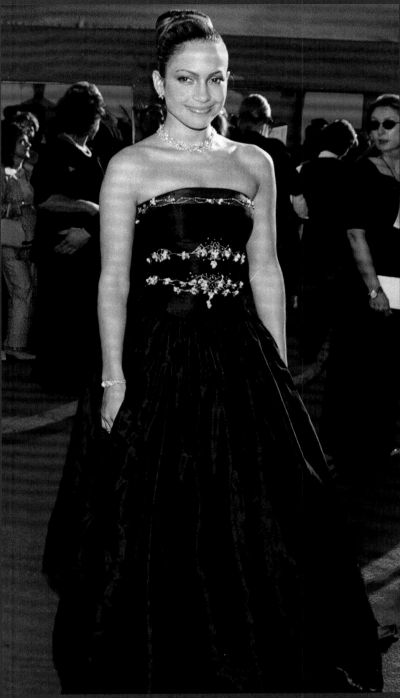

Jennifer Lopez
at the 71st Academy Awards, 1999

75

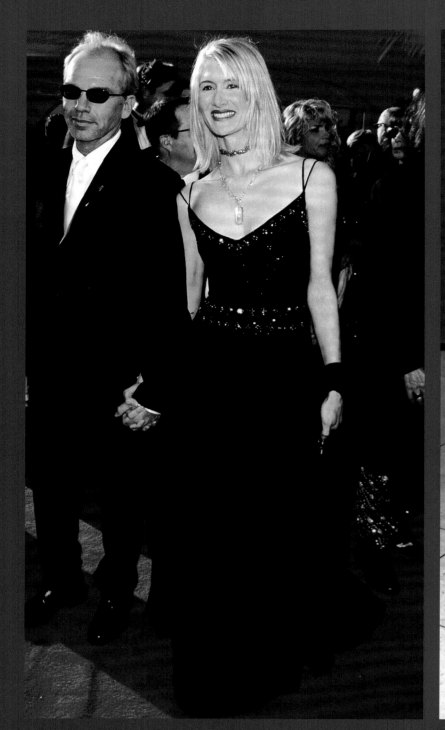

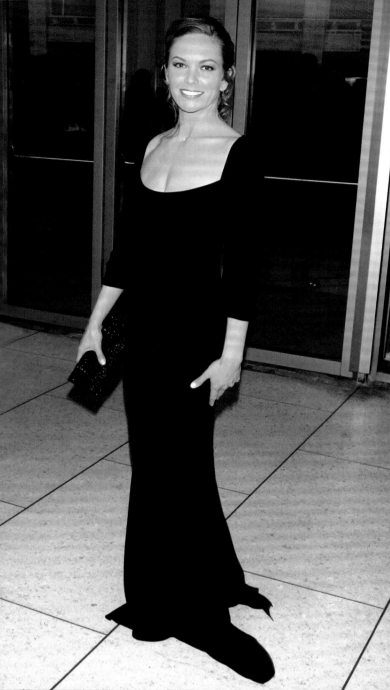

Laura Dern
at the 71st Academy Awards, 1999.

Diane Lane
at the Film Society of Lincoln Center Gala
Tribute to Francis Ford Coppola, 2002.

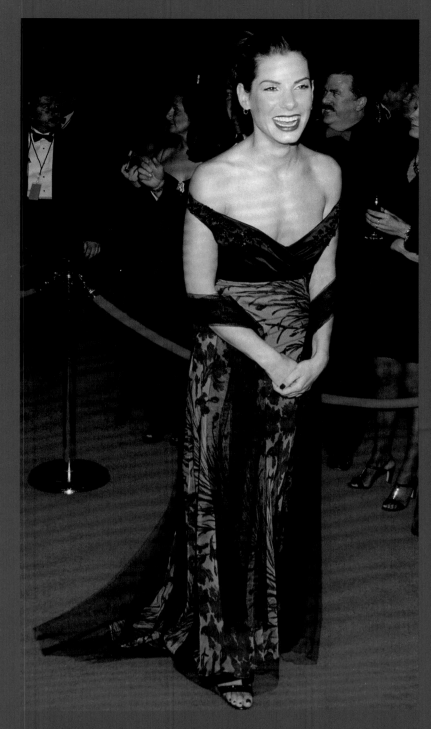

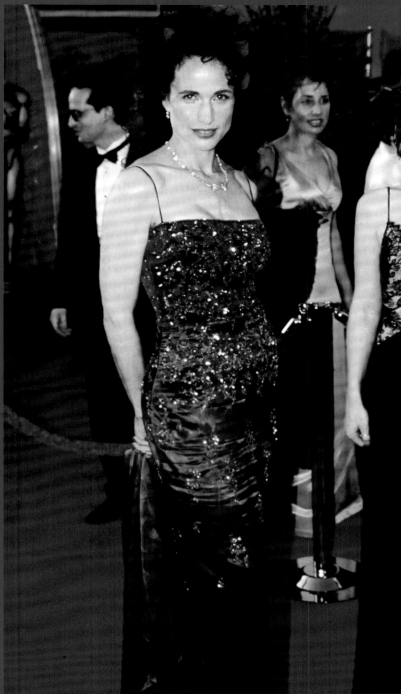

Sandra Bullock
at the People's Choice Awards, 1999.

Andie MacDowell
at the 71st Academy Awards, 1999.

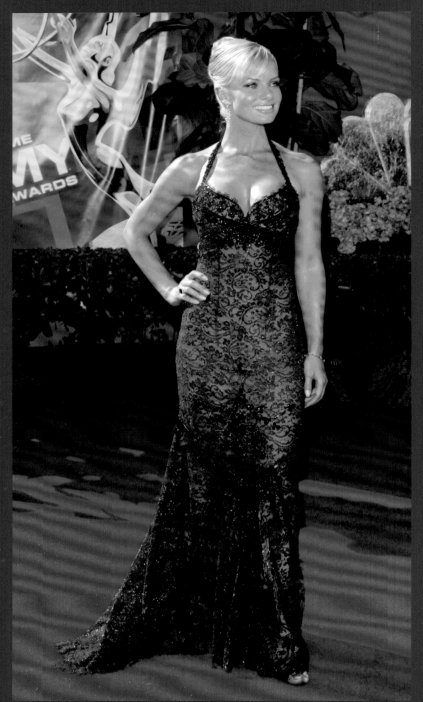

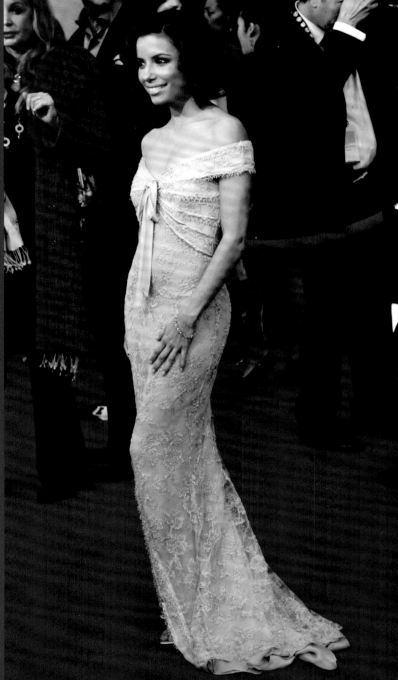

Jaime Pressly
at the 58th Primetime Emmy Awards, 2006.

Eva Longoria
at the 12th Screen Actors Guild Awards, 2006.

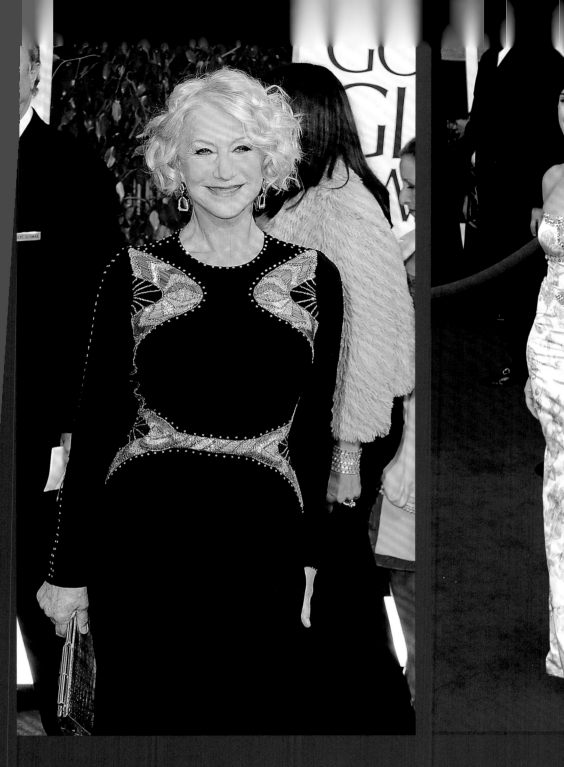

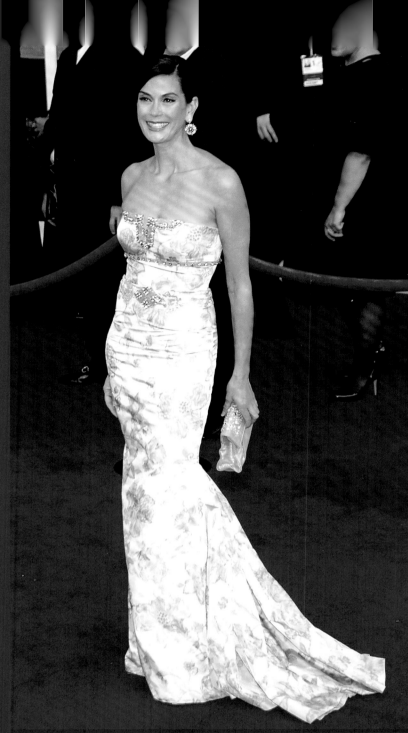

Dame Helen Mirren
at the 70th Golden Globe Awards, 2013.

Teri Hatcher
at the 14th Screen Actors Guild Awards, 2008.

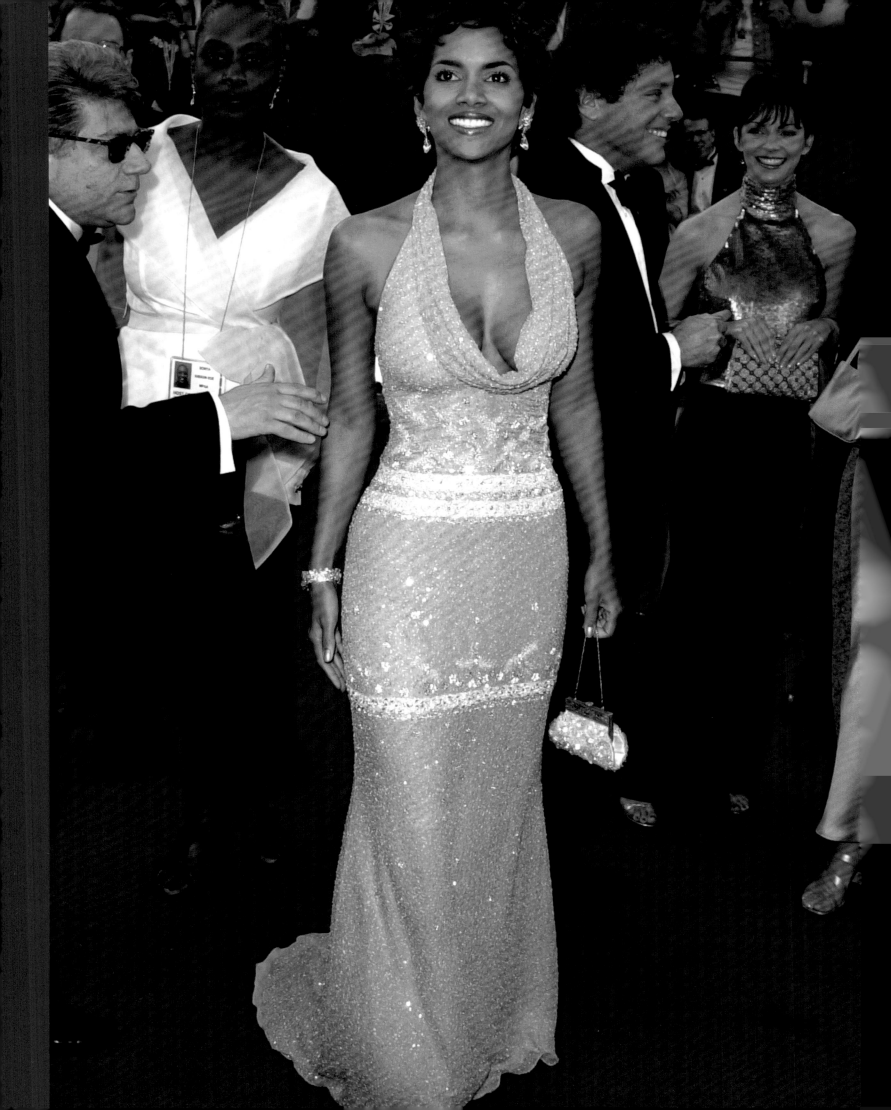

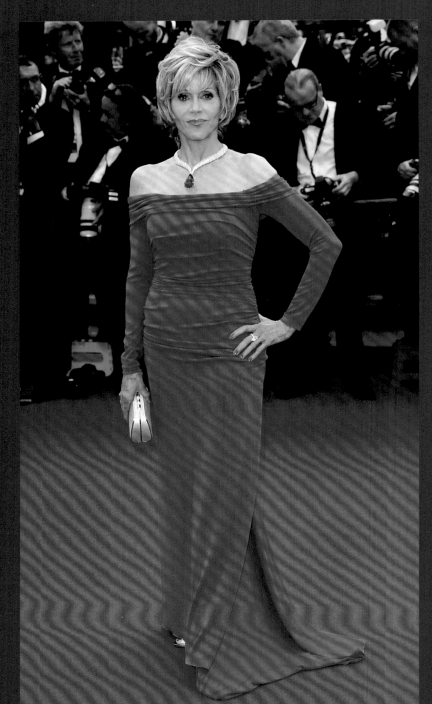

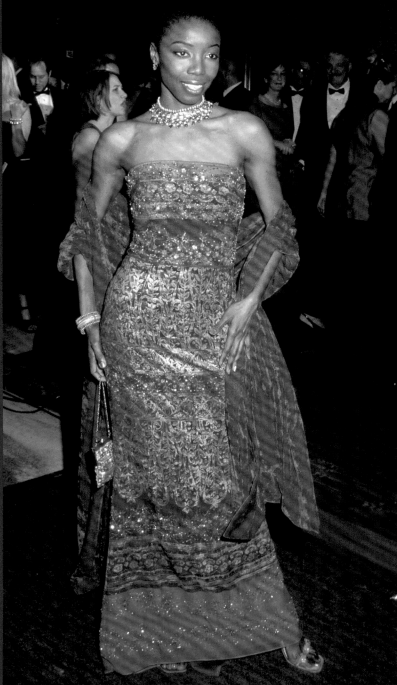

Jane Fonda
at the Cannes Film Festival, 2013.

Heather Headley
at the 60th Tony Awards, 2000.

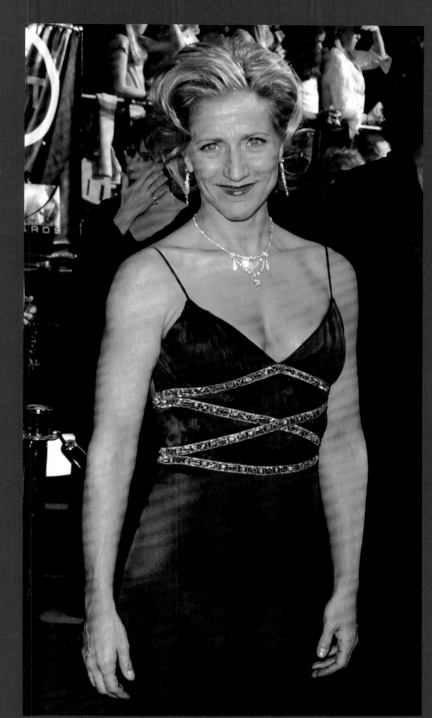

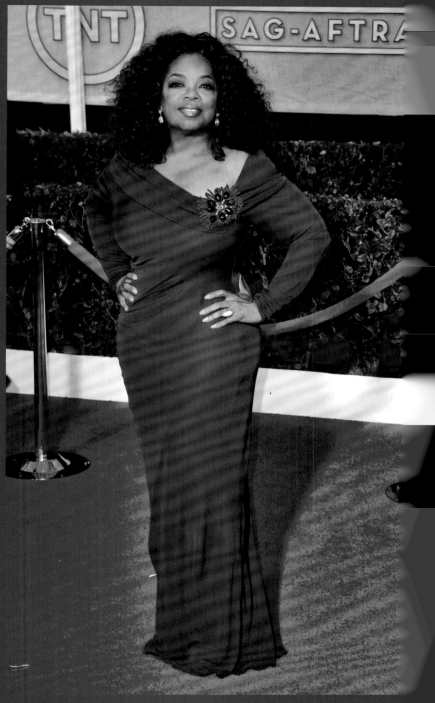

Edie Falco
at the 9th Screen Actors Guild Awards, 2003.

Oprah Winfrey
at the 20th Screen Actors Guild Awards, 2014.

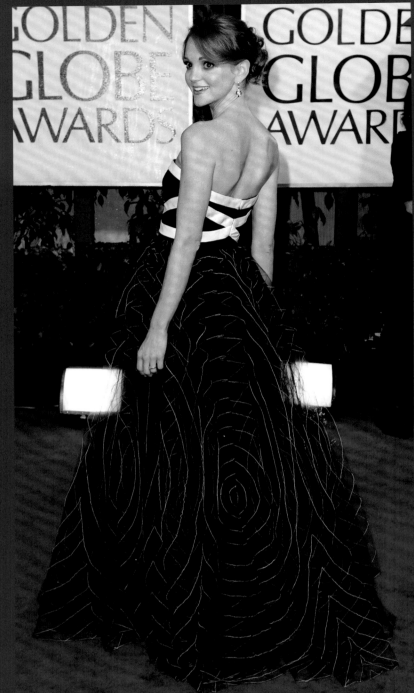

Gina Rodriguez
at the 72nd Golden Globe Awards, 2015.

Jayma Mays
at the 67th Golden Globe Awards, 2010.

Rumer Willis
at the Metropolitan Museum of Art Costume
Institute's opening night gala for
Alexander McQueen: Savage Beauty, 2011.

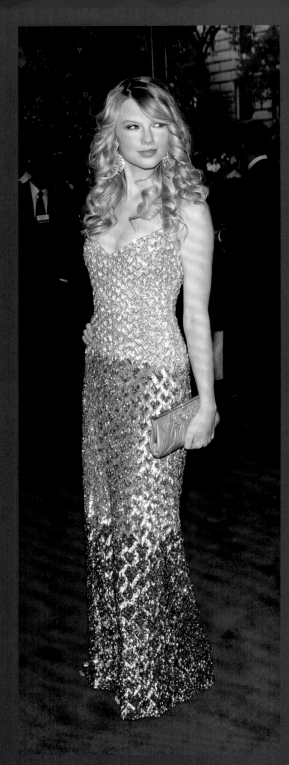

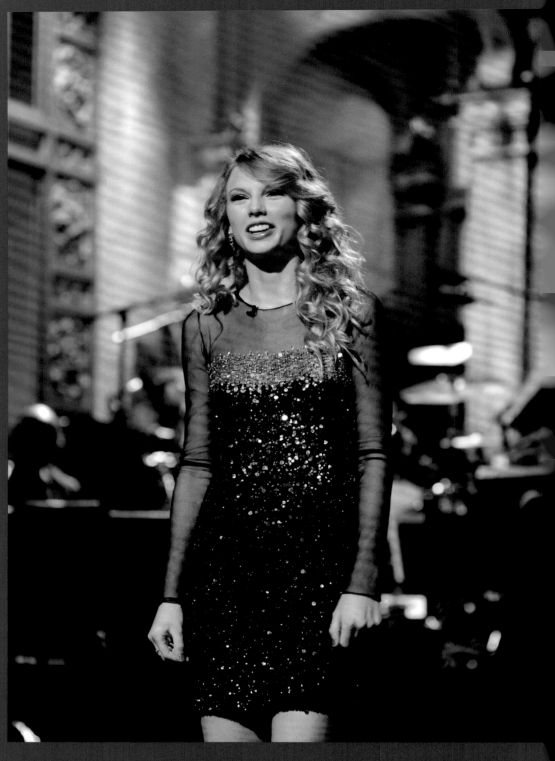

Taylor Swift
at the Metropolitan Museum of Art Costume Institute's opening night
gala for *Superheroes: Fantasy and Fashion*, 2008 (above left);
performing on *Saturday Night Live*, November 2009 (above right);
and at Covergirl's 50th Anniversary Party, 2011 (opposite).

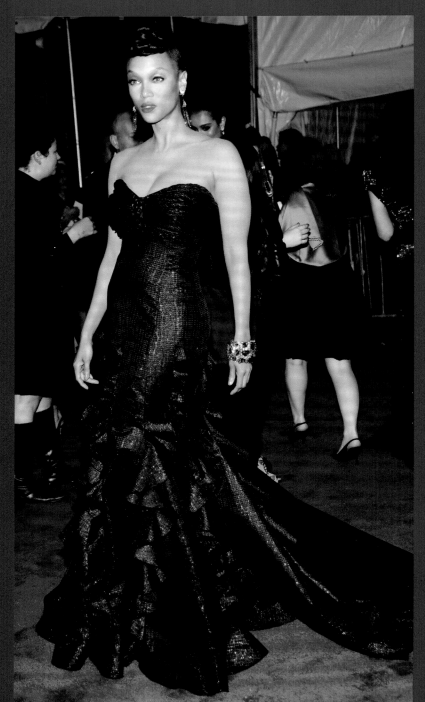

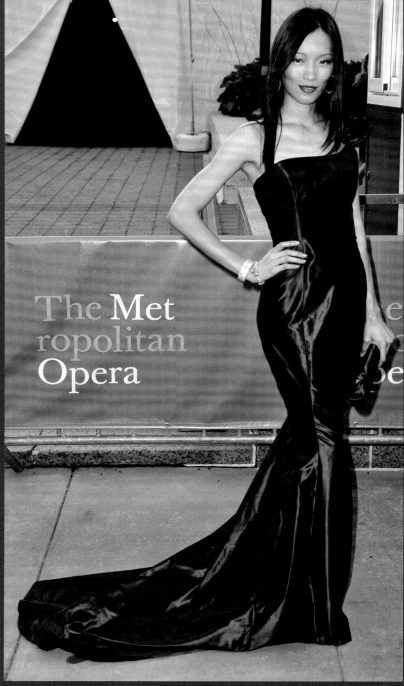

Tyra Banks
at the Metropolitan Museum of Art Costume
Institute's opening night gala for *The Model
as Muse: Embodying Fashion*, 2009.

Ling Tan
at the season-opening performance
of *Tosca* at the Metropolitan Opera
House at Lincoln Center, 2009.

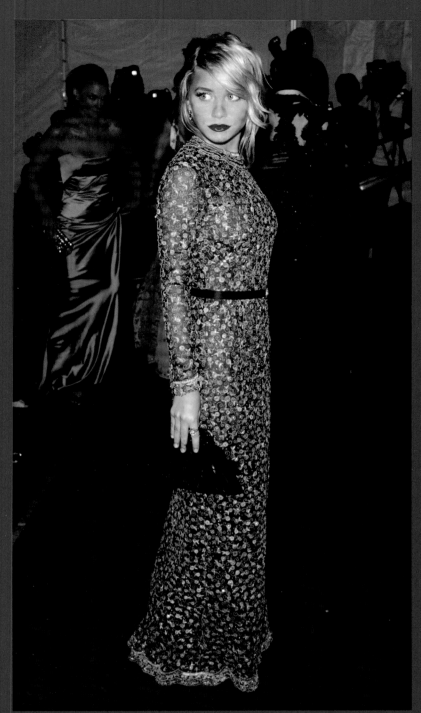

Ashley Olsen
at the Metropolitan Museum of Art Costume
Institute's opening night gala for
*AngloMania: Tradition and Transgression
in British Fashion*, 2006.

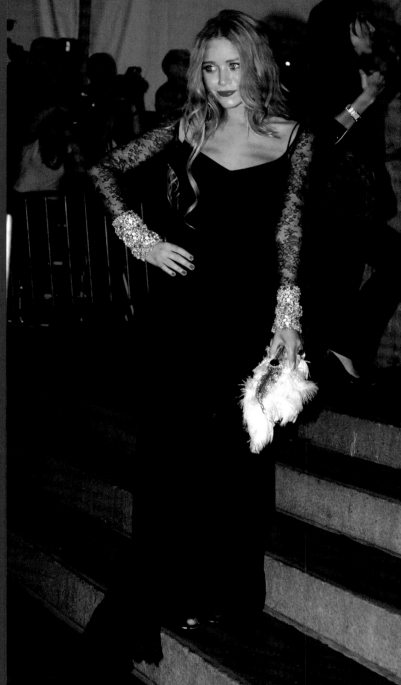

Mary-Kate Olsen
at the Metropolitan Museum of Art Costume
Institute's opening night gala for
*AngloMania: Tradition and Transgression
in British Fashion*, 2006.

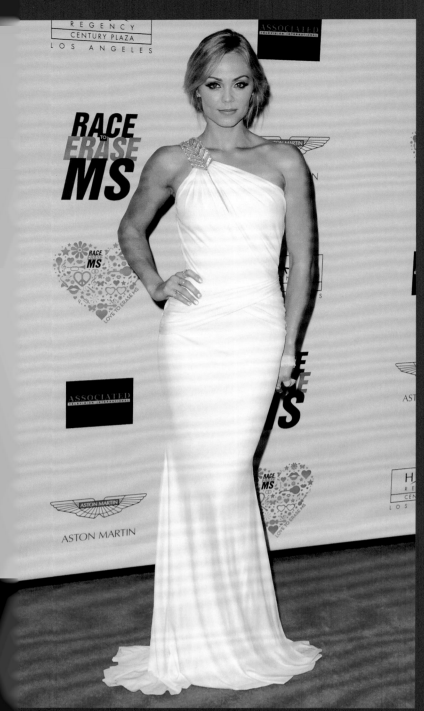

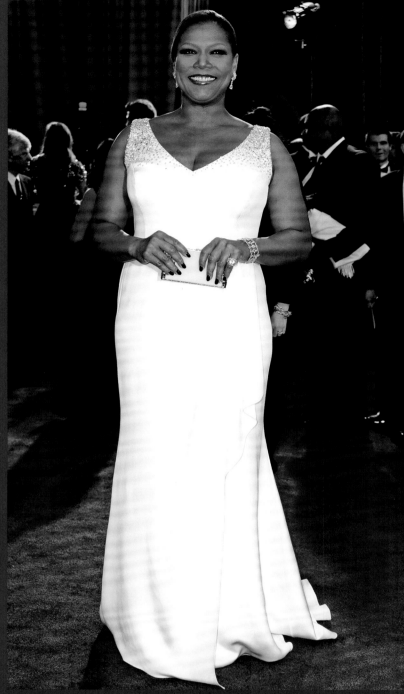

Laura Vandervoort
at the 21st Annual Race to Erase MS, 2014

Queen Latifah
at the 85th Academy Awards, 2013

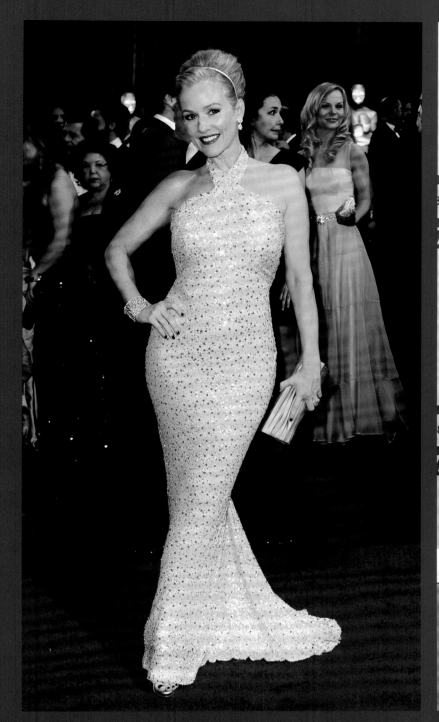

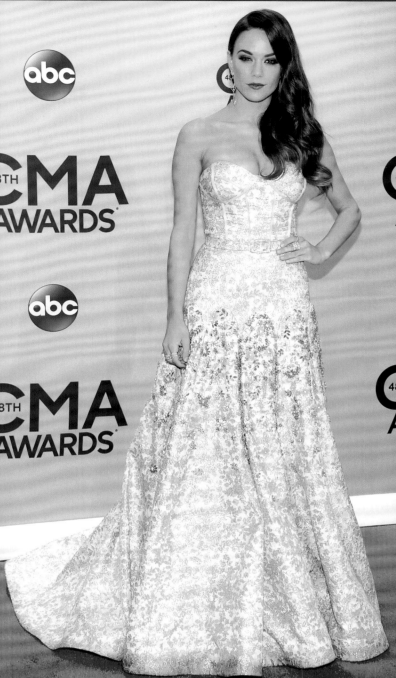

Penelope Ann Miller
at the 84th Academy Awards, 2012.

Jana Kramer
at the 48th Annual Country Music Awards, 2014.

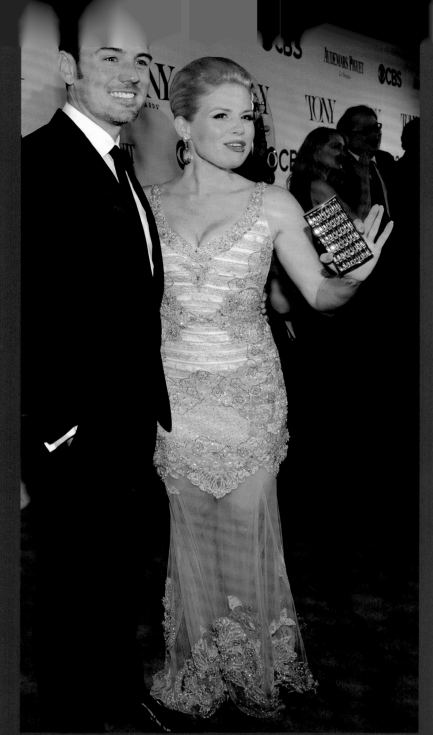

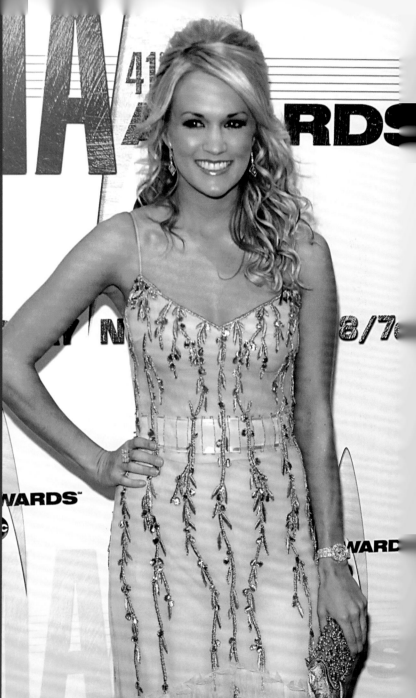

Megan Hilty
at the 67th Tony Awards, 2013

Carrie Underwood
at the 41st Annual Country Music Awards, 2007

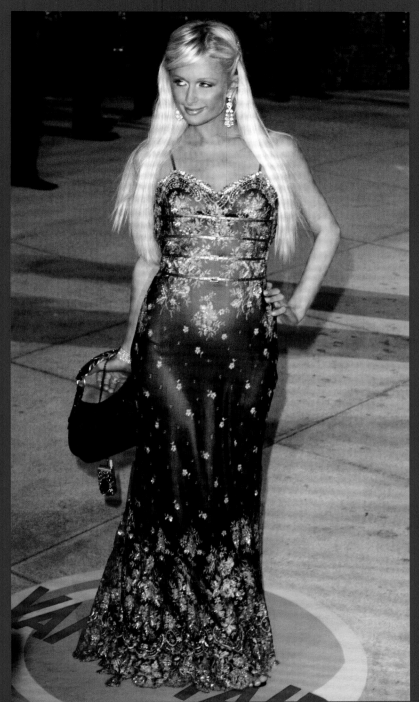

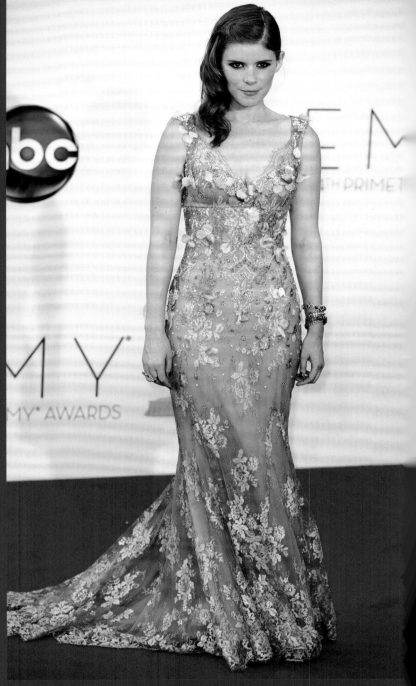

Paris Hilton
at the 76th Academy Awards, 2004.

Kate Mara
at the 64th Primetime Emmy Awards, 2012.

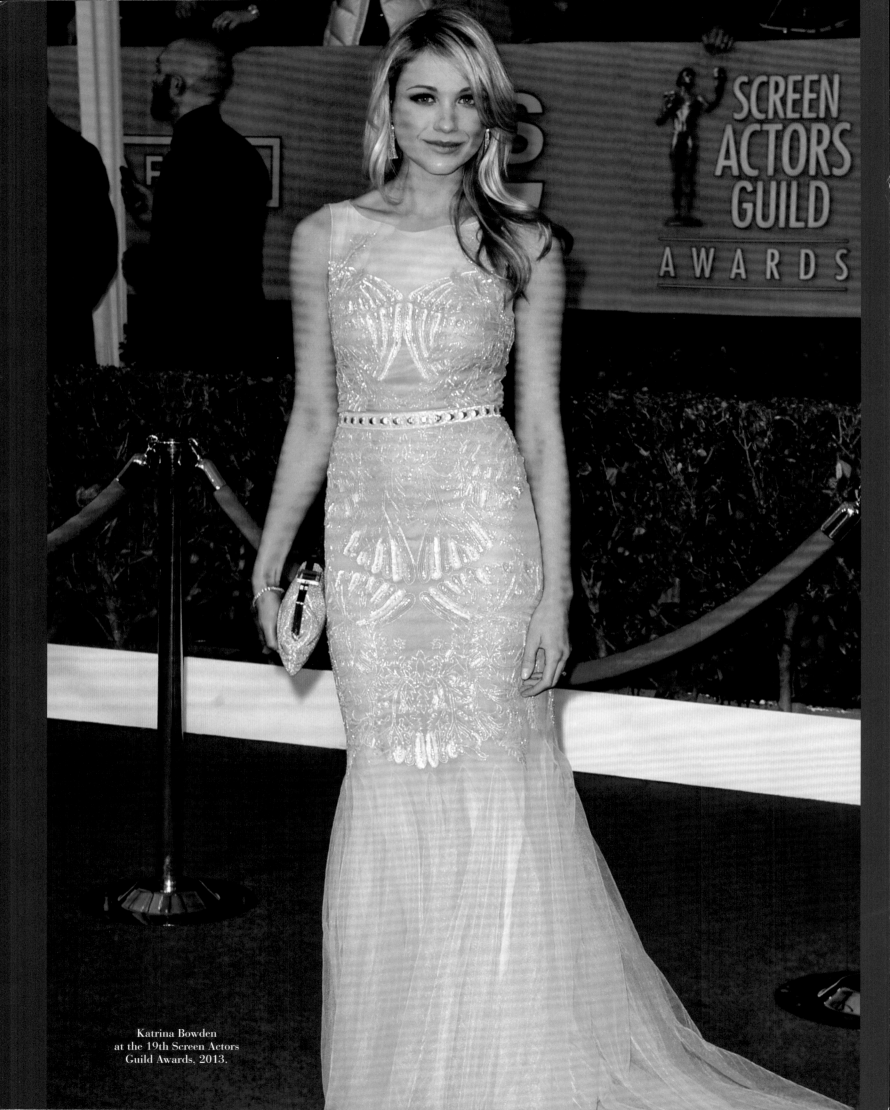

SCREEN
ACTORS
GUILD
AWARDS

Katrina Bowden
at the 19th Screen Actors
Guild Awards, 2013.

Jana Kramer
at the 48th Annual Country
Music Awards, 2013.

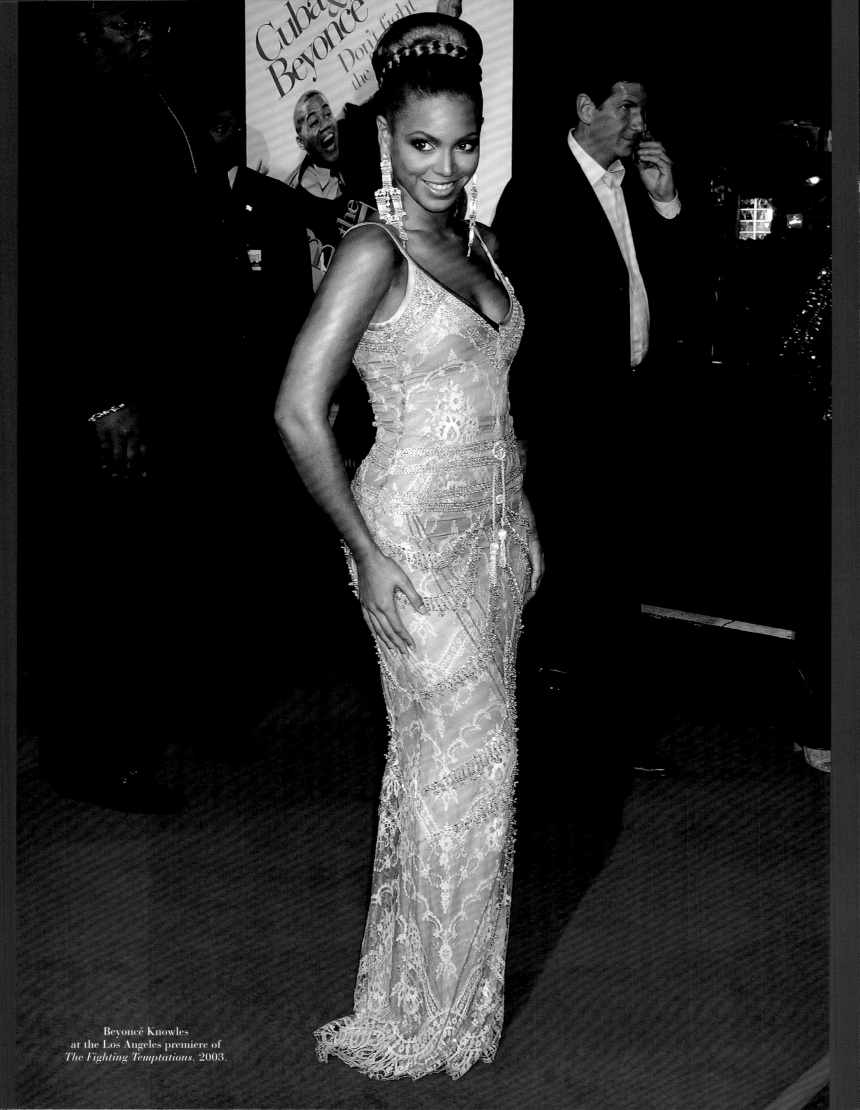

Beyoncé Knowles
at the Los Angeles premiere of
The Fighting Temptations. 2003.

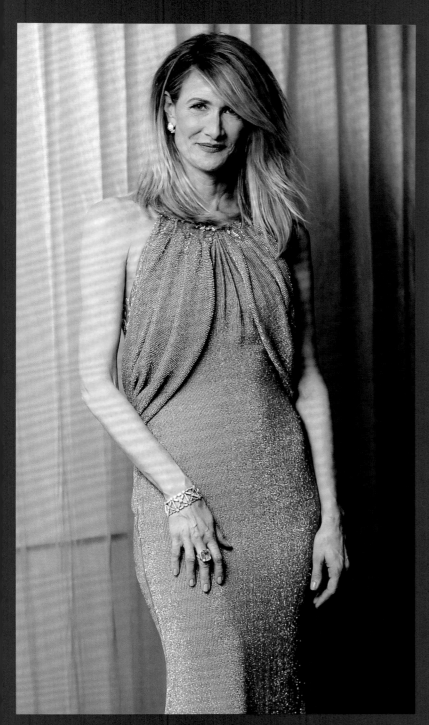

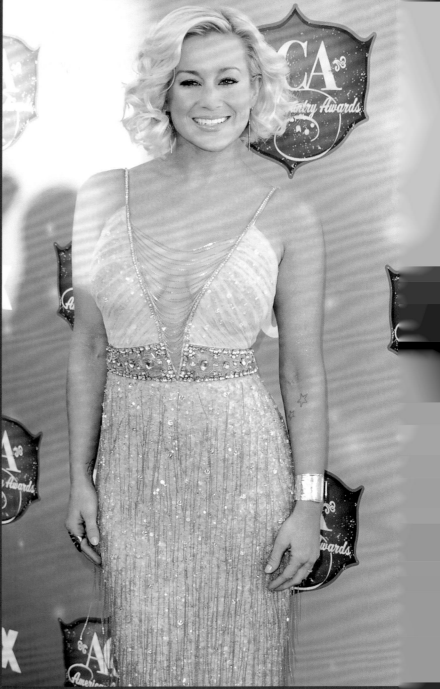

Laura Dern
at the *Vanity Fair* Oscar party, 2015.

Kellie Pickler
at the American Country Music Awards, 2013.

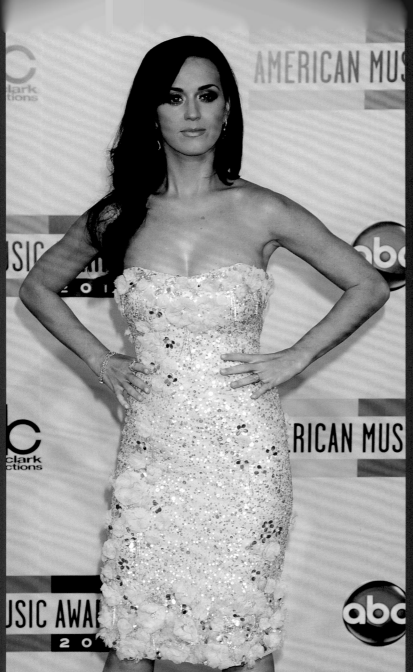

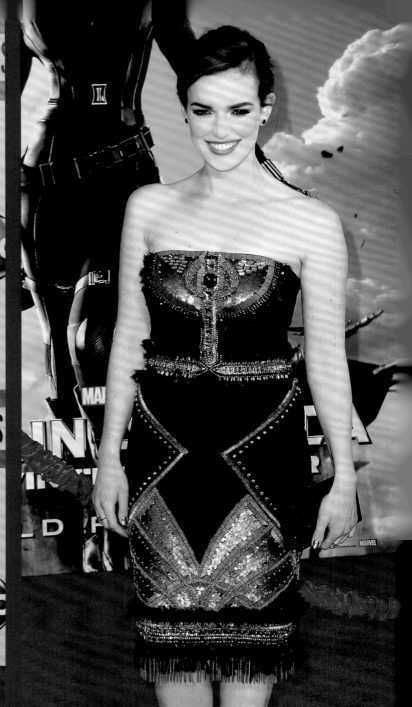

Katy Perry
at the American Music Awards, 2010

Elizabeth Henstridge
at the Los Angeles premiere of
Captain America: The Winter Soldier, 2014

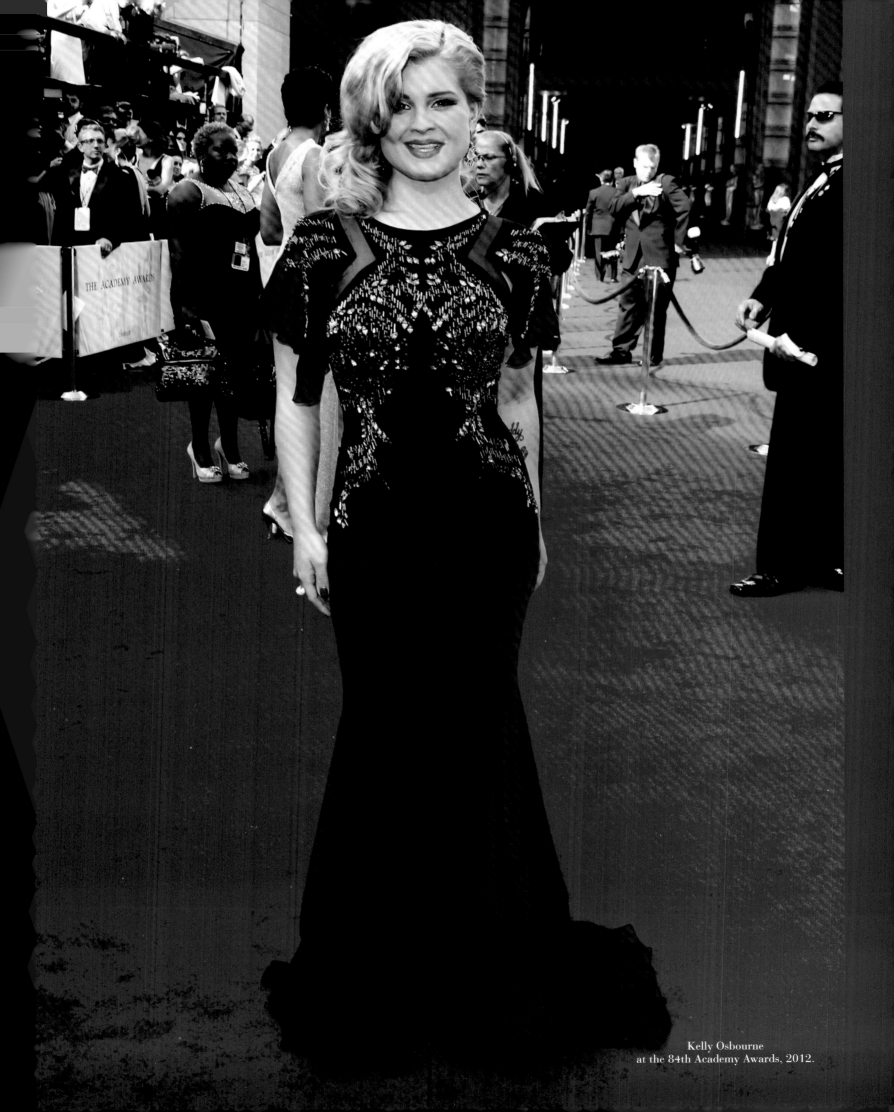

Kelly Osbourne
at the 84th Academy Awards, 2012.

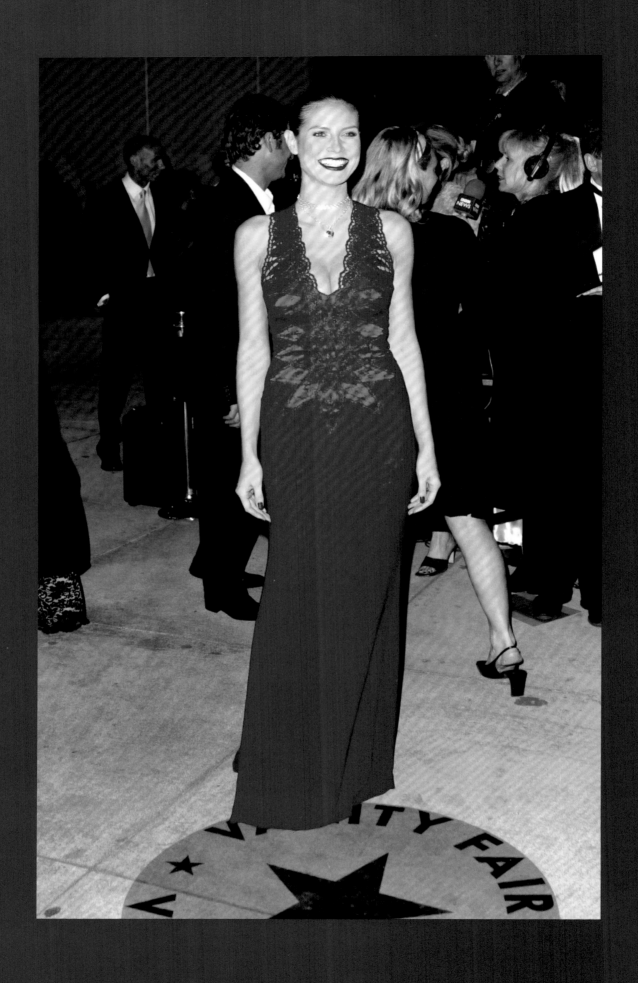

Heidi Klum
at the 74th Academy Awards, 2002.

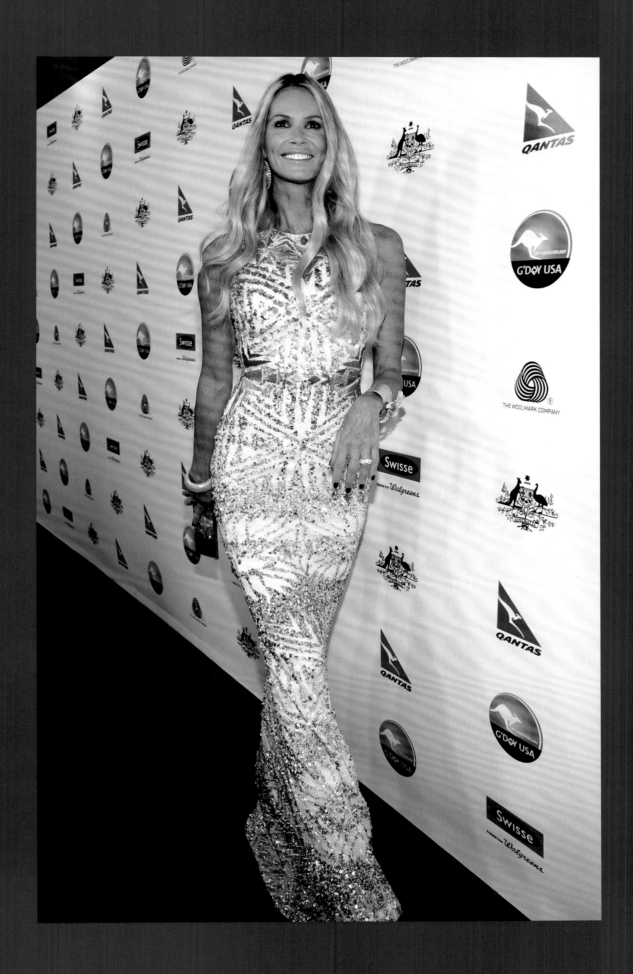

Elle Macpherson
at the G'Day USA Black Tie Gala in Los Angeles, 2013

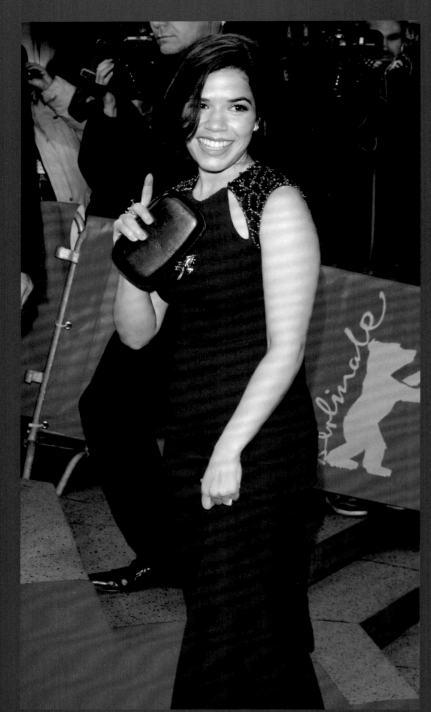

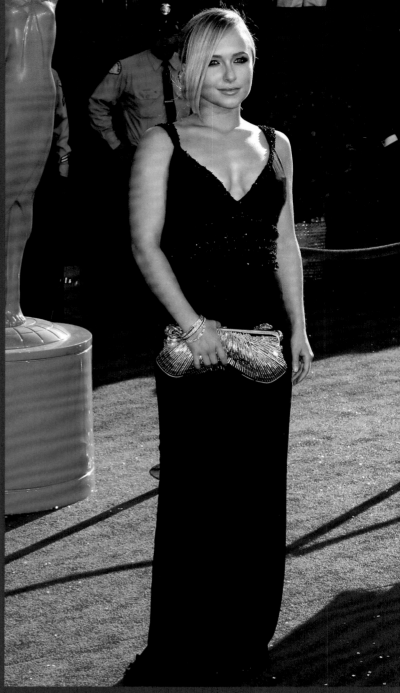

America Ferrera
at the premiere of *César Chávez*, Berlin
International Film Festival, 2014.

Hayden Panettiere
at the 60th Primetime Emmy Awards, 2008.

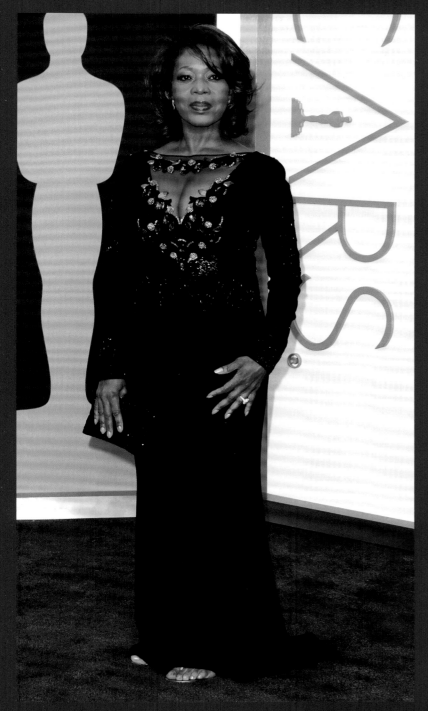

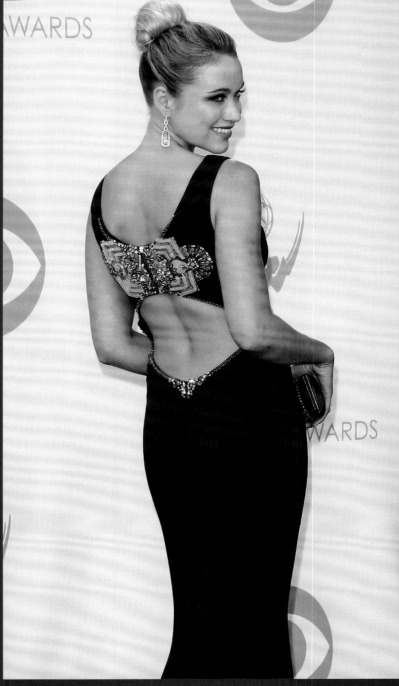

Alfre Woodard
at the 86th Academy Awards, 2014.

Katrina Bowden
at the 65th Primetime Emmy Awards, 2013.

Ashley Judd at the *Insurgent* premiere
at the Ziegfeld Theater in New York, 2015

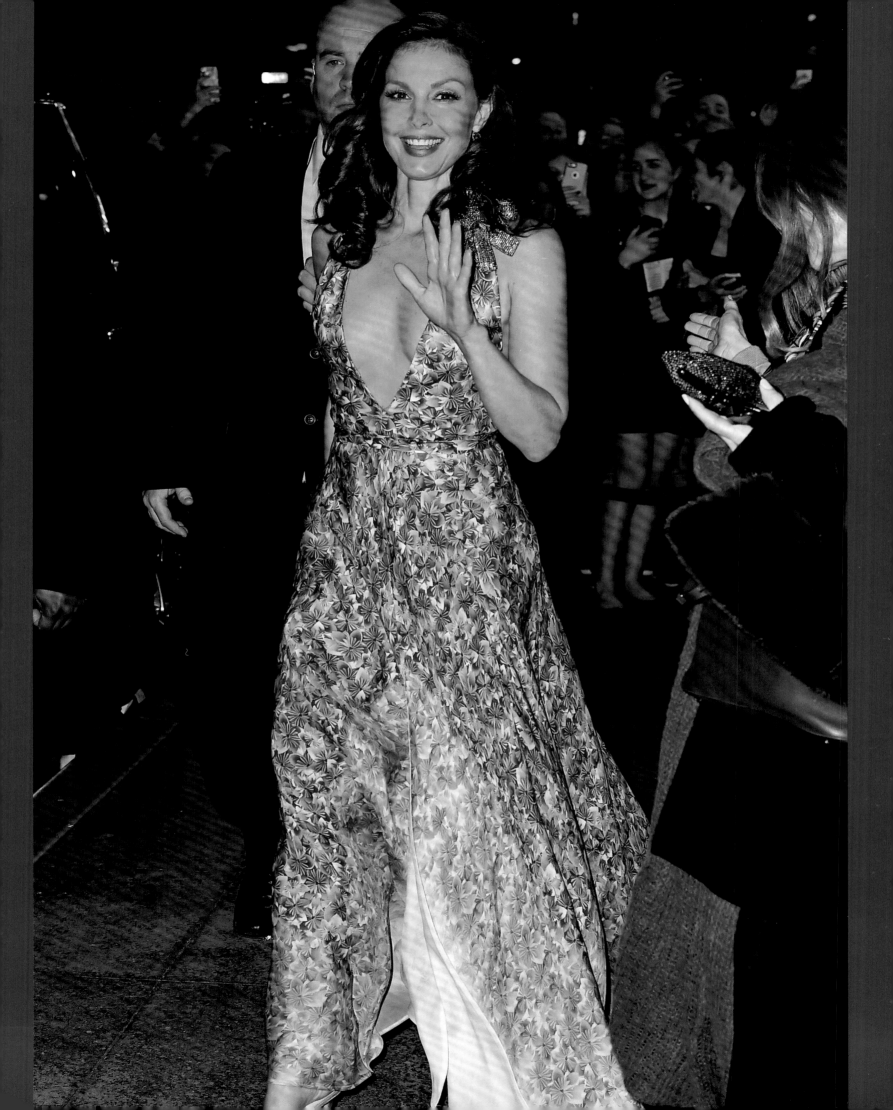

BRIDAL

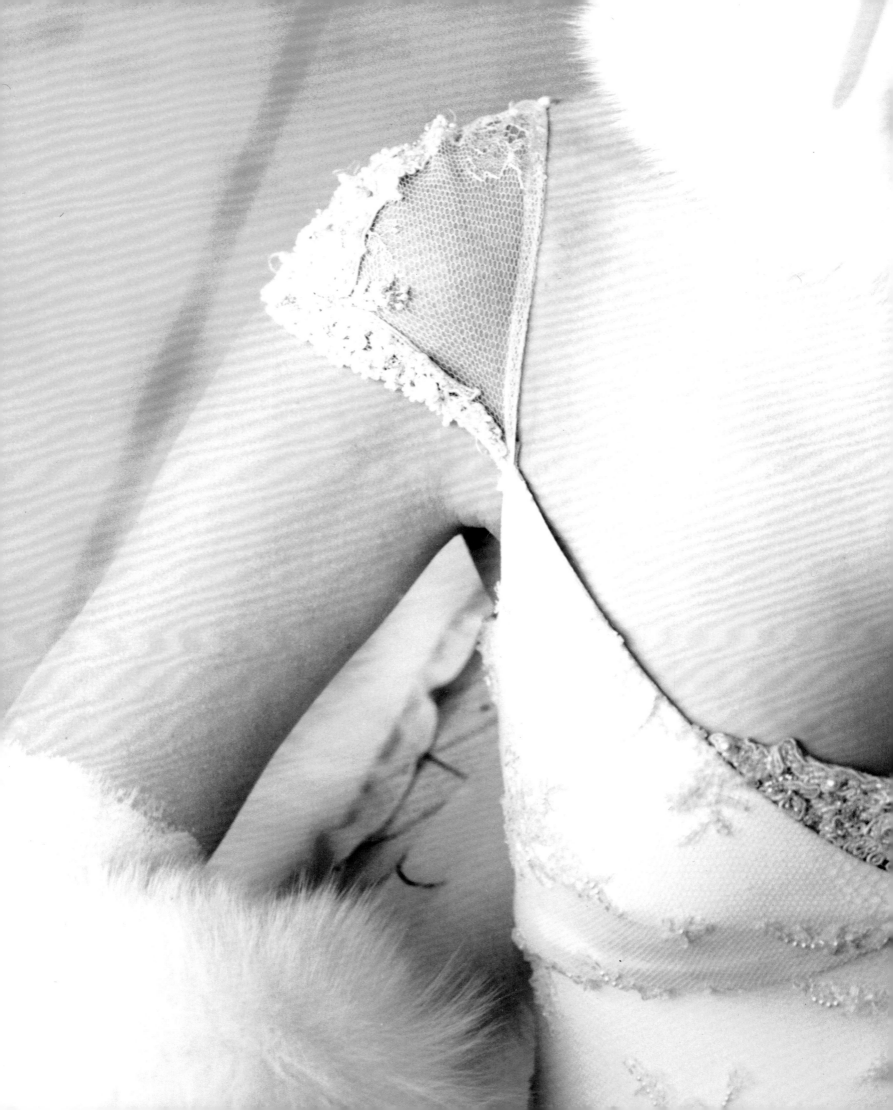

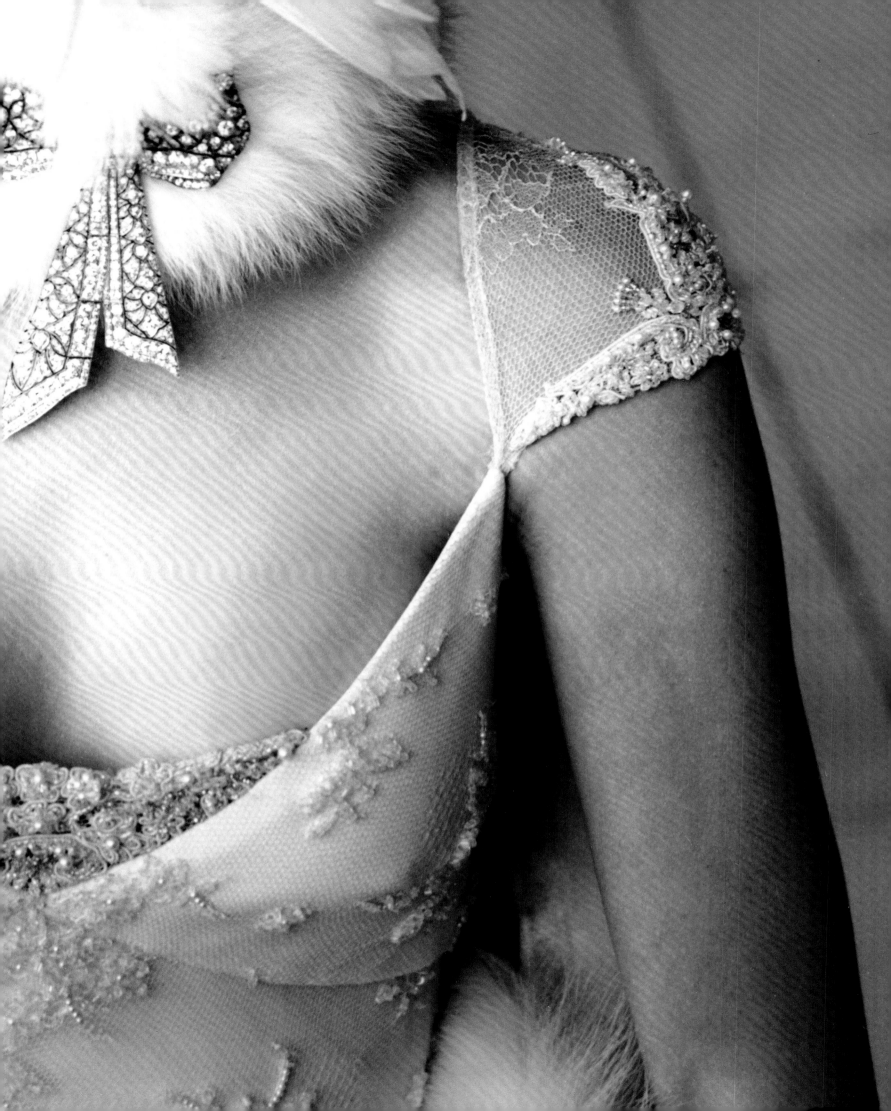

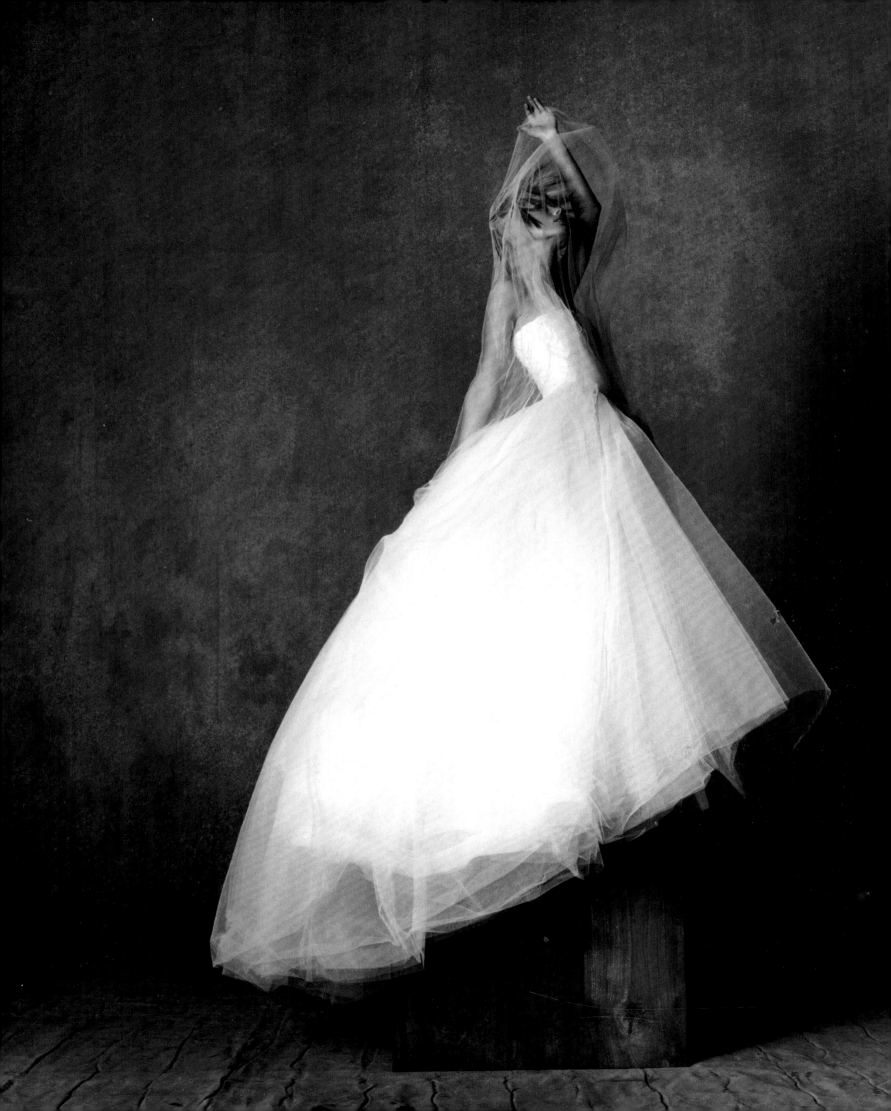

BRIDAL

Badgley Mischka first entered the bridal business with an exclusive collection for Bergdorf Goodman in 1997 and widened distribution in the following years. Bridal was a natural progression for Badgley Mischka as devoted clients had long been asking for white and ivory versions of the eveningwear for their once-in-a-lifetime day. Working with the same exquisite fabrics and intricate hand-detailing used in the evening collections, the gowns' clinging shapes are modified into modern romantic silhouettes with little cap sleeves, open necklines, and A-line skirts. "Brides love soft details like baroque pearls, diaphanous fabrics, and elegant embroideries that hark back to a vintage time, but the silhouette has to be modern and sexy," Badgley describes. "Even edgy girls are eager to appear romantic and a bit traditional on their wedding day."

Opposite A full-skirt silhouette hearkens back to the soft romance of bygone eras (2003 Bridal collection). *Following pages* 1999 Bridal collection. *Previous pages* Little cap sleeves and open necklines are romantic for modern brides (2001 Bridal collection).

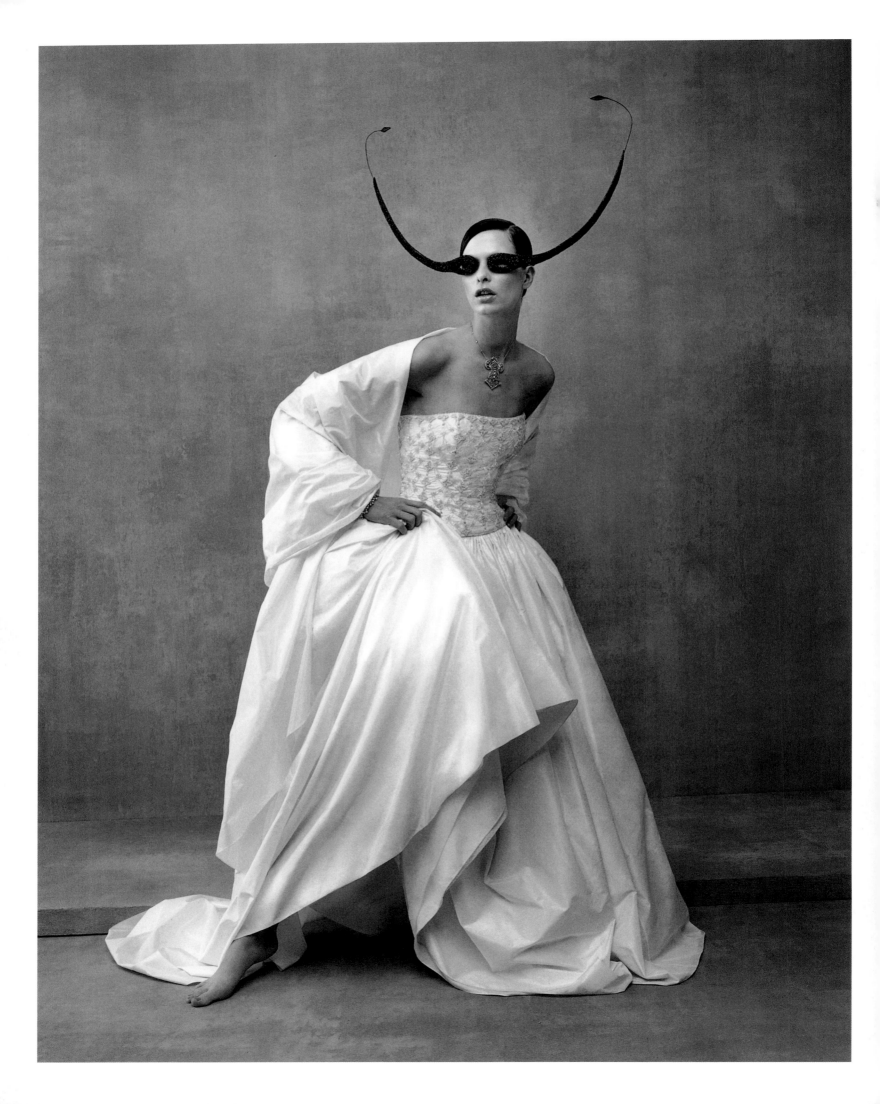

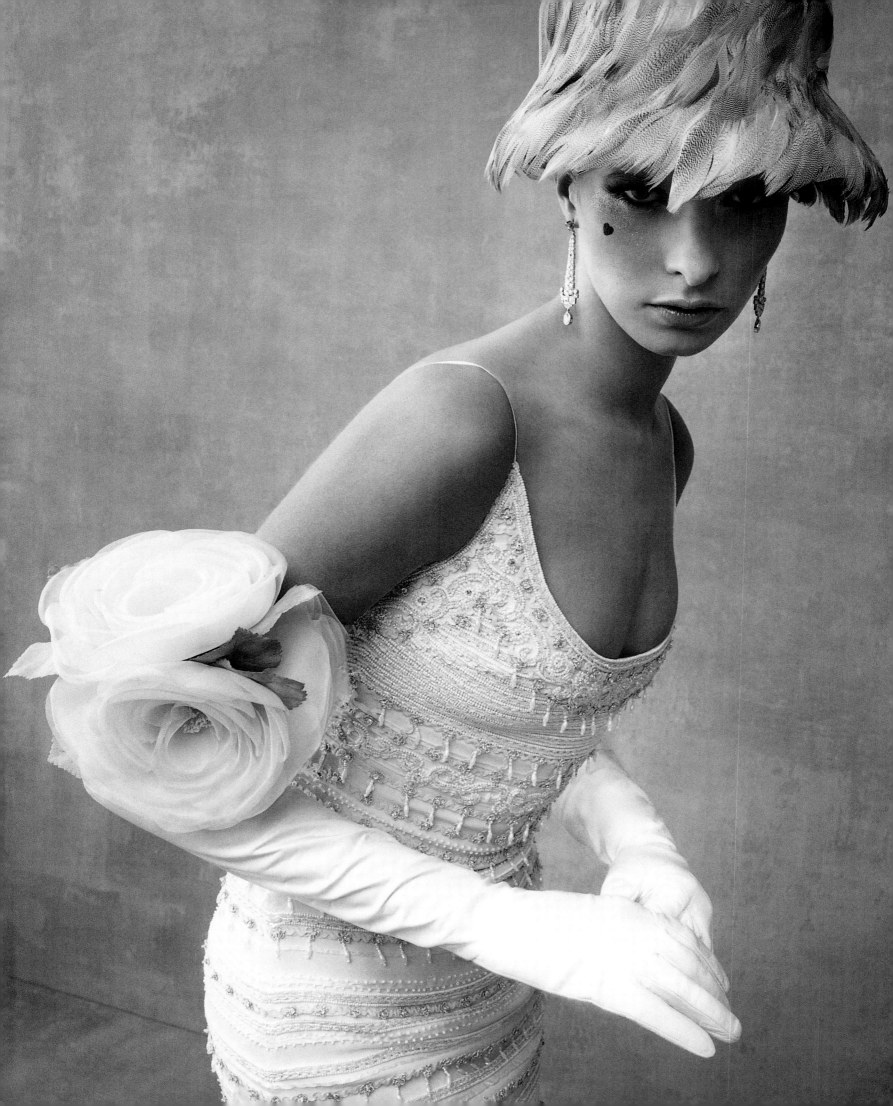

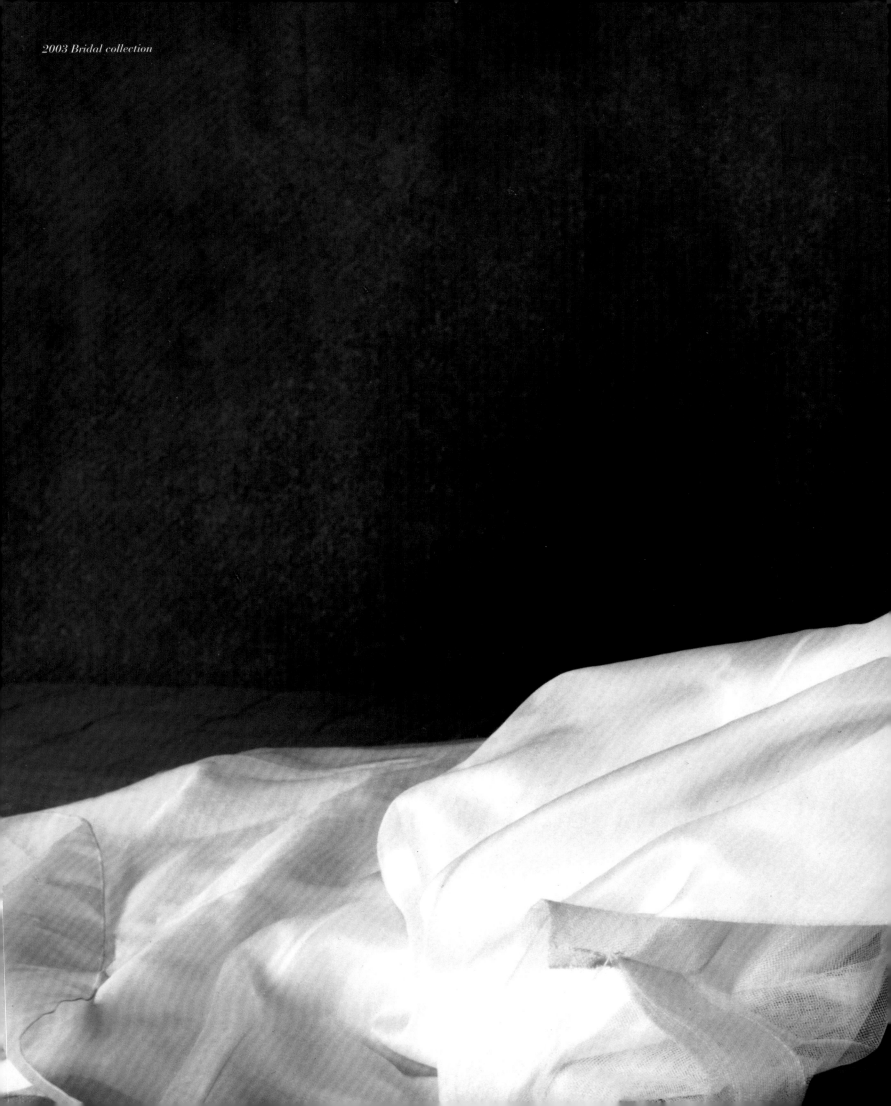

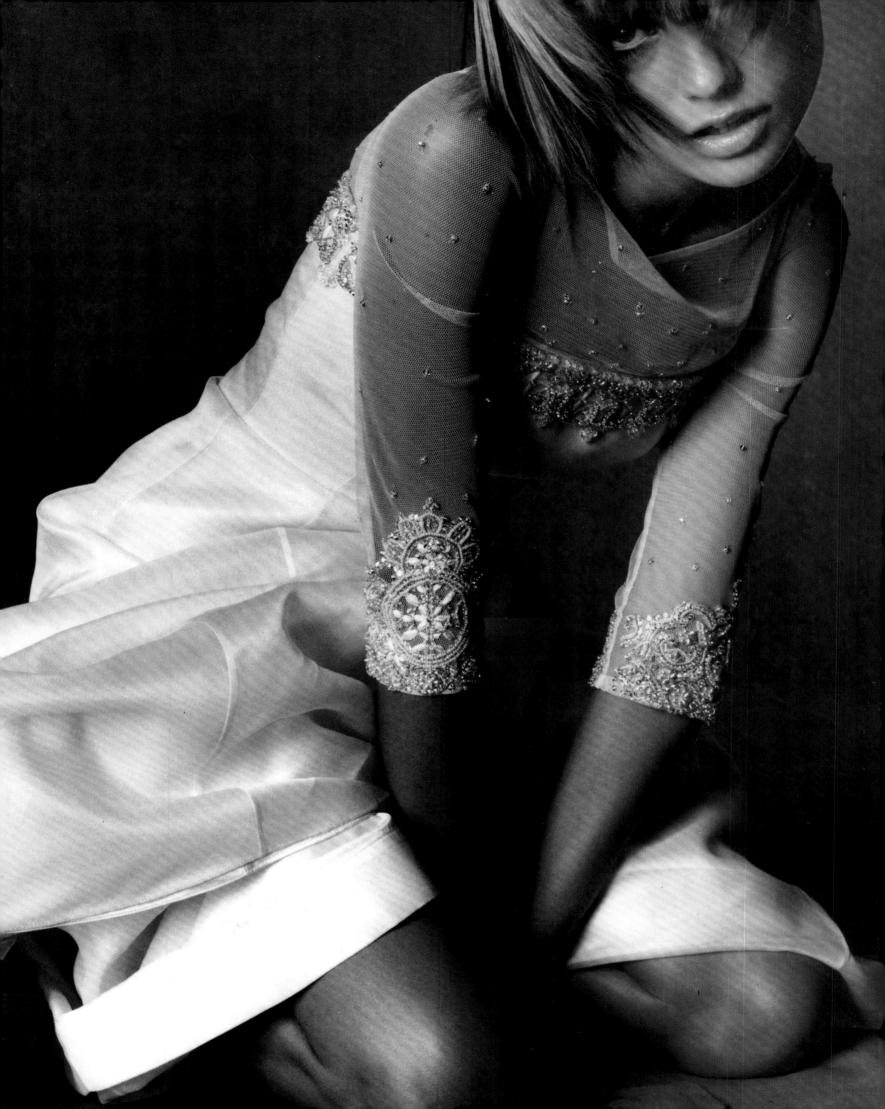

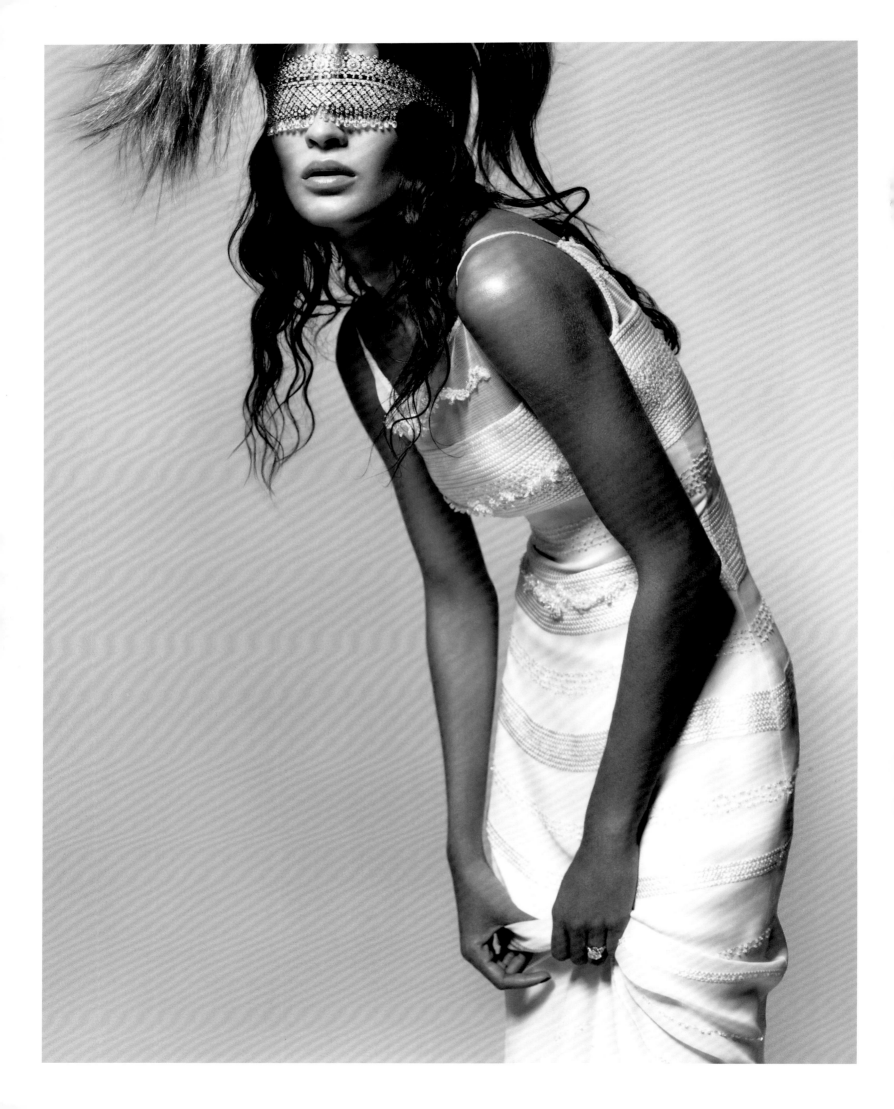

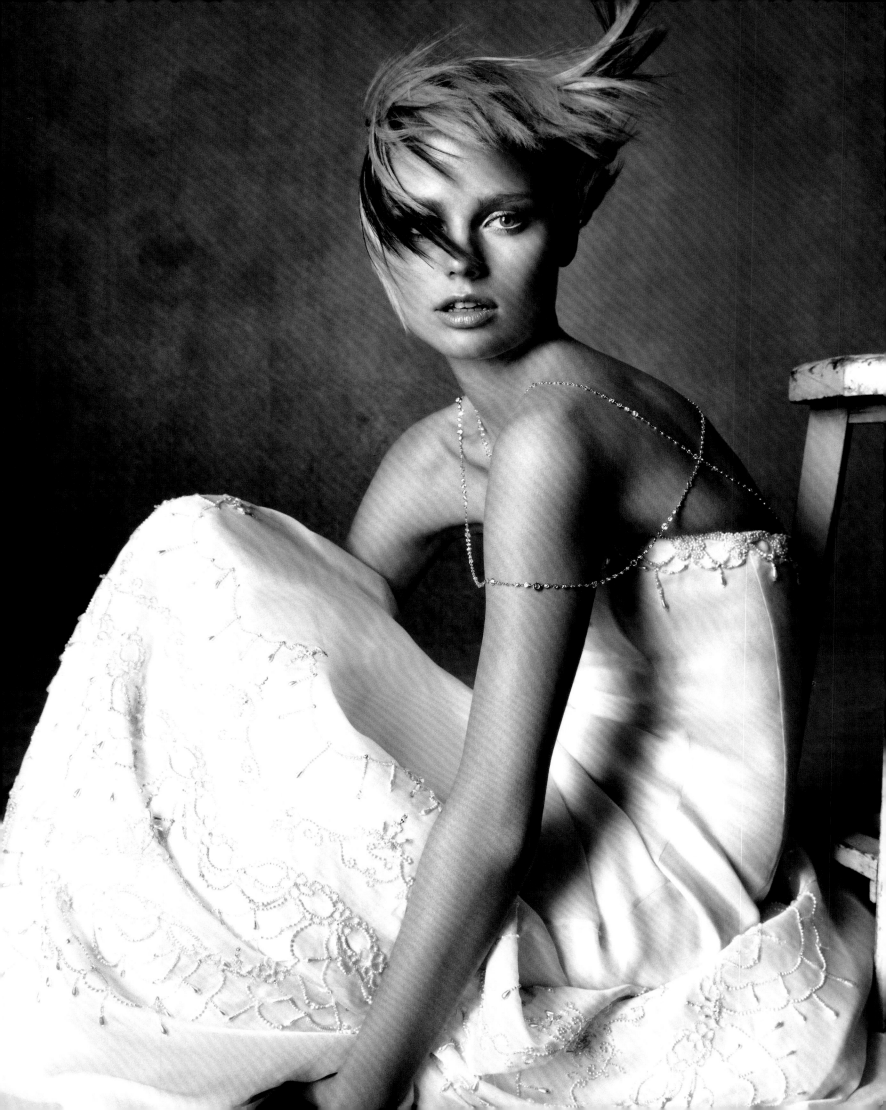

Opposite 2014–2015
Bridal collection.
Previous pages Even
edgy girls like to be
softly romantic on their
special day. 2000 Bridal
collection (left) and
2003 Bridal collection
(right).

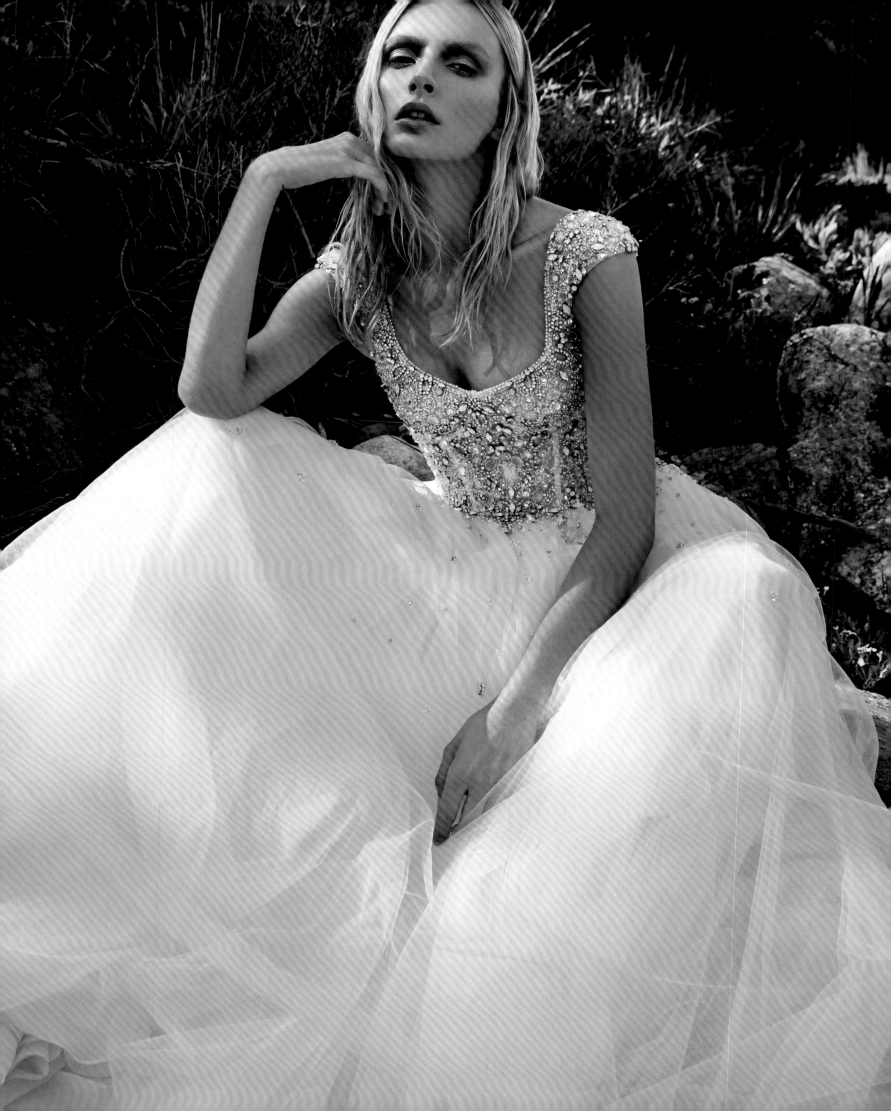

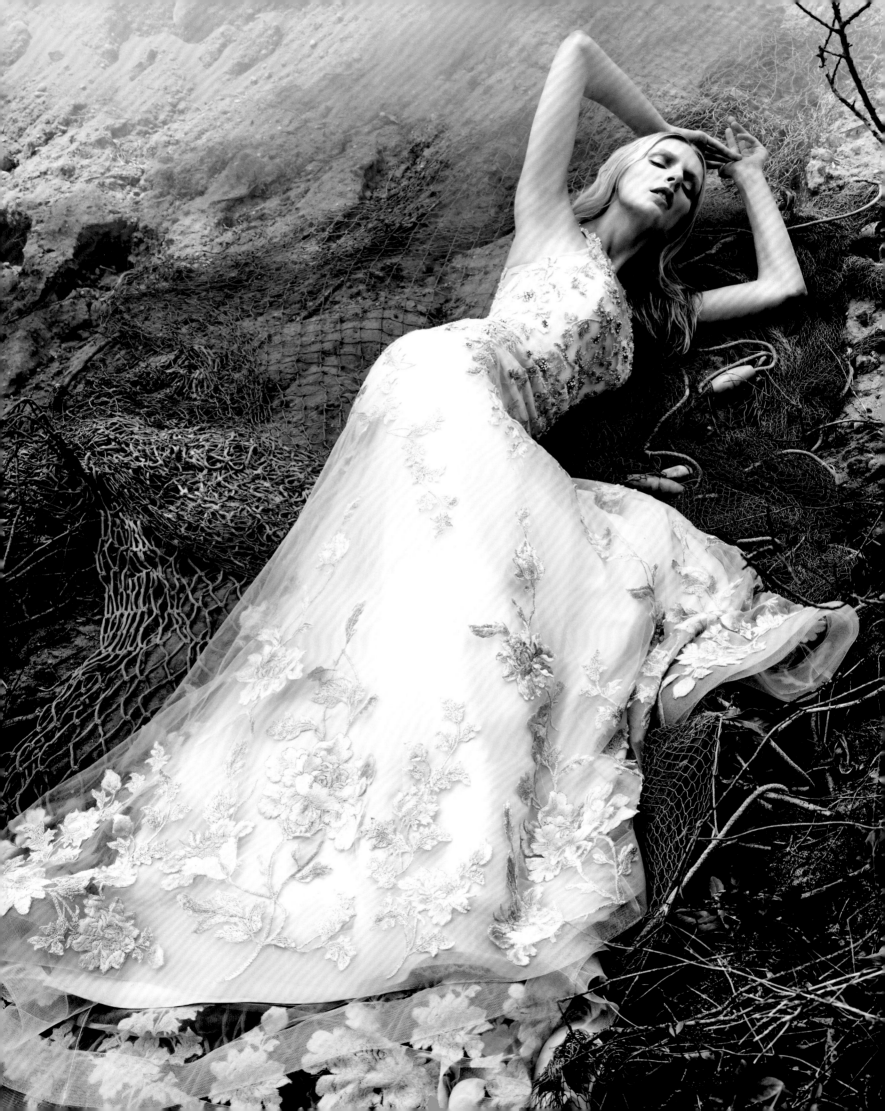

2014–2015
Bridal collection.

Right Hollywood goddess gown (2014–2015 Bridal collection). *Following pages, left* Beading detail. *Following pages, right* Built on what Badgley Mischka does best, the bridal line maintains the nostalgic but modern feel of the duo's evening designs (2003 Bridal collection).

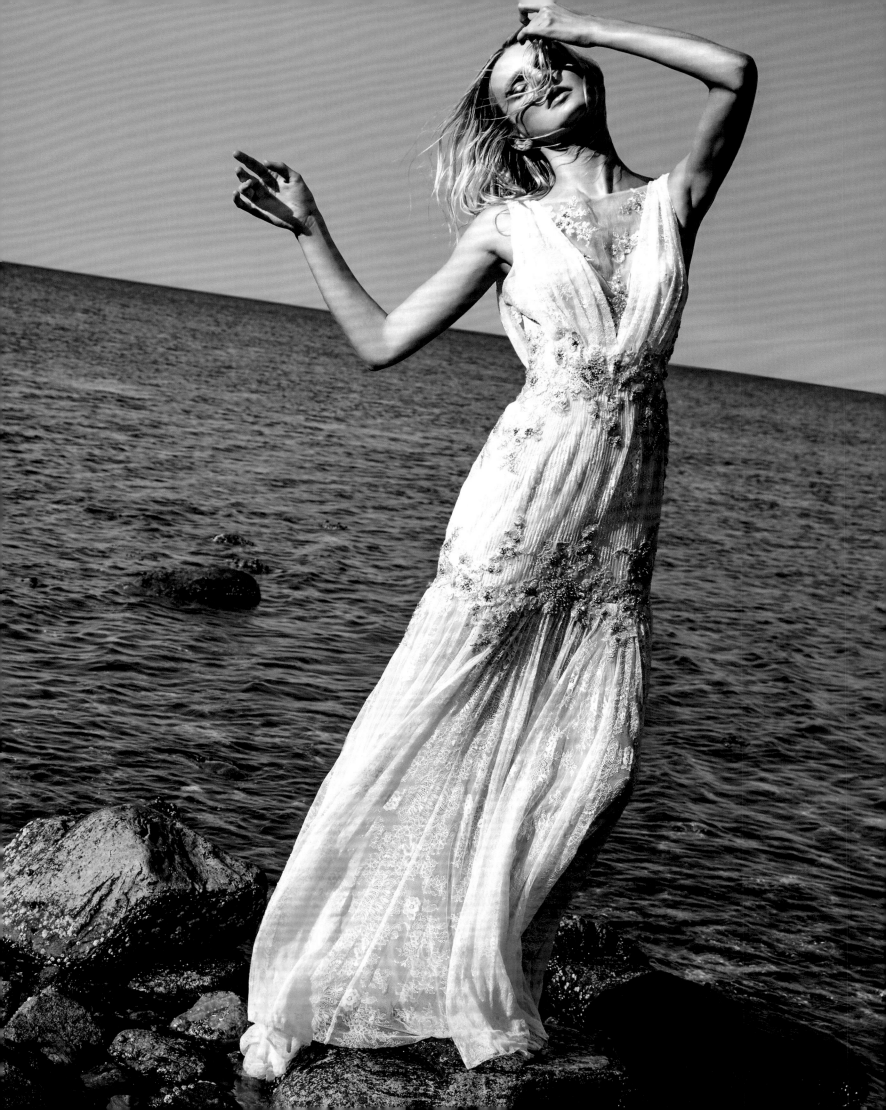

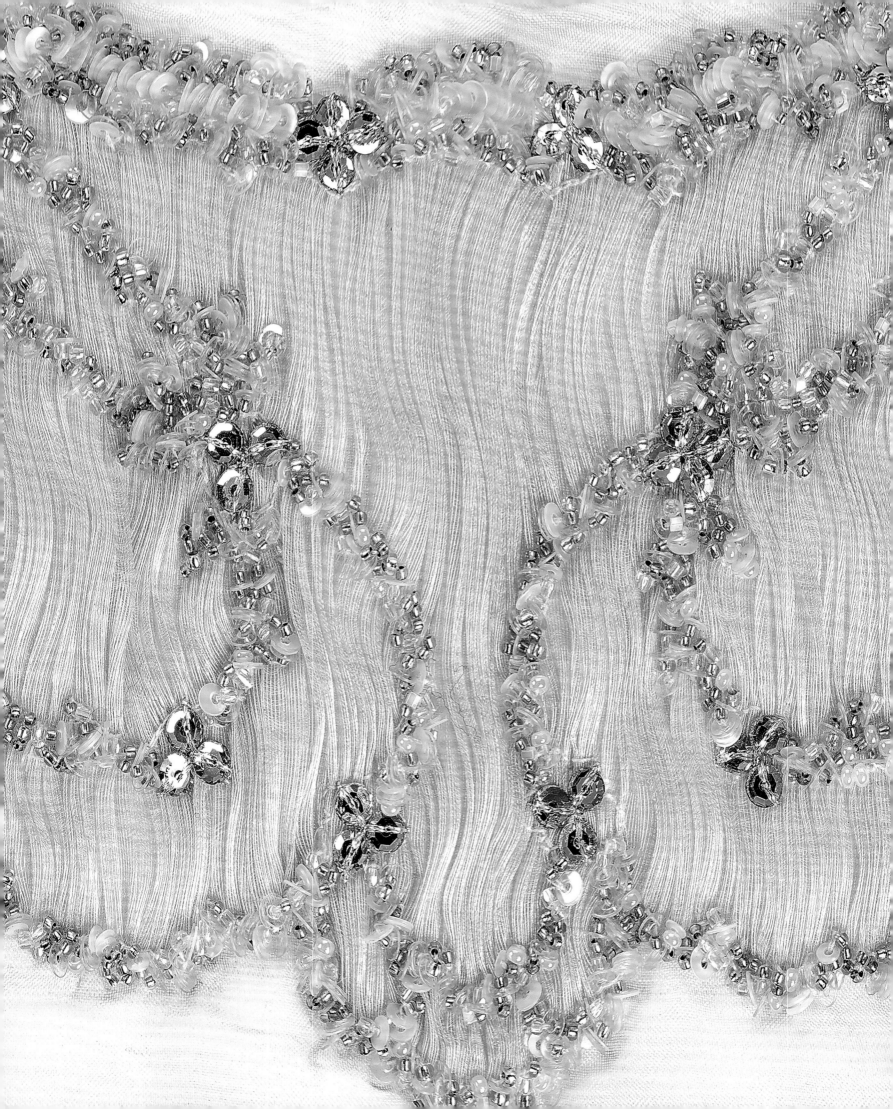

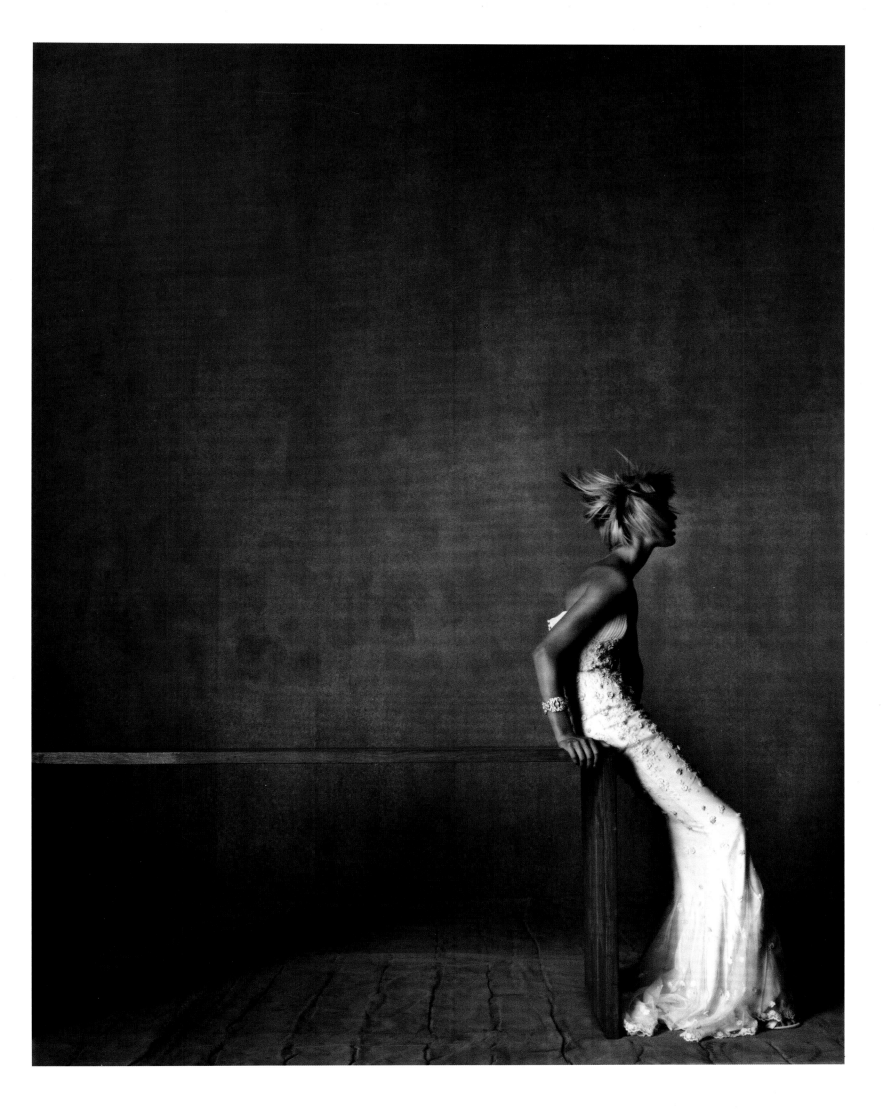

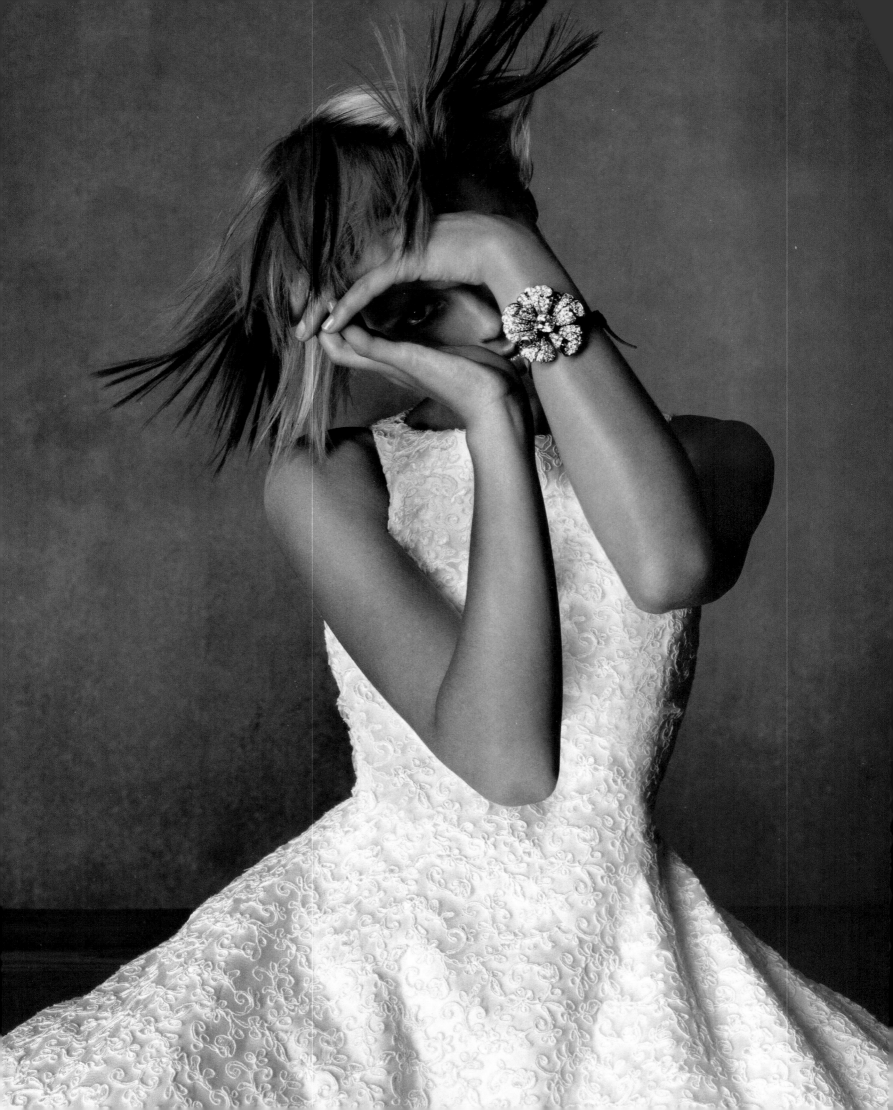

Opposite 2003 Bridal
collection. *Following pages*
A unique view of the
bride through the lens
of classic couture (1999
Bridal collection).

129

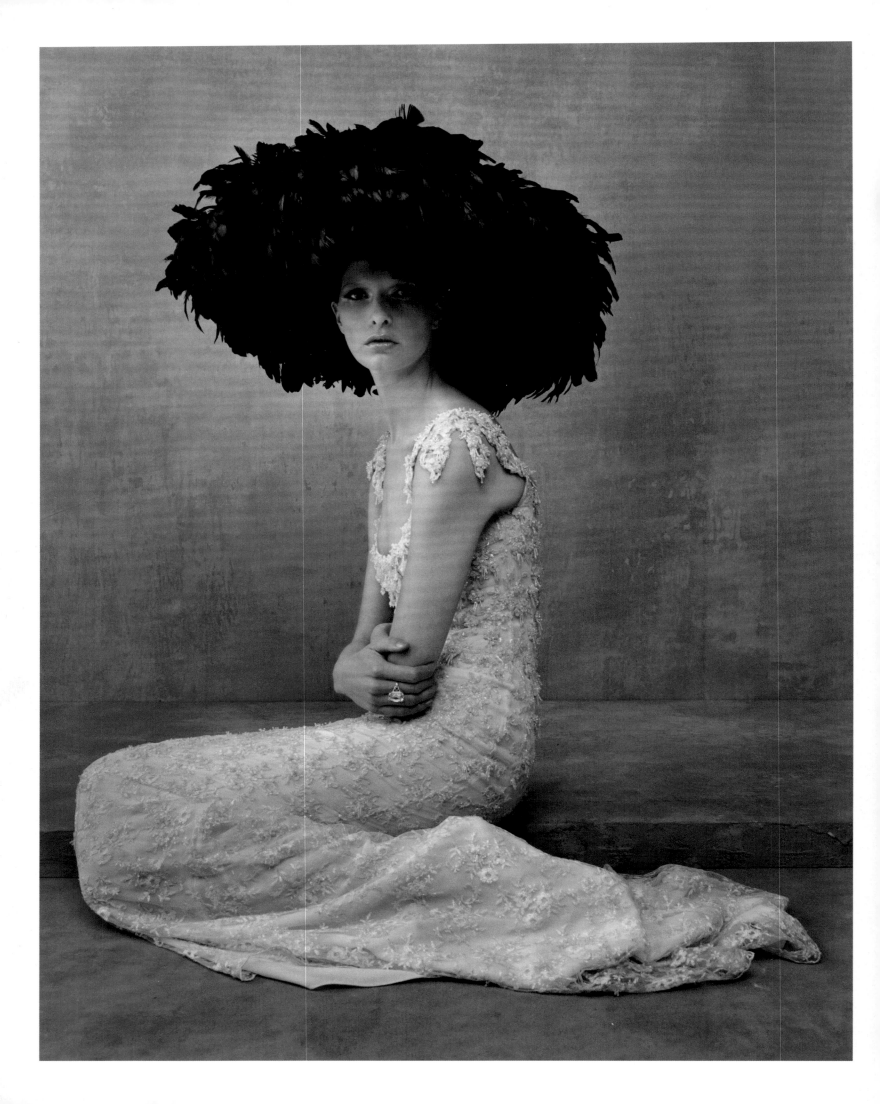

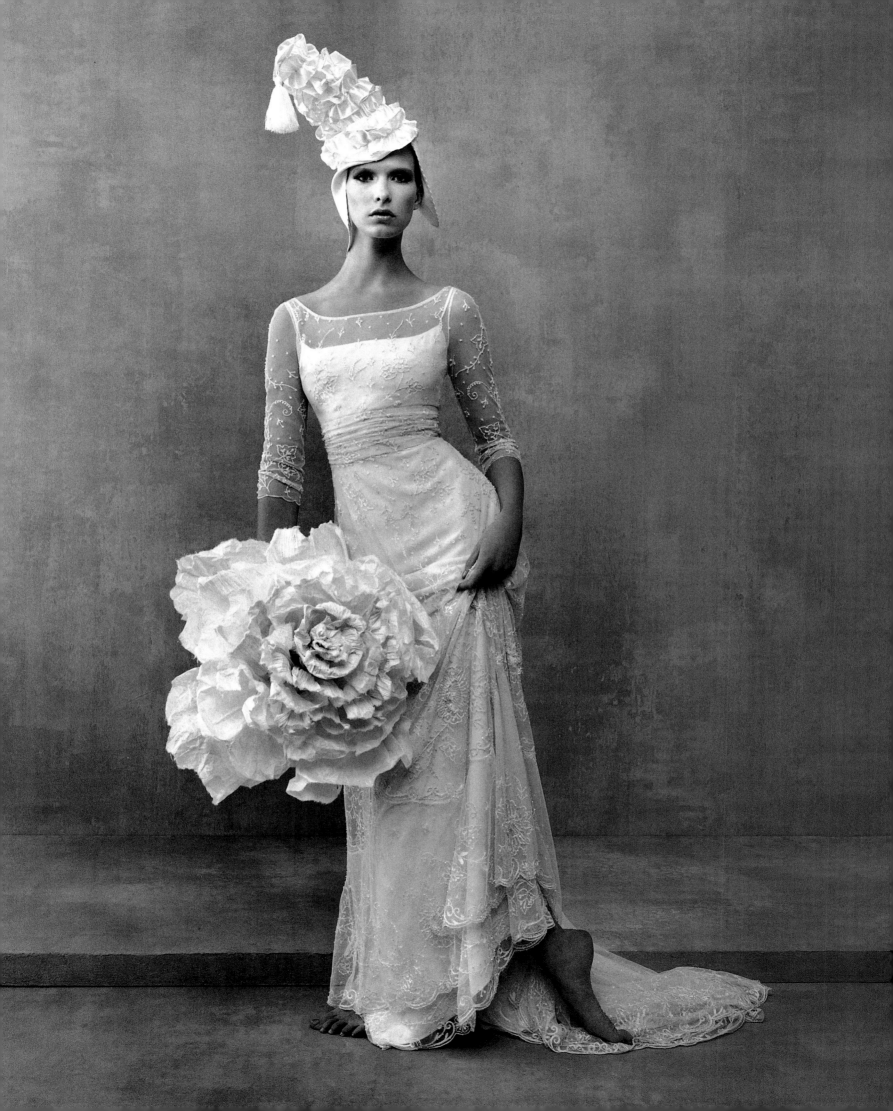

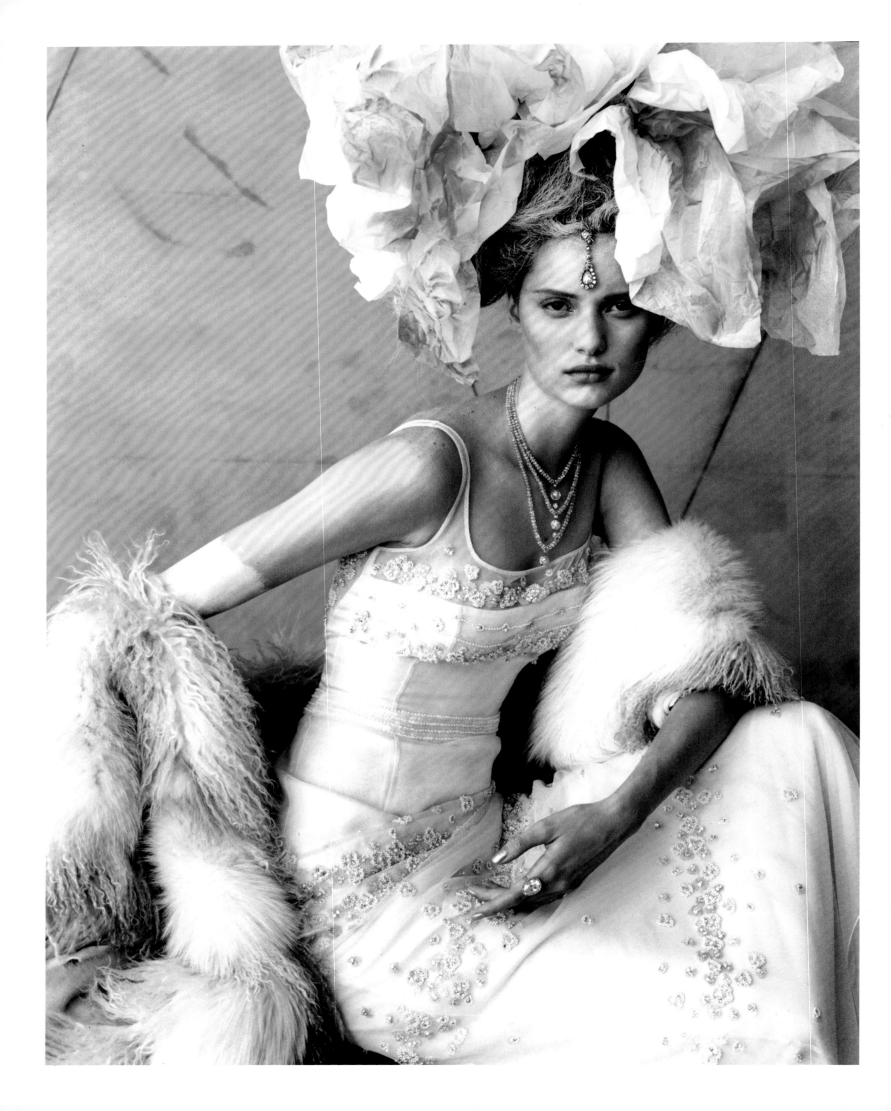

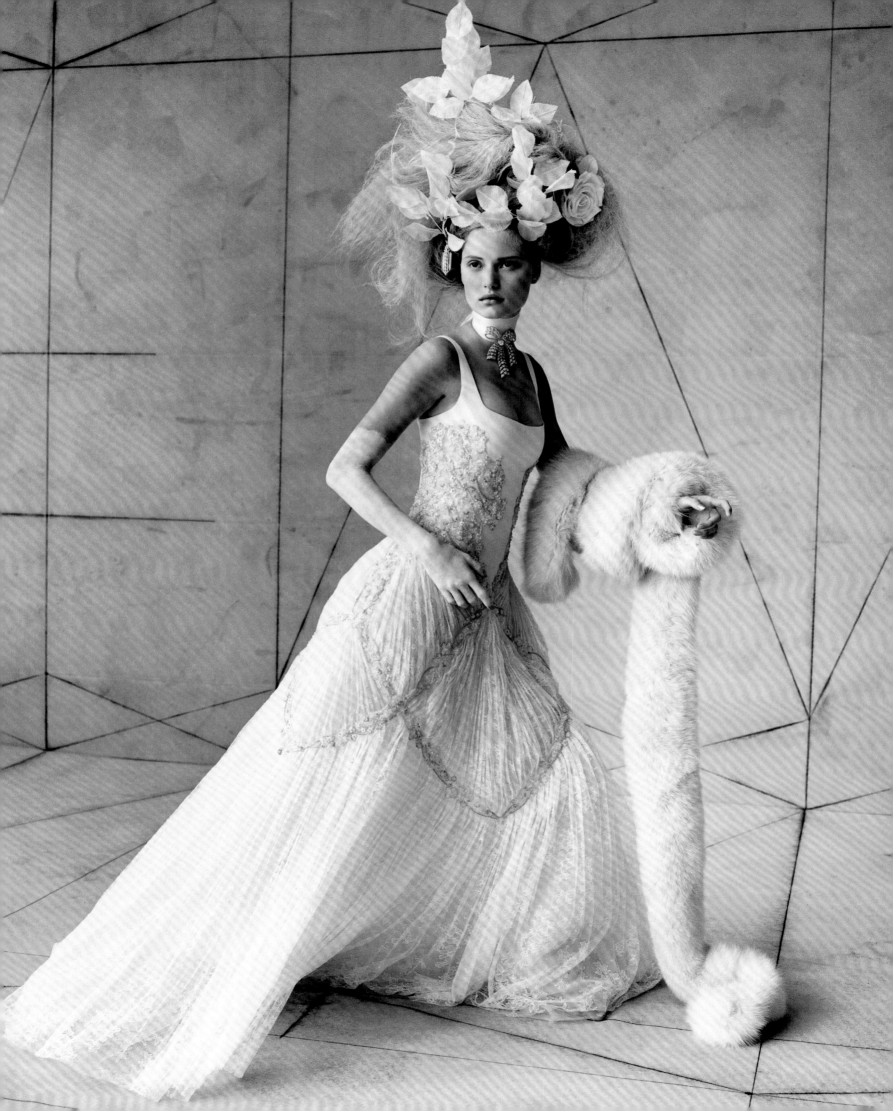

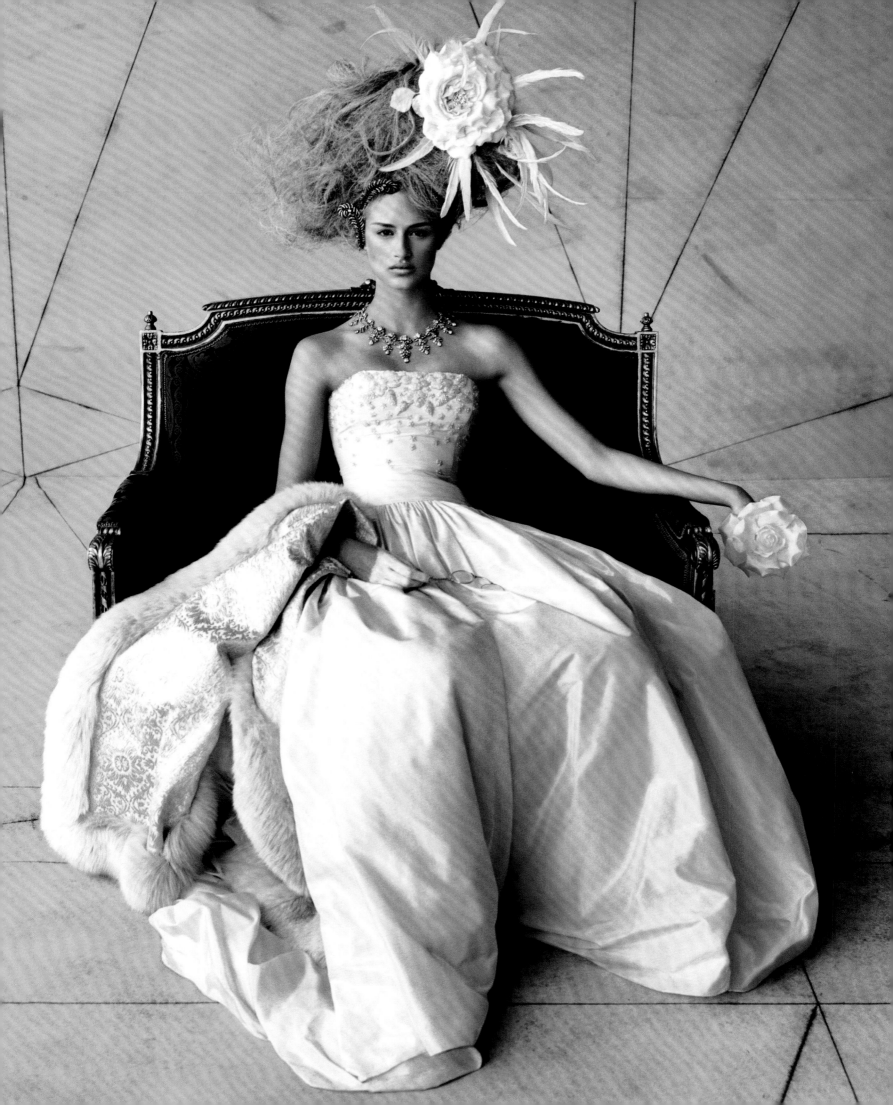

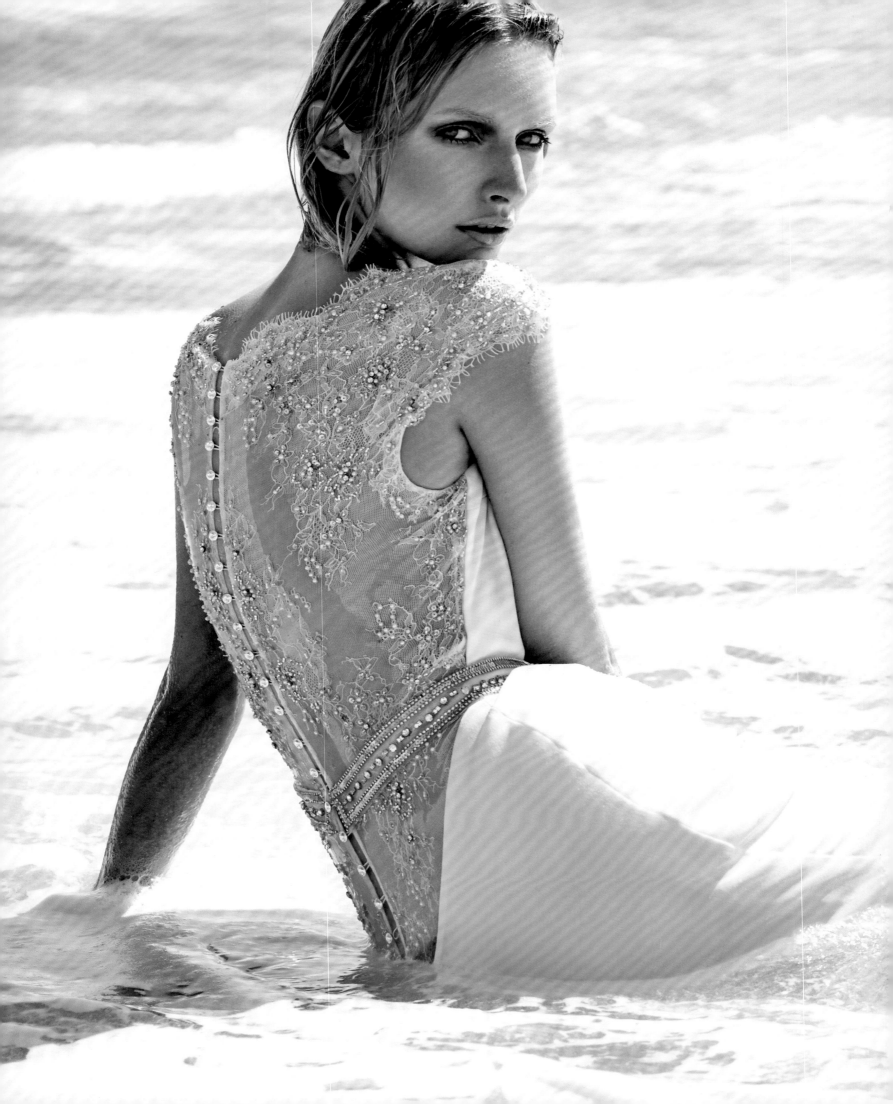

"We believe in fairy tales.
Every life deserves a little fantasy."
—Badgley Mischka

Opposite and following pages
2014–2015 Bridal collection.

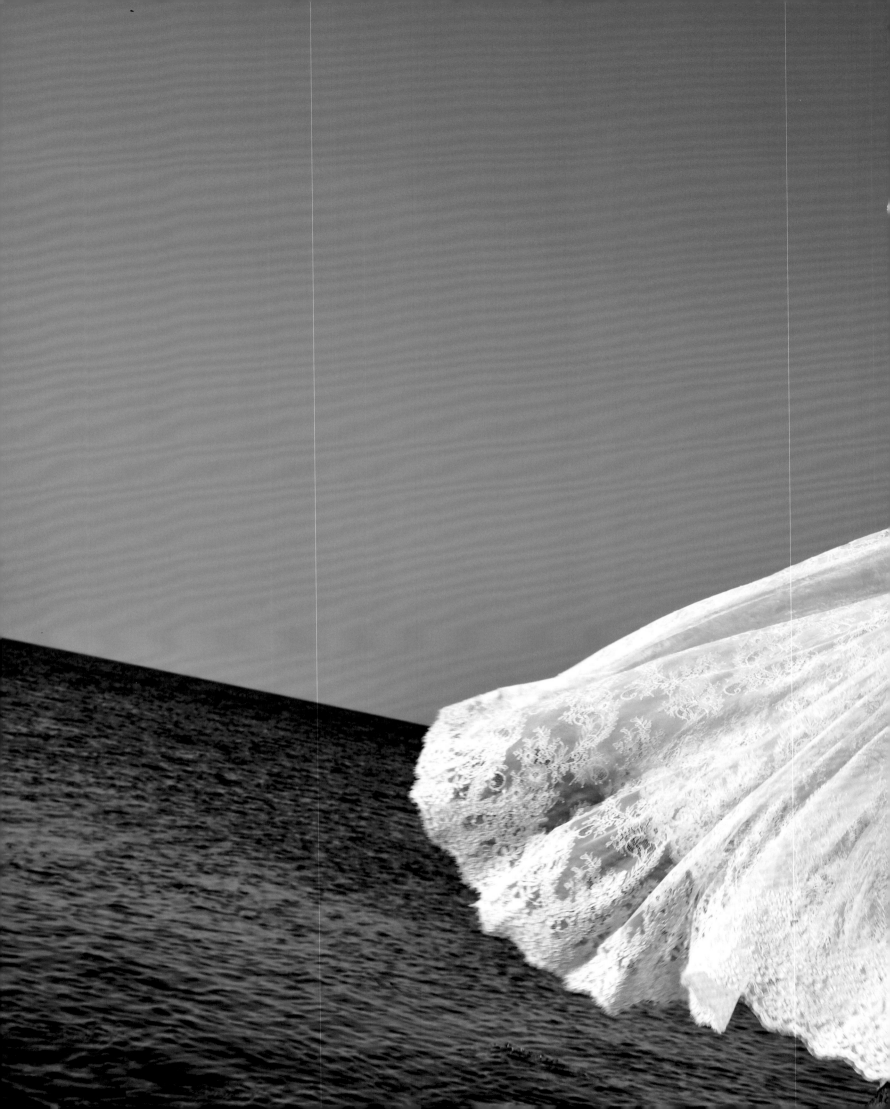

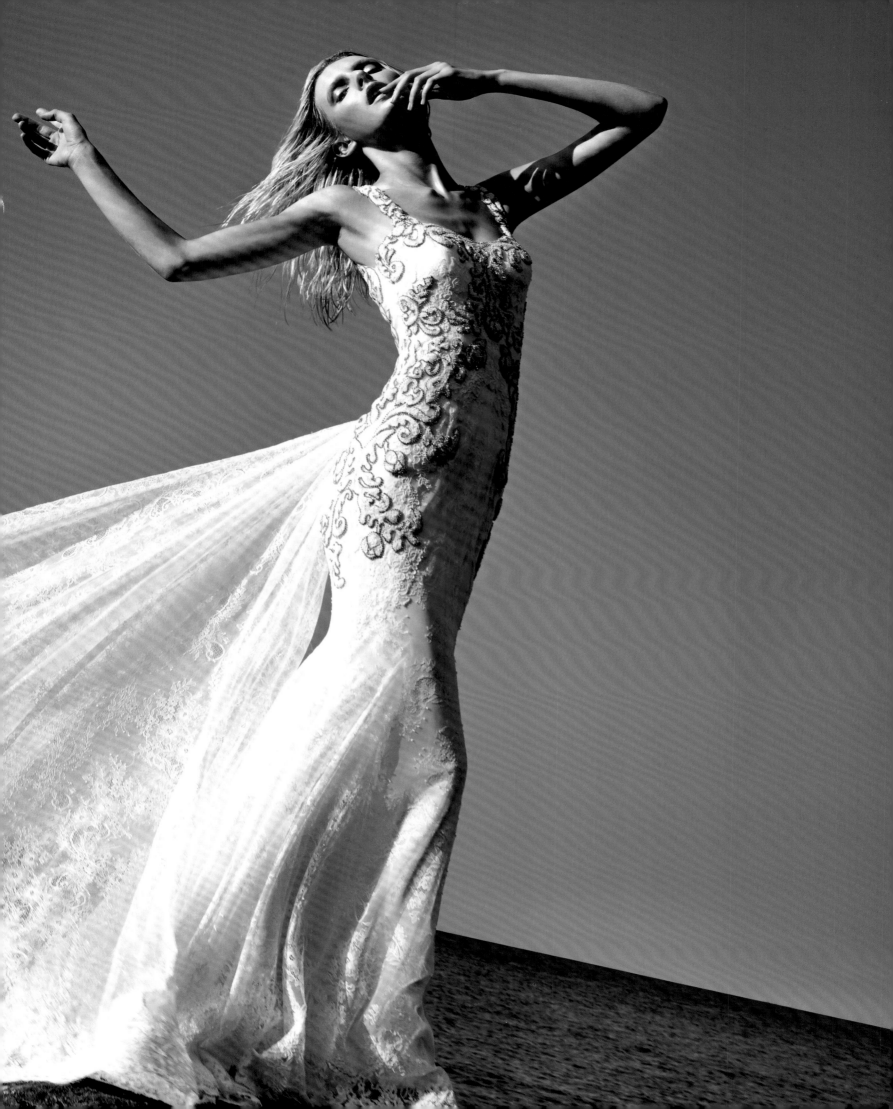

TIMELESS
SILHOUETTES

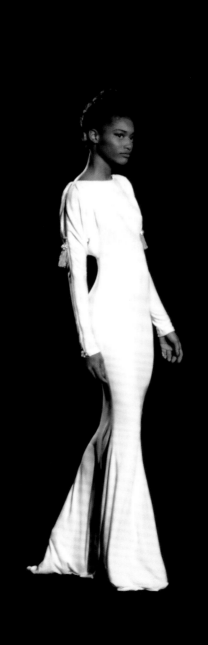

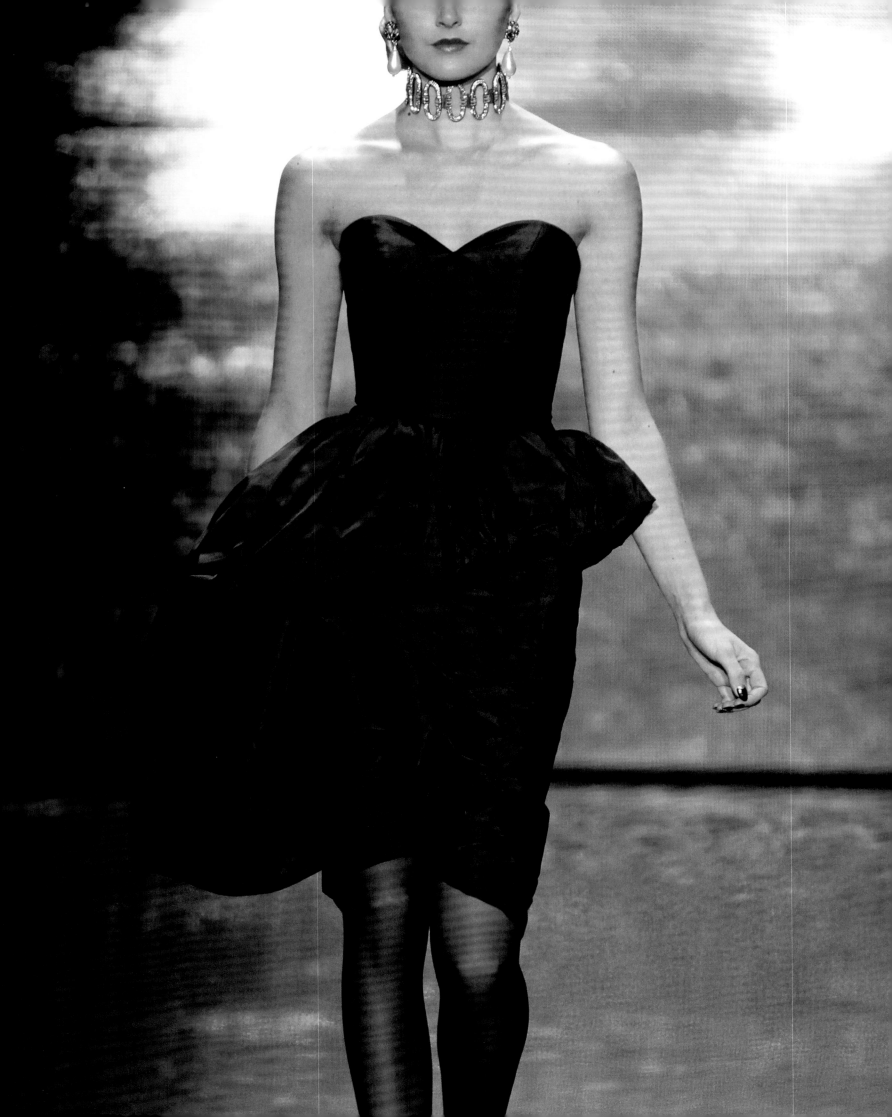

COCKTAIL

The very first collection that Badgley Mischka created was very simple but hinted at what the brand would become. The collection featured twenty black (and one red) cocktail dresses that their friends could wear to dinner and dancing.

It has always been about clothes that can transform the wearer with minimal effort—"one zip and you're glamorous" has been the mantra from the beginning. Modern glamour has been a constant in the company and the designers' lives. Even the studio's denizens dress as if at a cocktail party, and it is implicit that their client's lives begin at 5:00 pm.

Badgley and Mischka remain steadfast believers that the right cocktail dress can take a woman anywhere. It is a staple of the social wardrobe and will never go out of style.

Opposite Classic strapless cocktail dress (Fall/Winter 2011 collection). *Following pages* A look back at some early cocktail-dress designs from Badgley Mischka's Spring 1997 and 2000 collections, captured by Roxanne Lowit. *Previous pages* Fall/Winter 2013 collection.

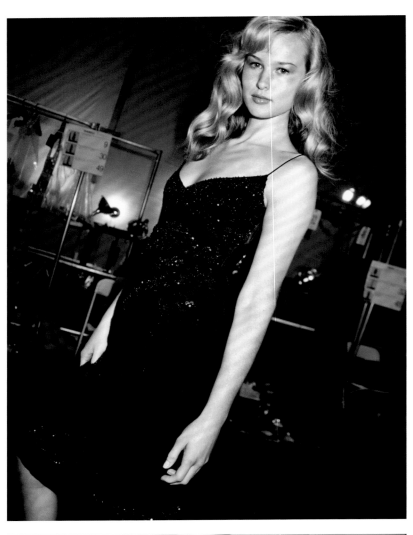

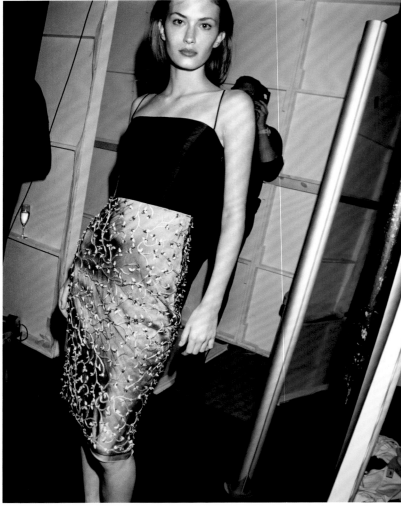

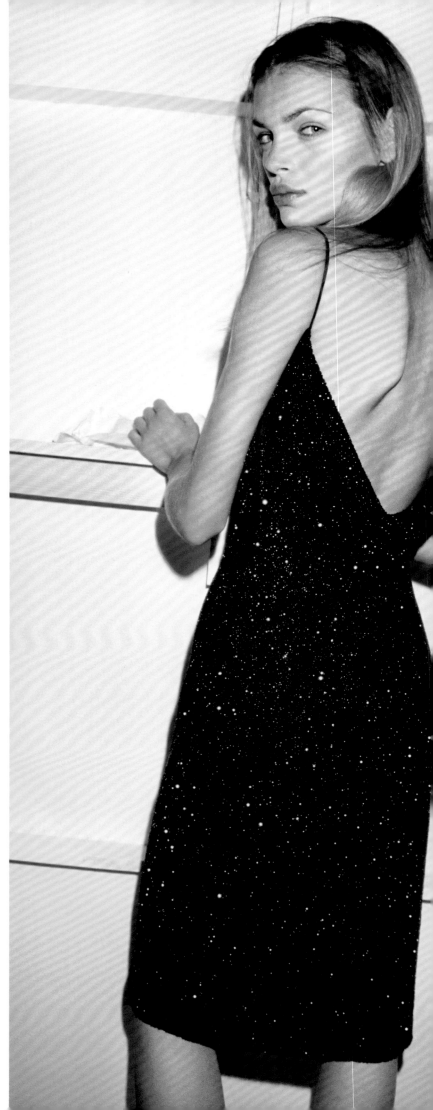

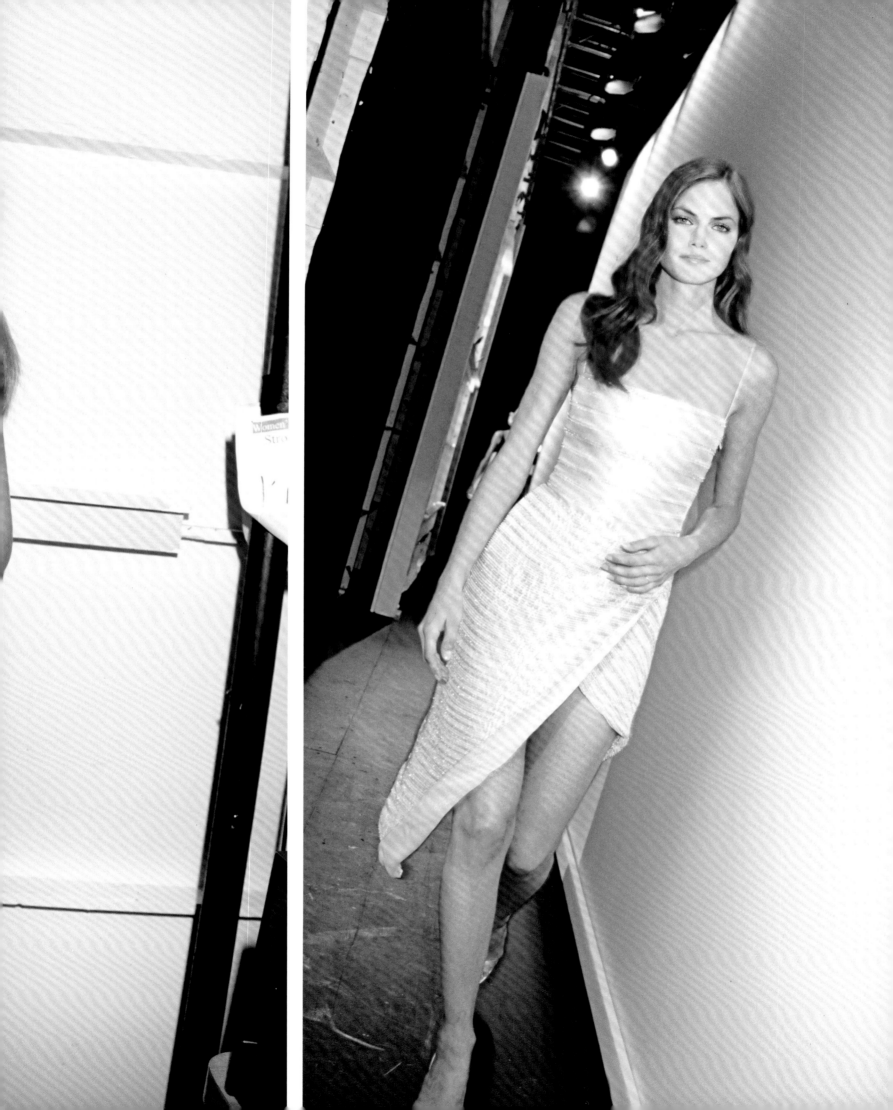

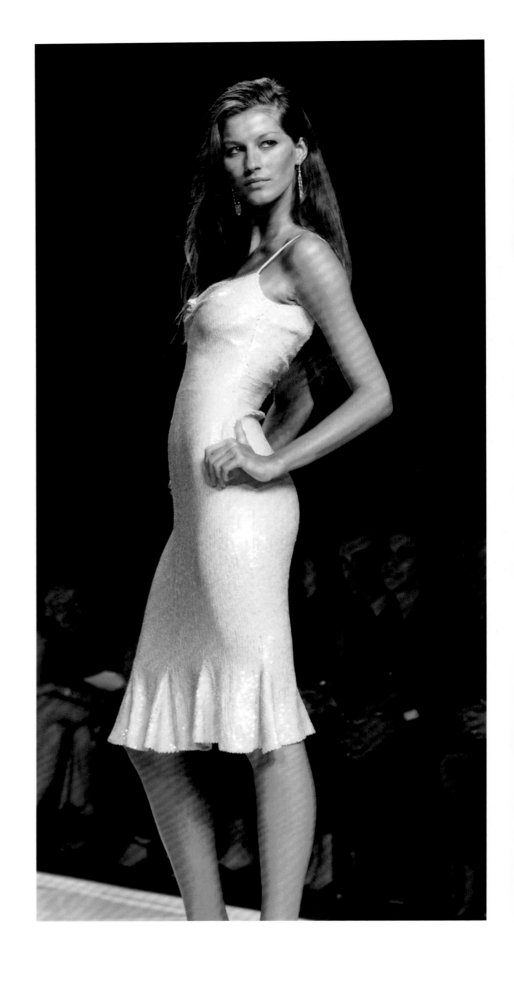

Right Gisele Bündchen
(Spring/Summer 2000
collection). *Opposite* Fall/
Winter 2013 collection.

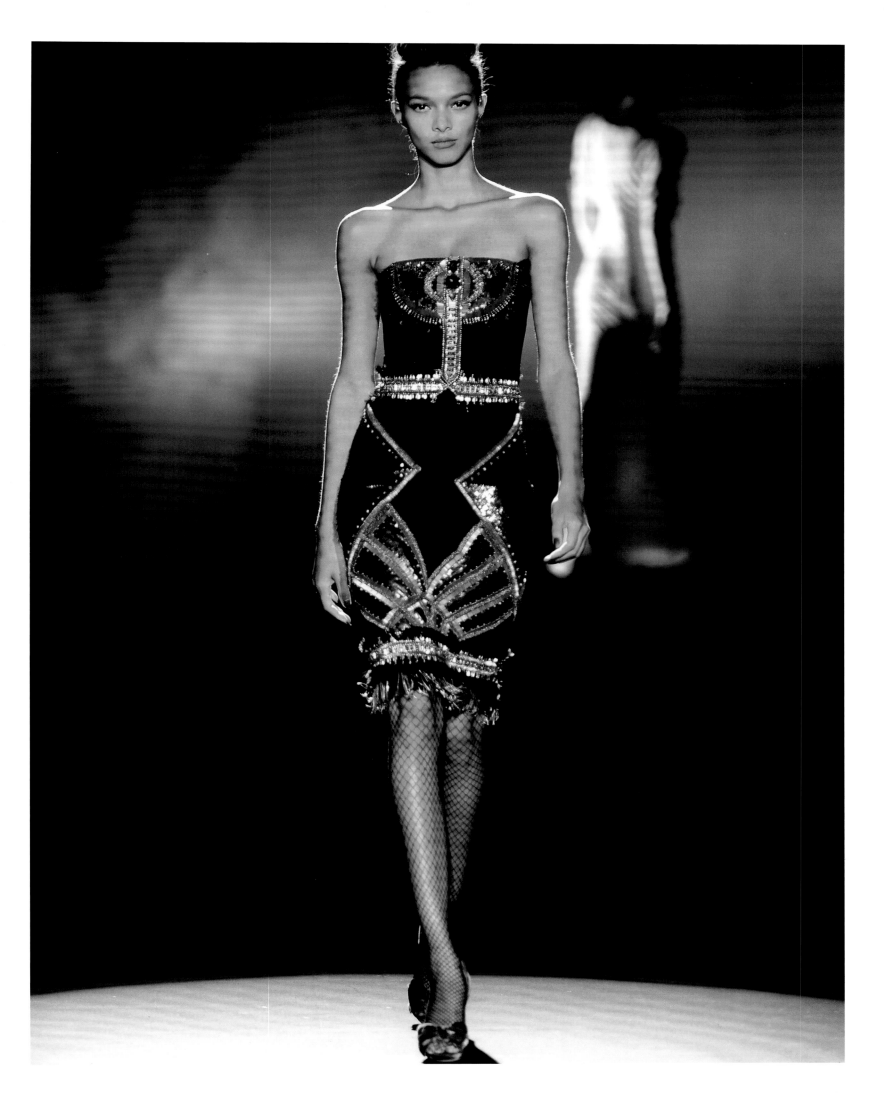

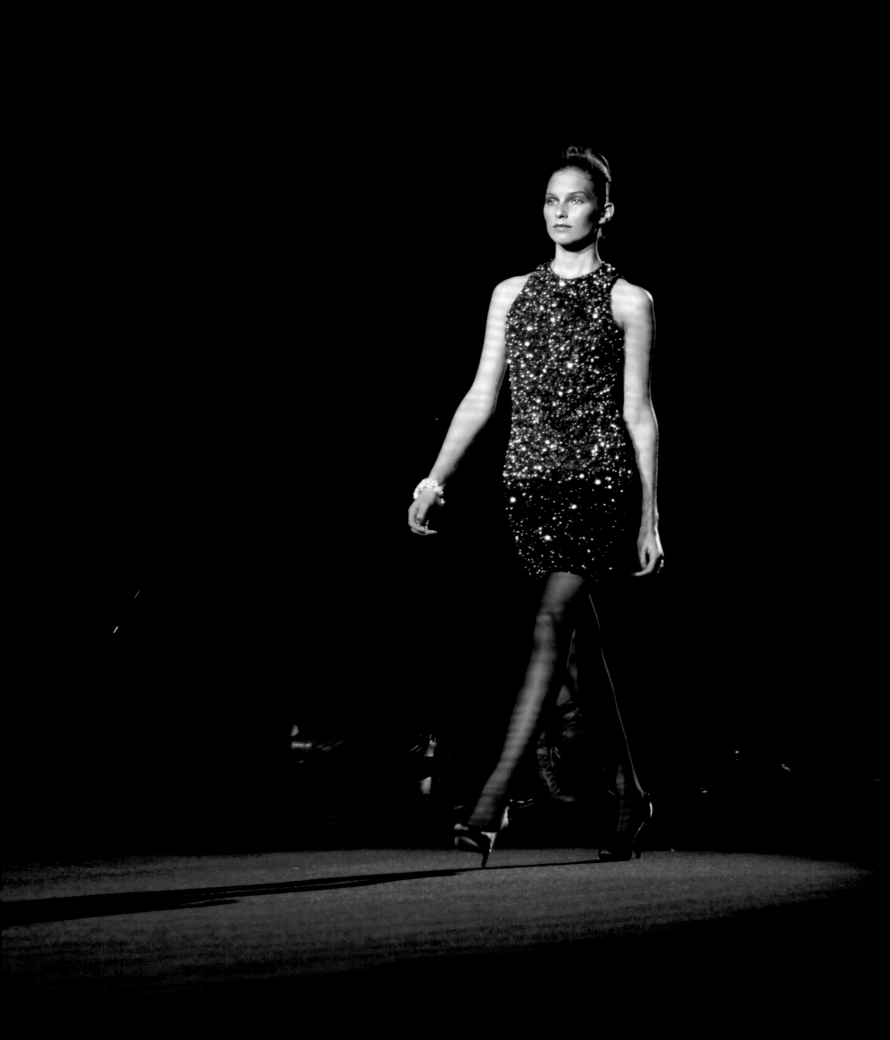

Fall/Winter 2015
collection.

152

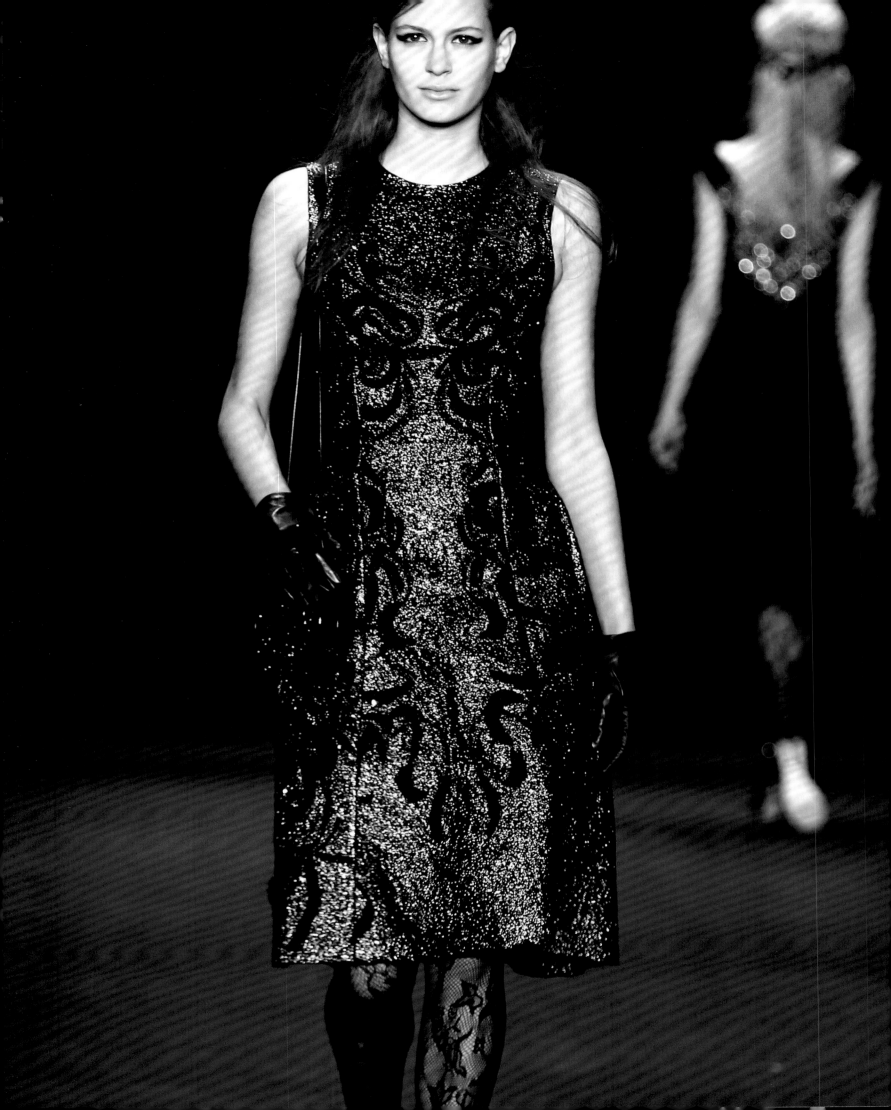

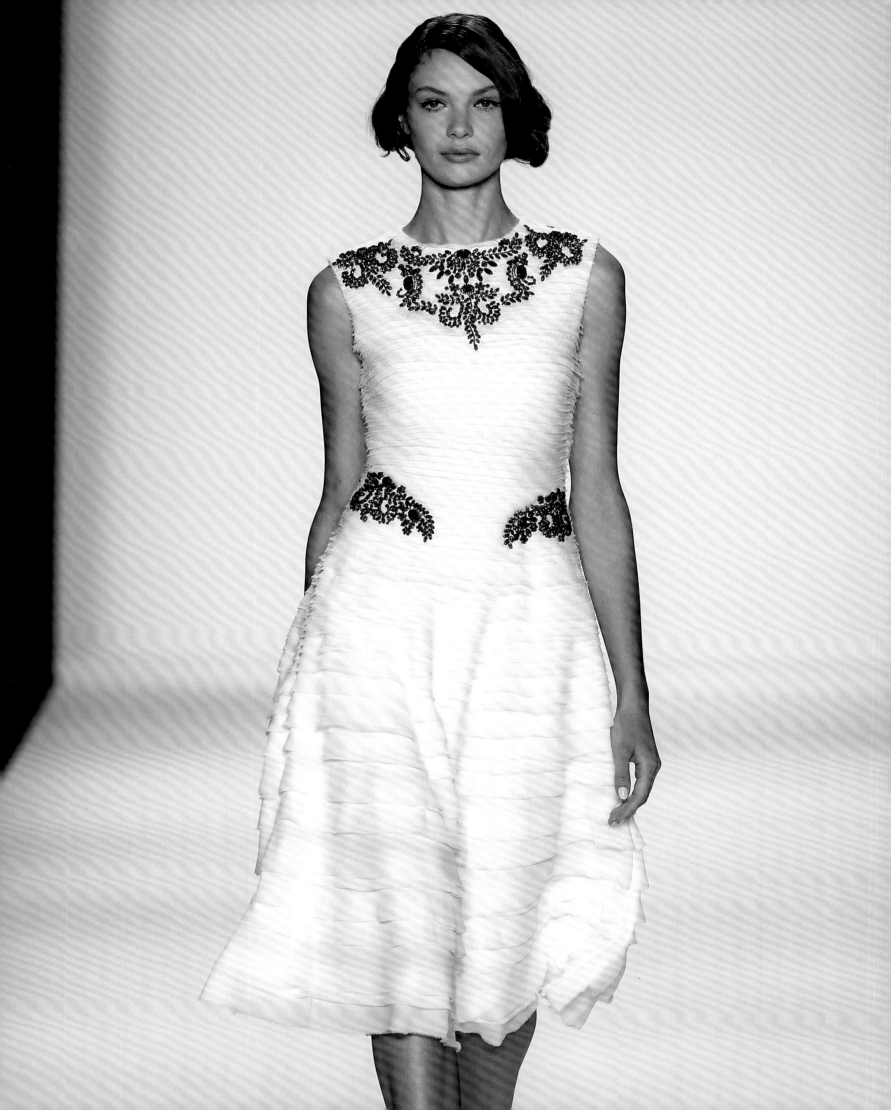

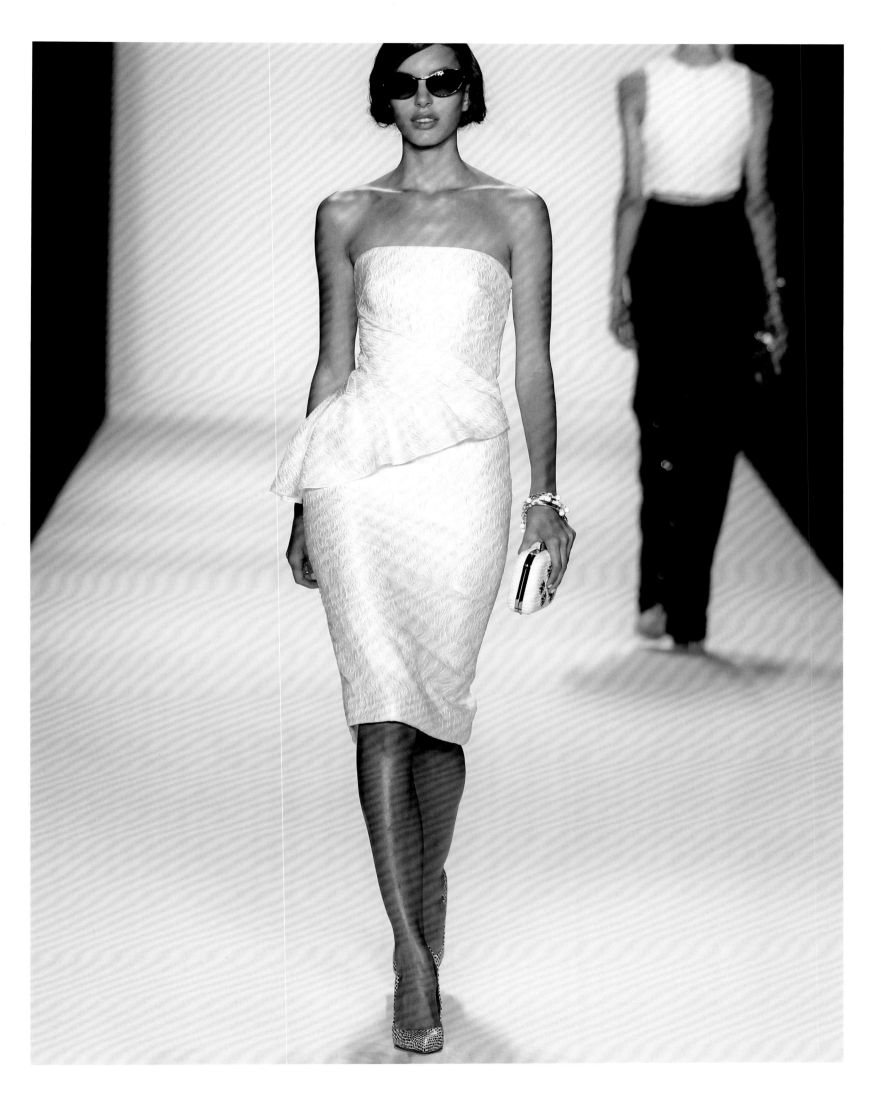

Opposite Fall/Winter 2002
collection. *Previous pages*
Cocktail-dress looks from
the Spring/Summer 2014
collection.

156

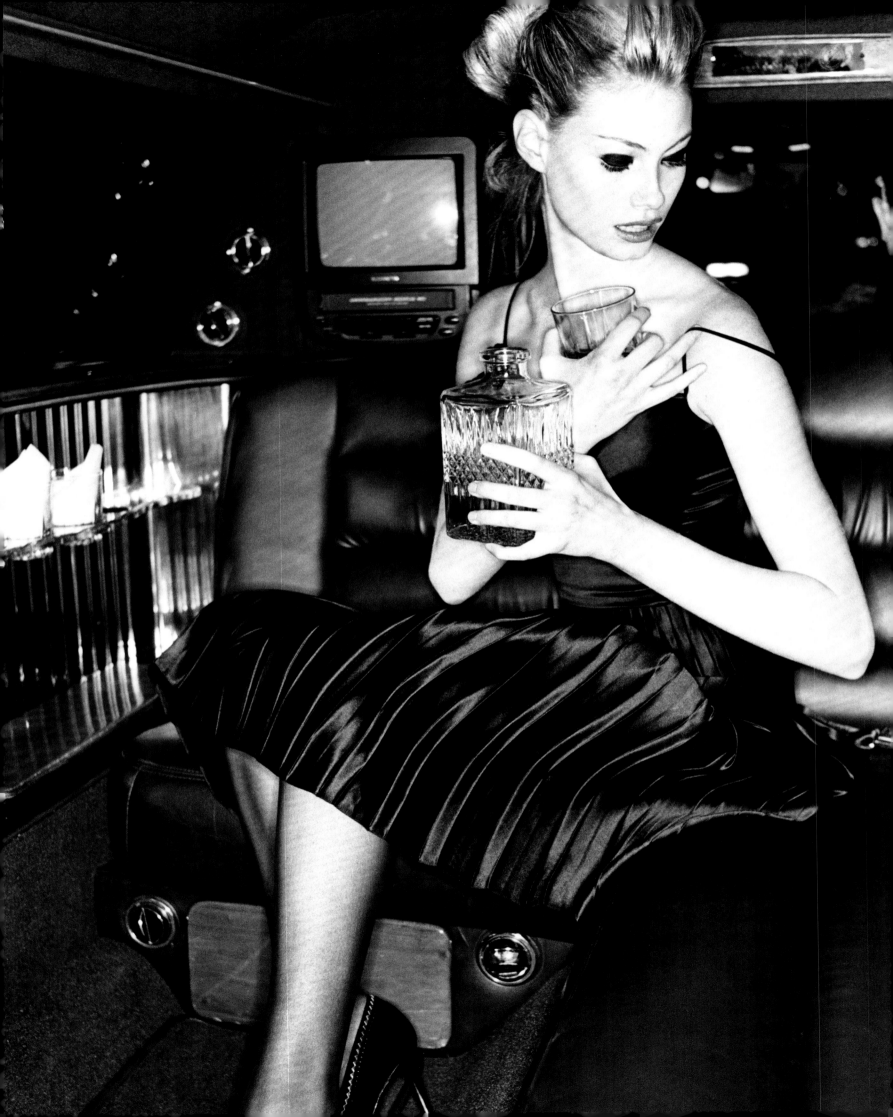

EVENING

If there is a cornerstone to the Badgley Mischka brand, it is indisputably the evening gown. When Badgley and Mischka started out, the evening gown was all but dead—a world of dowagers and "Dynasty." Mark and James felt an innate pull toward the evocation of the glory days of Hollywood and reinvented the evening gown as a streamlined, vaguely vintage yet totally modern option for all women.

It was evening gowns that first propelled the brand into the public eye, gaining traction with winners, nominees, and attendees at the Academy Awards, Emmys, and Golden Globes, as well as with socialites and ingénues around the world.

"An evening gown should be a fantasy, a dream," according to Badgley. "It should speak to a woman's longing for beauty," Mischka adds. "Every woman deserves the chance to express her inner goddess—that's what evening gowns are for."

Opposite Spring/Summer 2014 collection. *Following pages* One-of-a-kind evening wear with scrolls of appliqué, embroidery, and beadwork is the stuff of dreams (Spring/Summer 2013 collection).

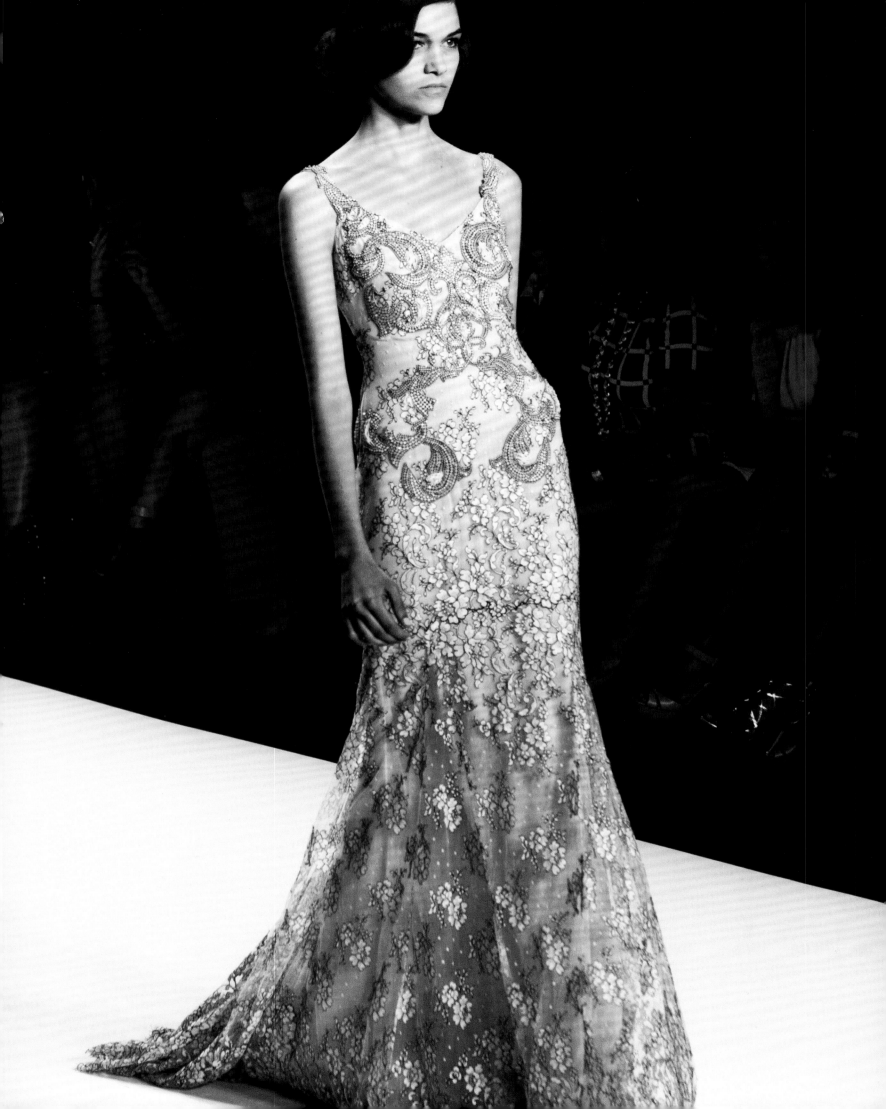

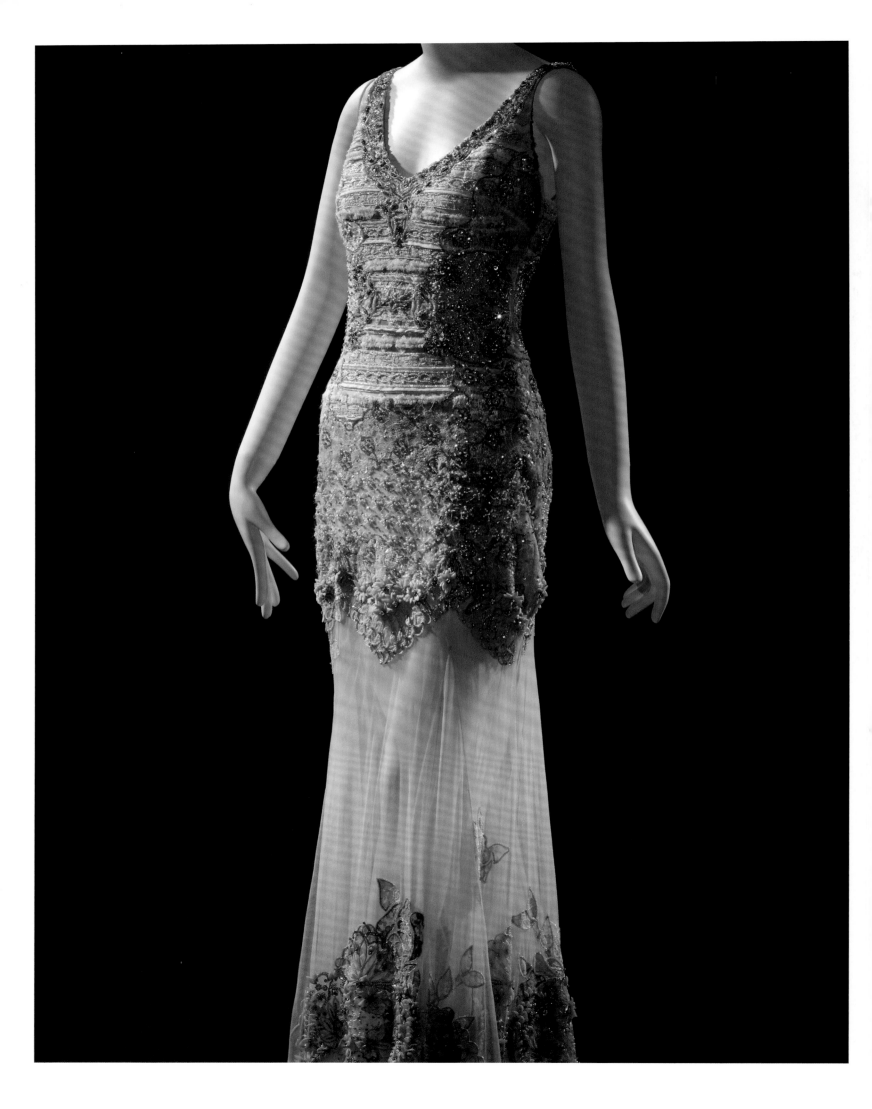

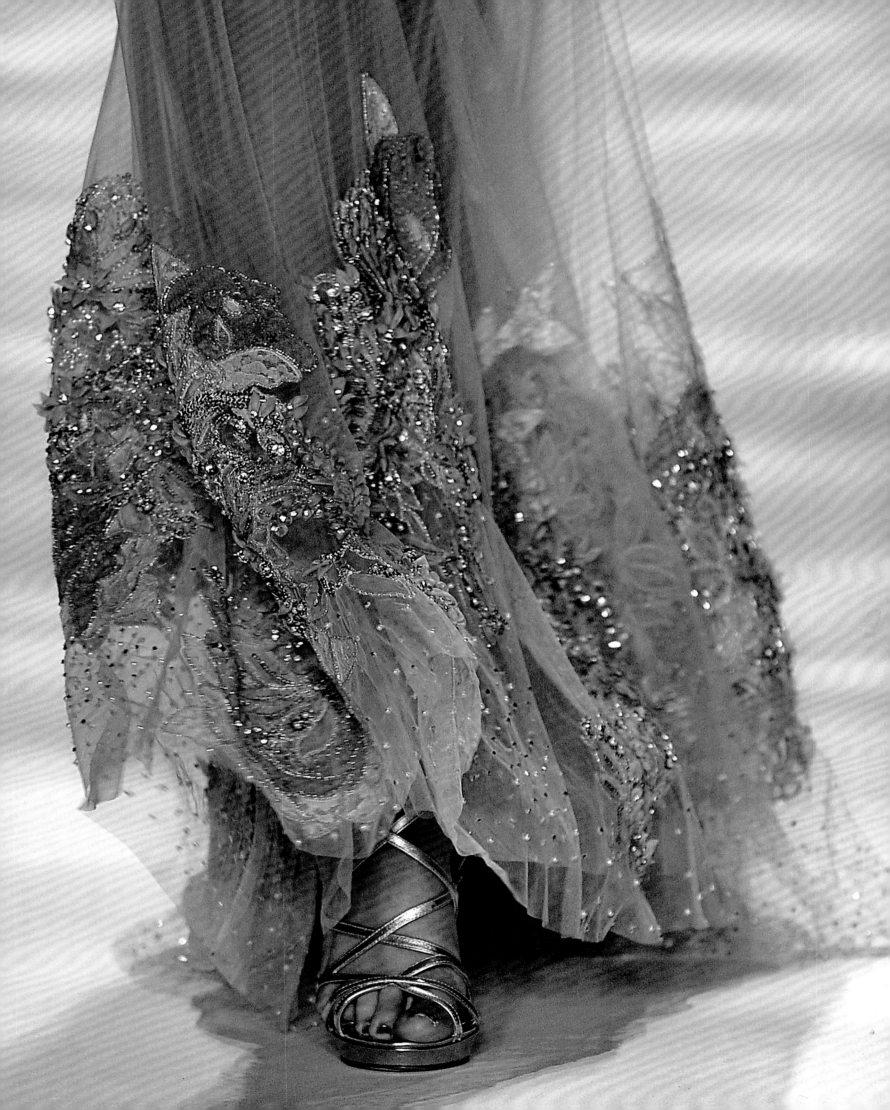

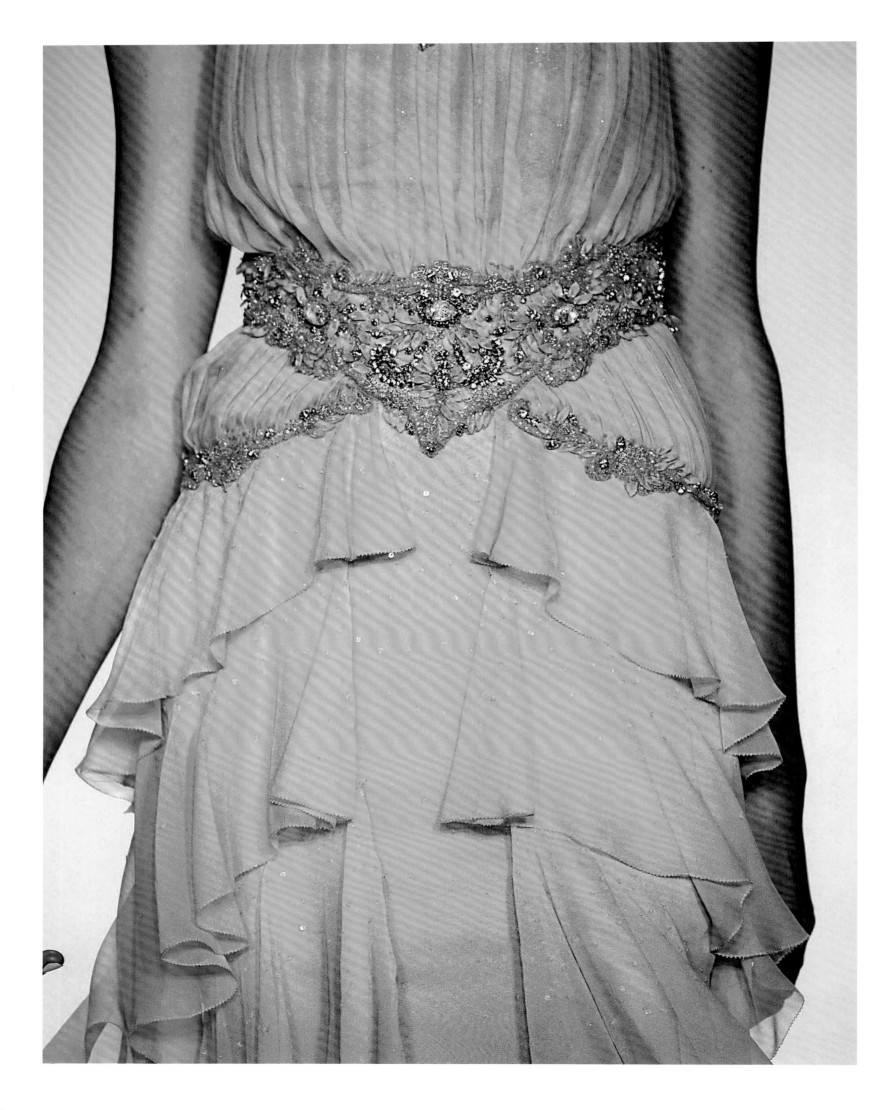

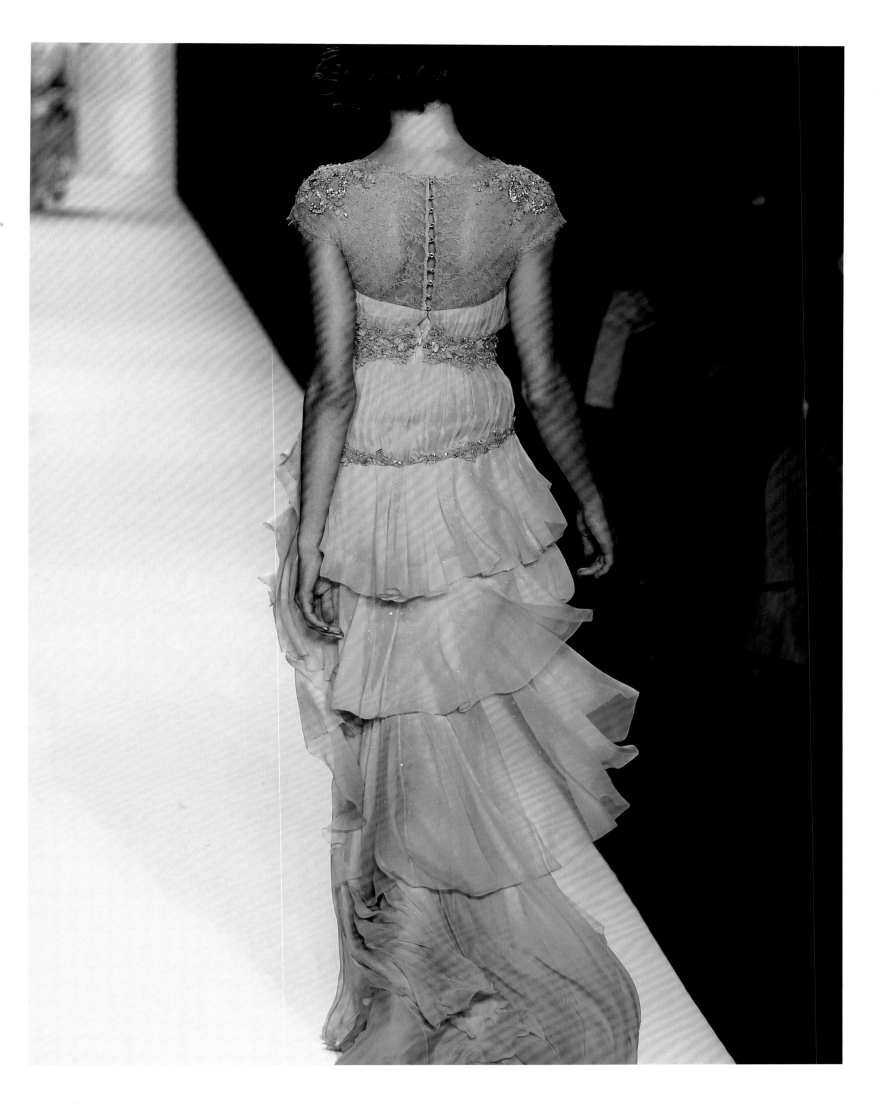

Opposite A signature
fishtail gown from the
Fall/Winter 2014 col-
lection. *Previous pages*
The 1935 film version
of *A Midsummer Night's
Dream* gave inspiration
to a collection of frothy
and romantic gowns
(Spring/Summer 2013
collection). *Following
pages, left* A deep-V
back from the Spring/
Summer 2013 collec-
tion. *Following pages,
right* The rarefied air
displaced by a fluttering
chiffon ruffle and beads
so subtle they are about
an effervescent shine
redefine high drama
in this look from the
Spring/Summer 2014
collection.

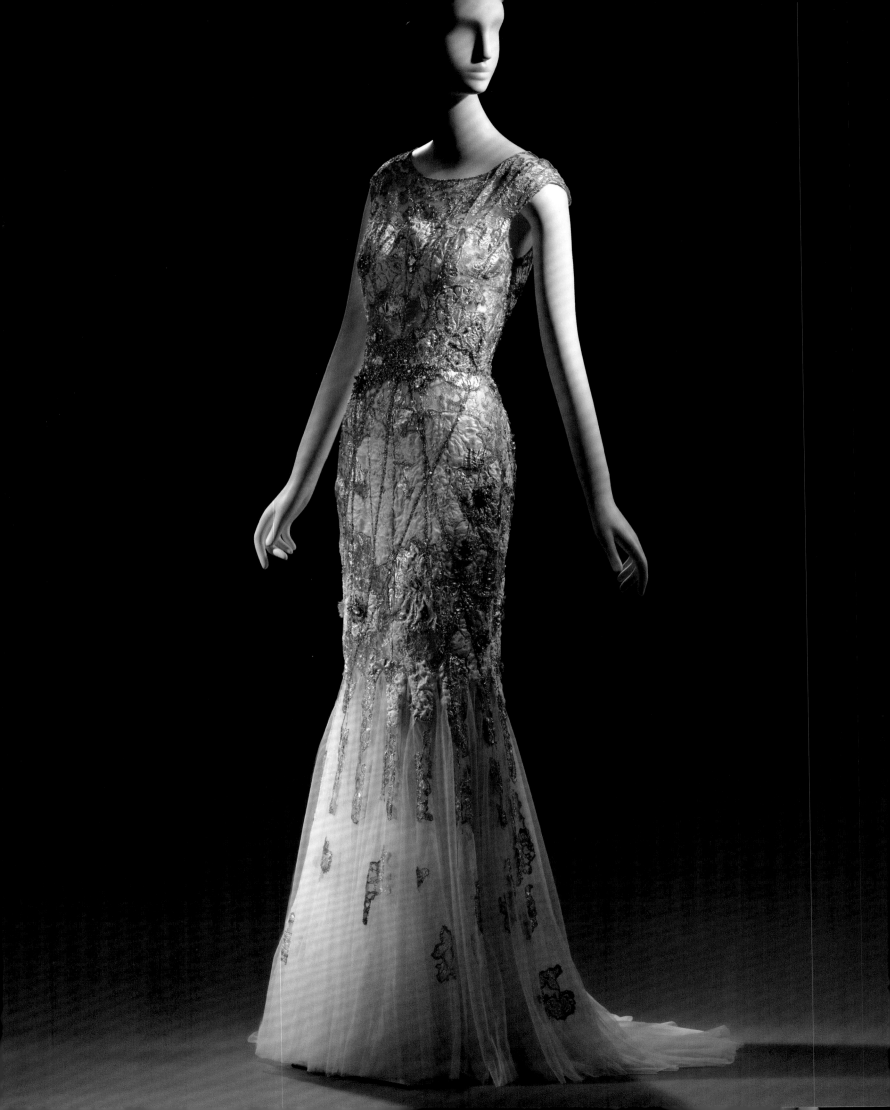

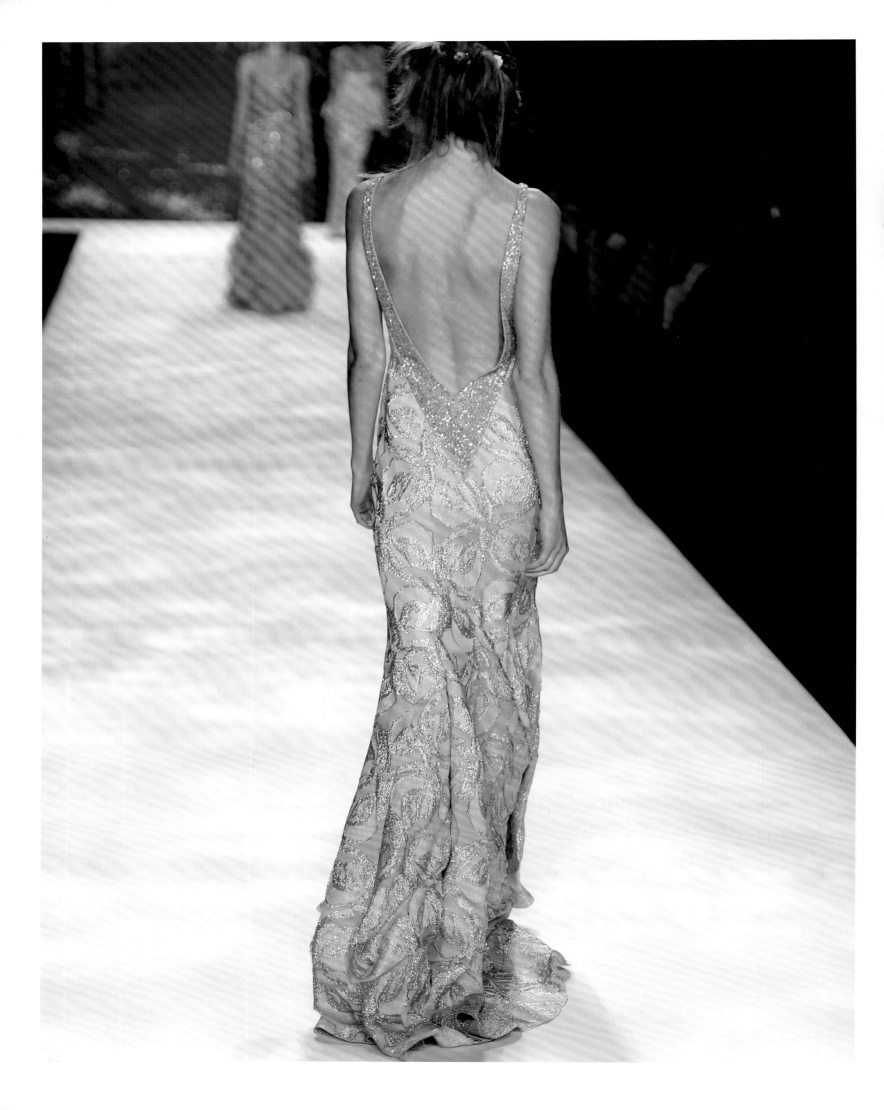

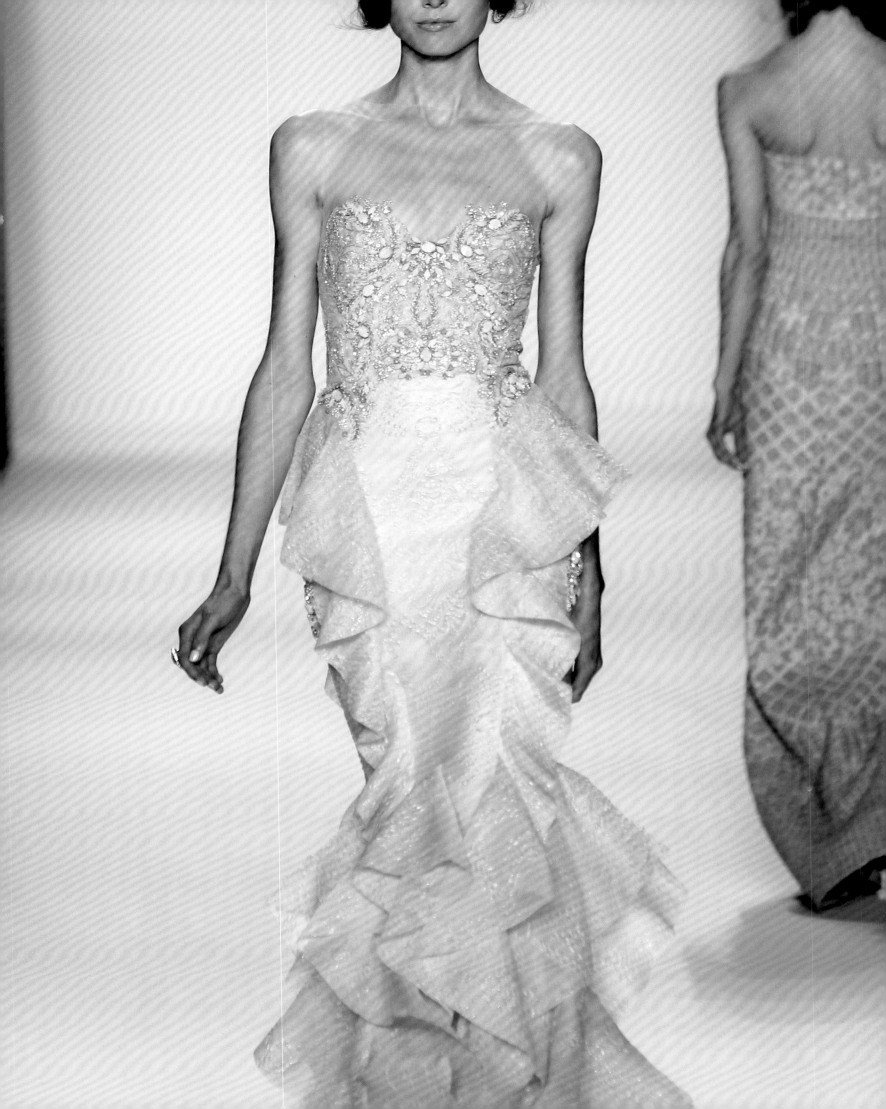

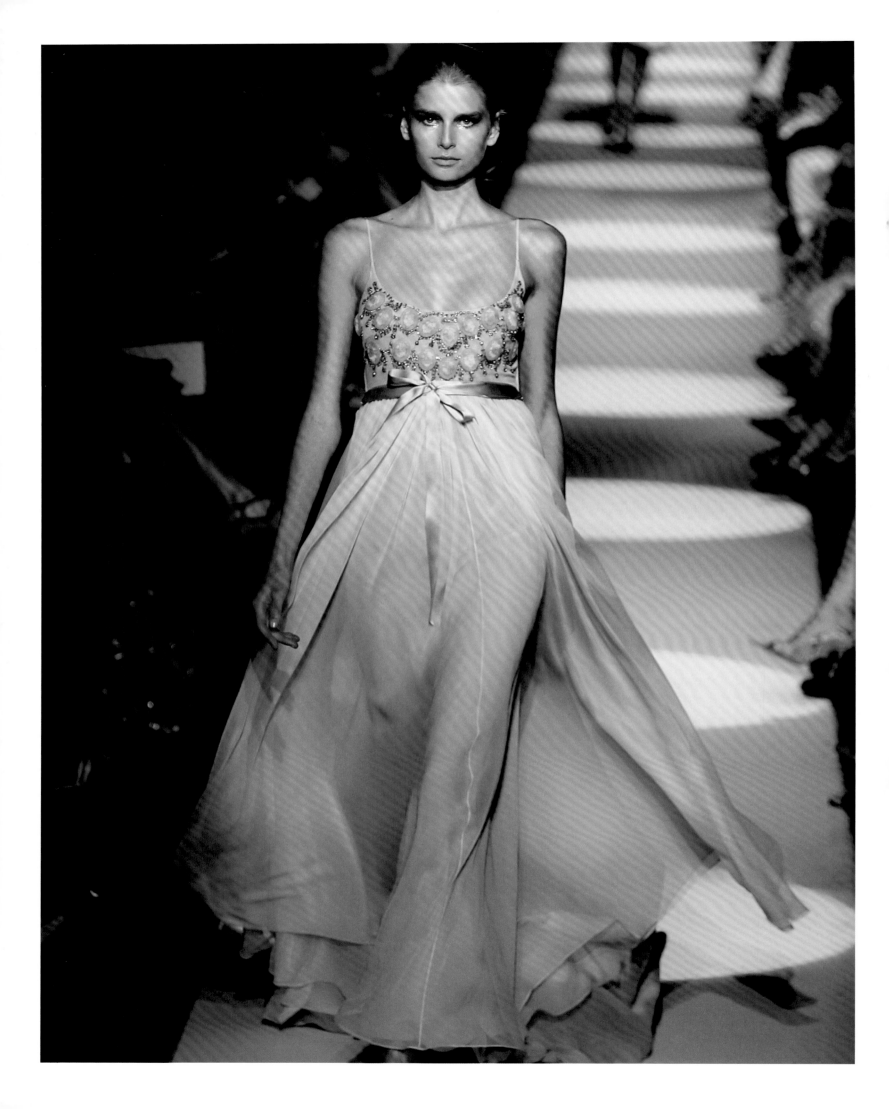

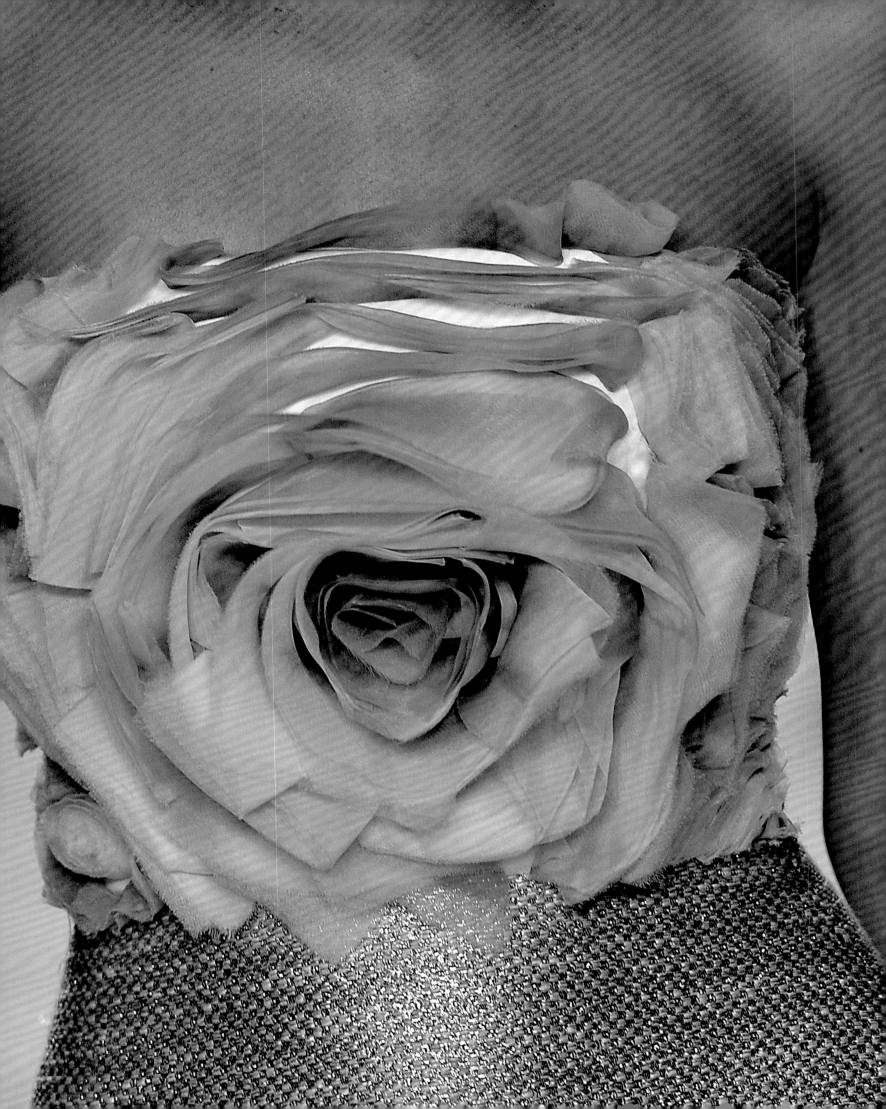

Opposite Beaded gown, circa 2000. *Previous pages, right* Bodice detail (Spring/ Summer 2013 collection). *Previous pages, left* Spring/ Summer 2006 collection.

172

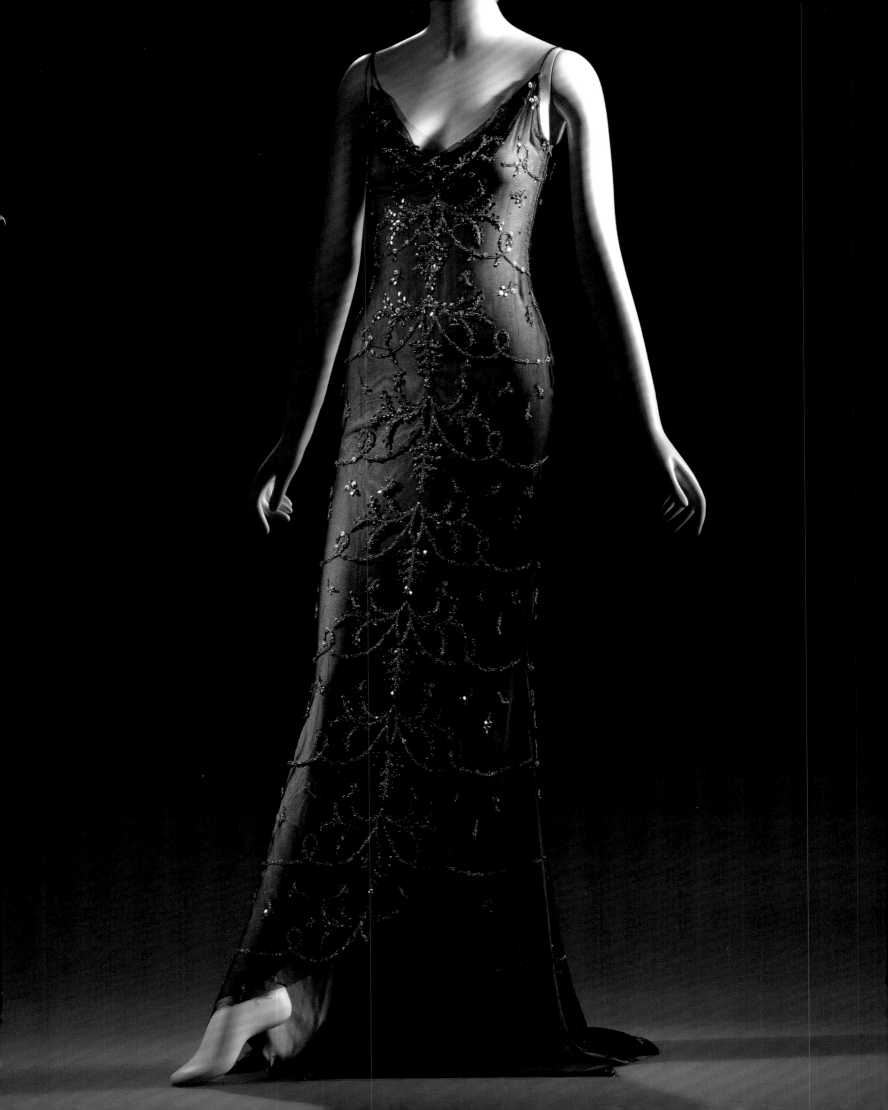

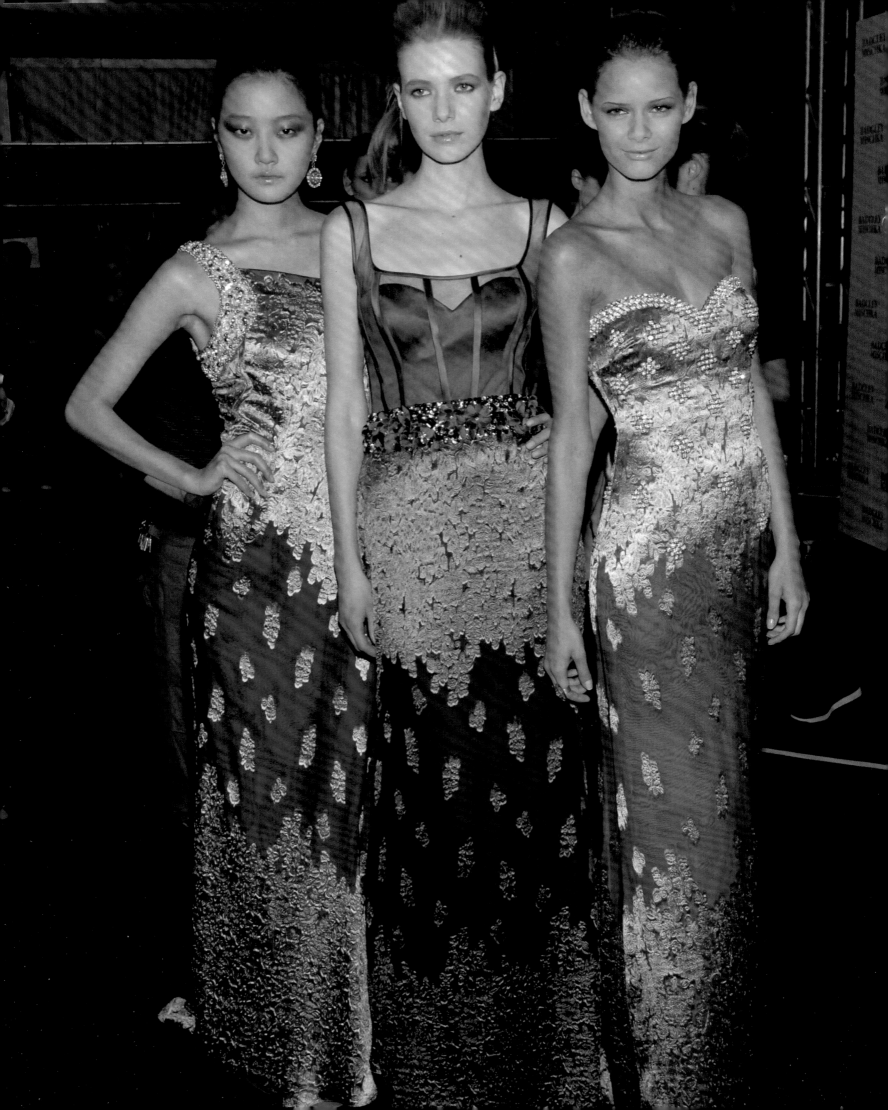

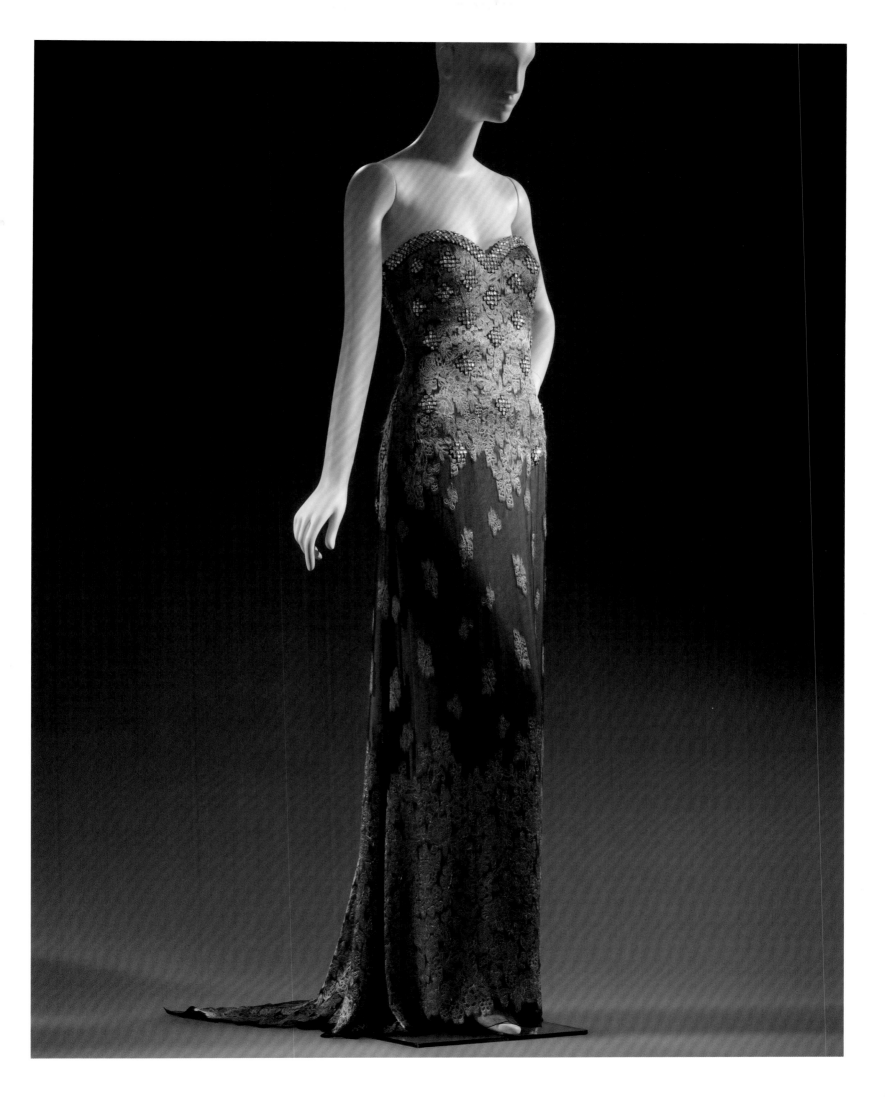

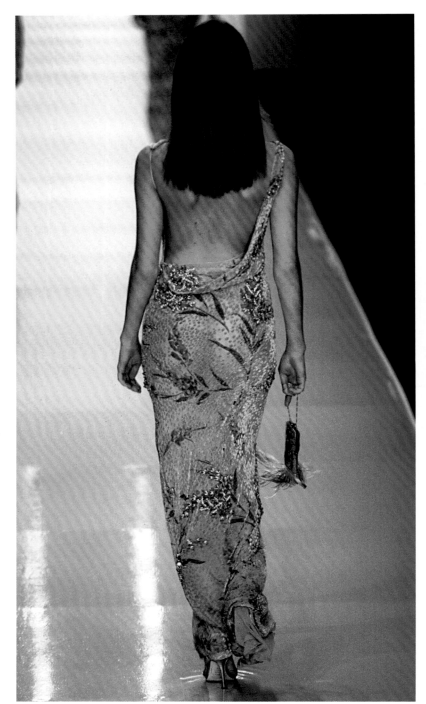

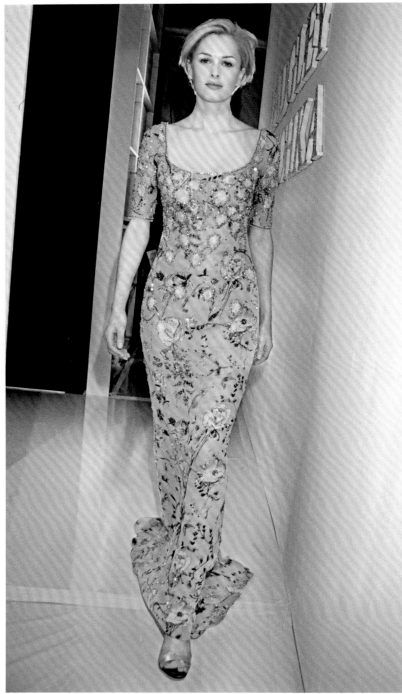

Above and opposite
From the Spring/Summer
1997 and 1998 collections,
these elegant variations
on the mermaid gown
with fishtail trains feature
the couture elements and
custom beading that define
Badgley Mischka's style.
Previous pages Fall/Winter
2009 collection. *Following
pages* Detail Spring/Sum-
mer 1998 collection.

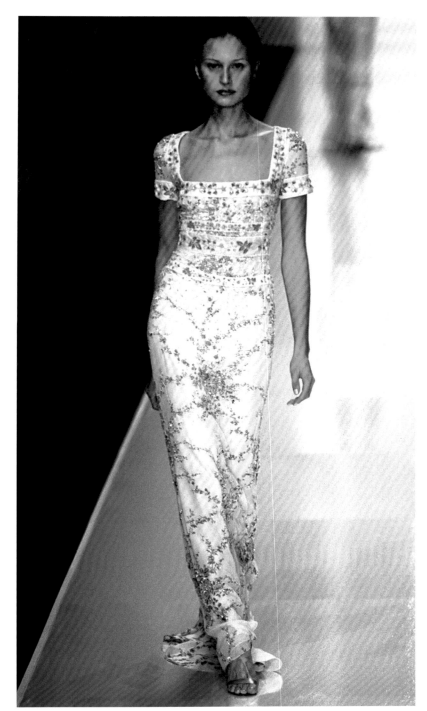
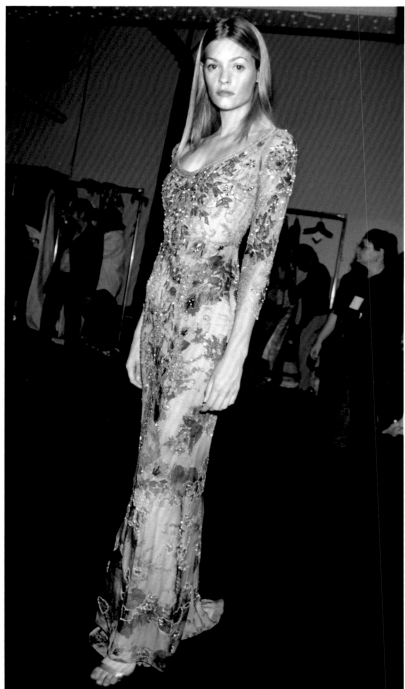

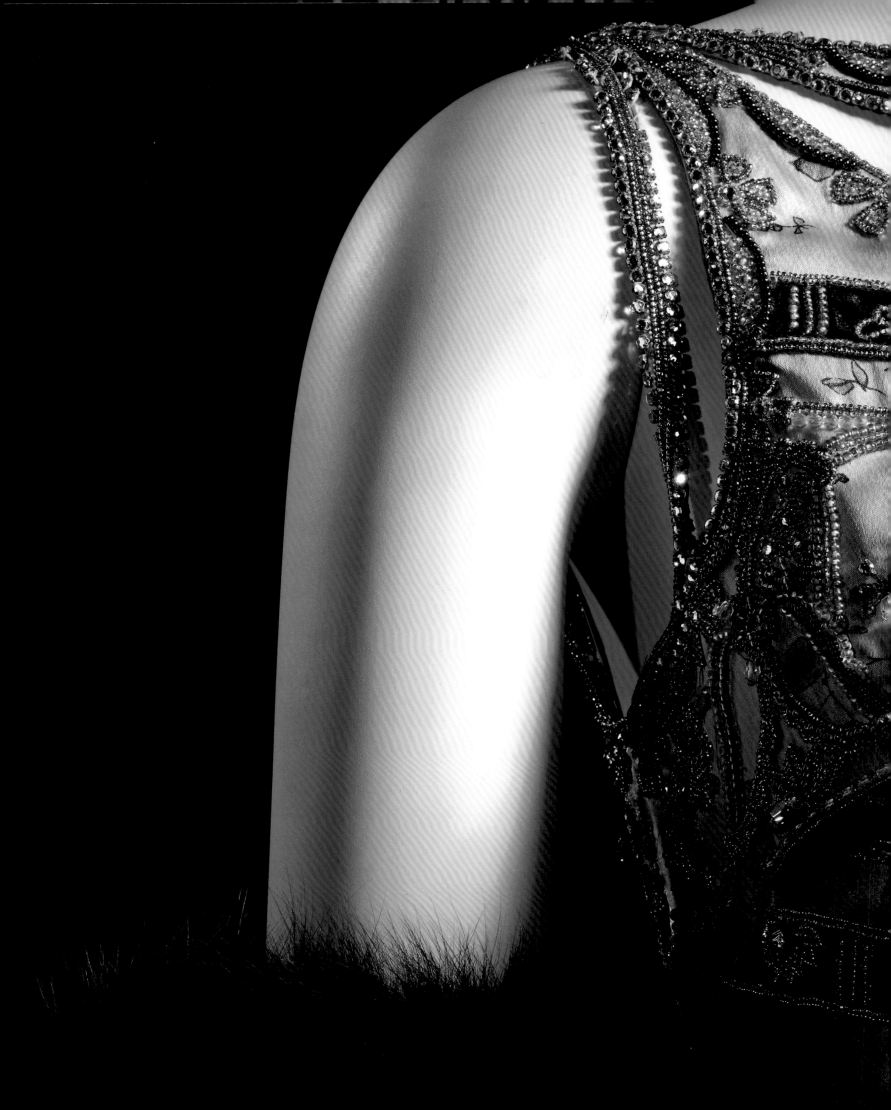

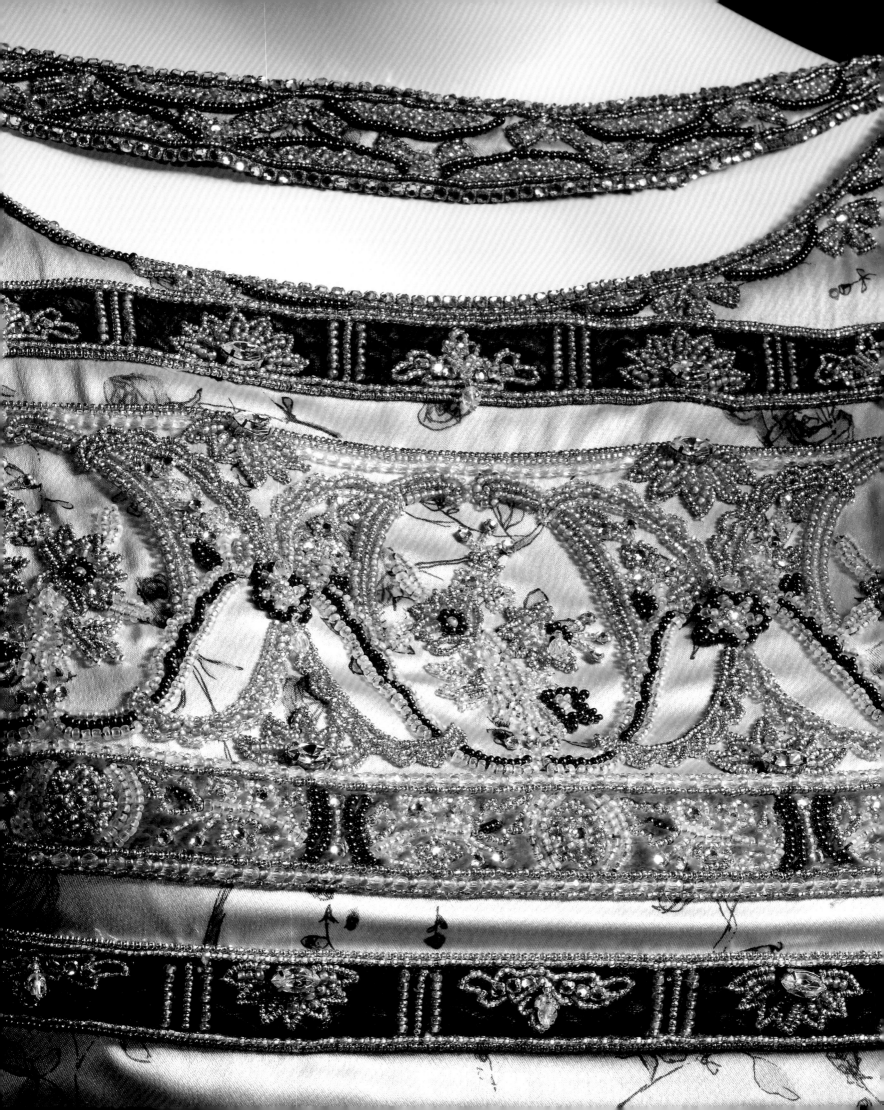

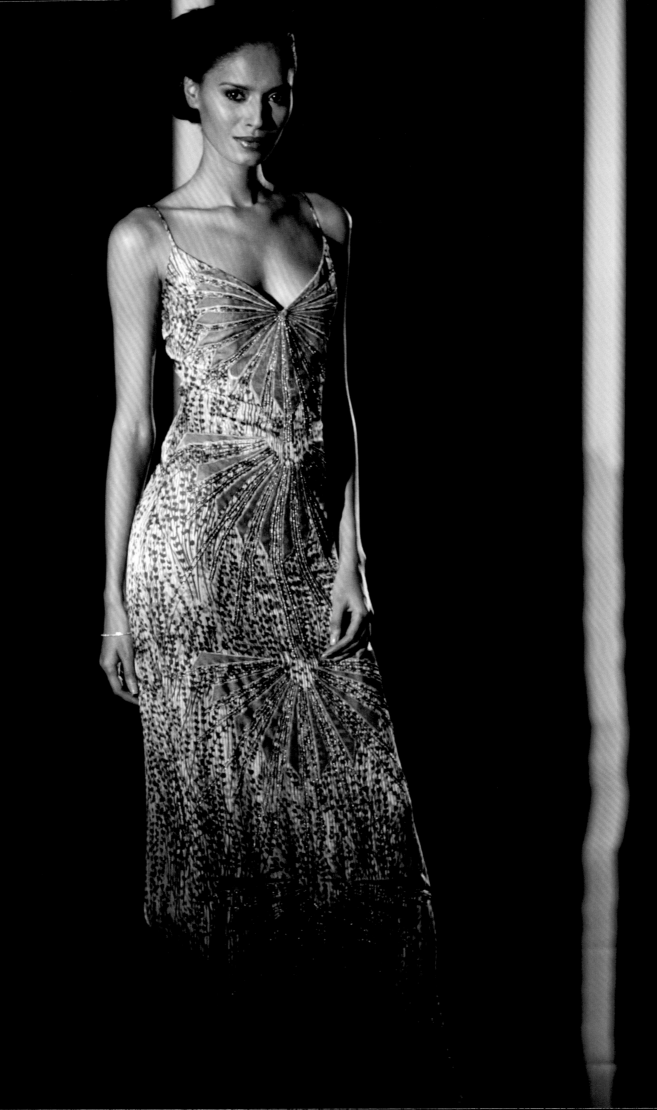

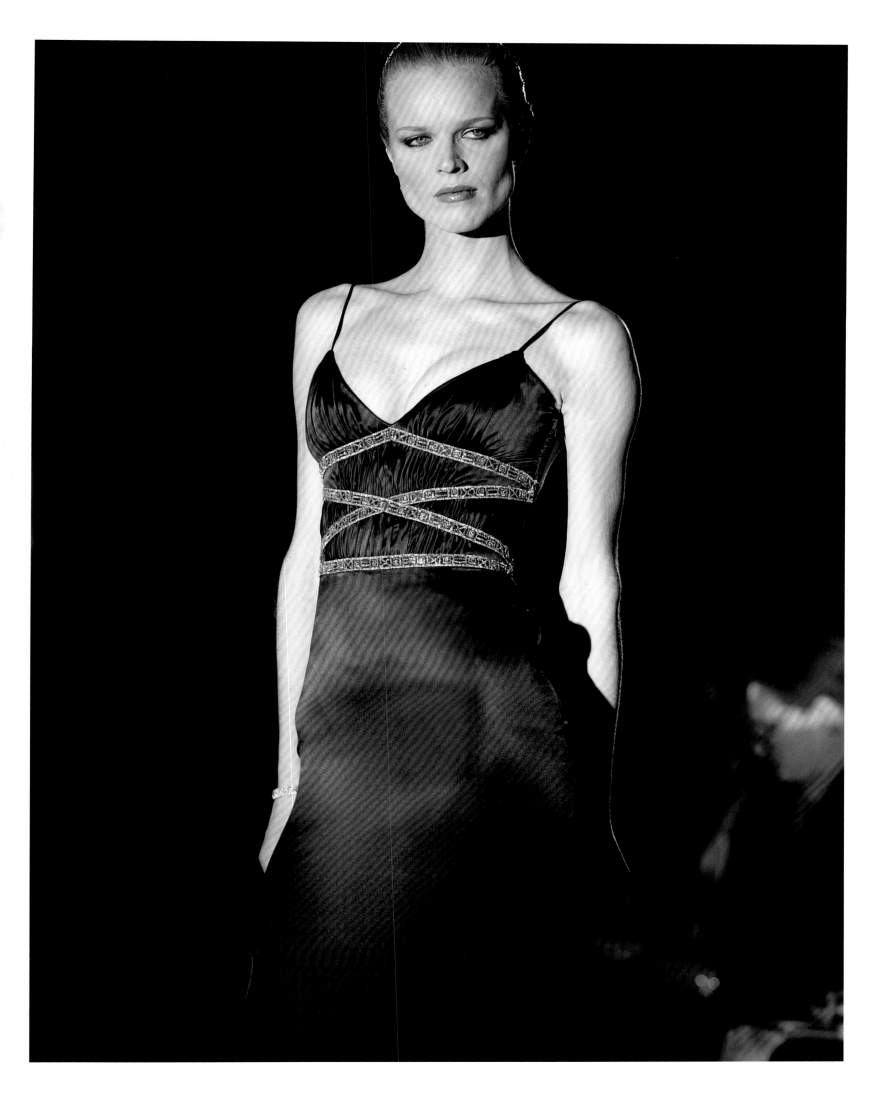

Opposite A beautifully
cut black silhouette
(Fall/Winter 2009
collection). *Previous
pages* Richly embroidered
and bead-encrusted
gowns on sultry, vintage-
colored fabrics (Fall/
Winter 2003 collection).

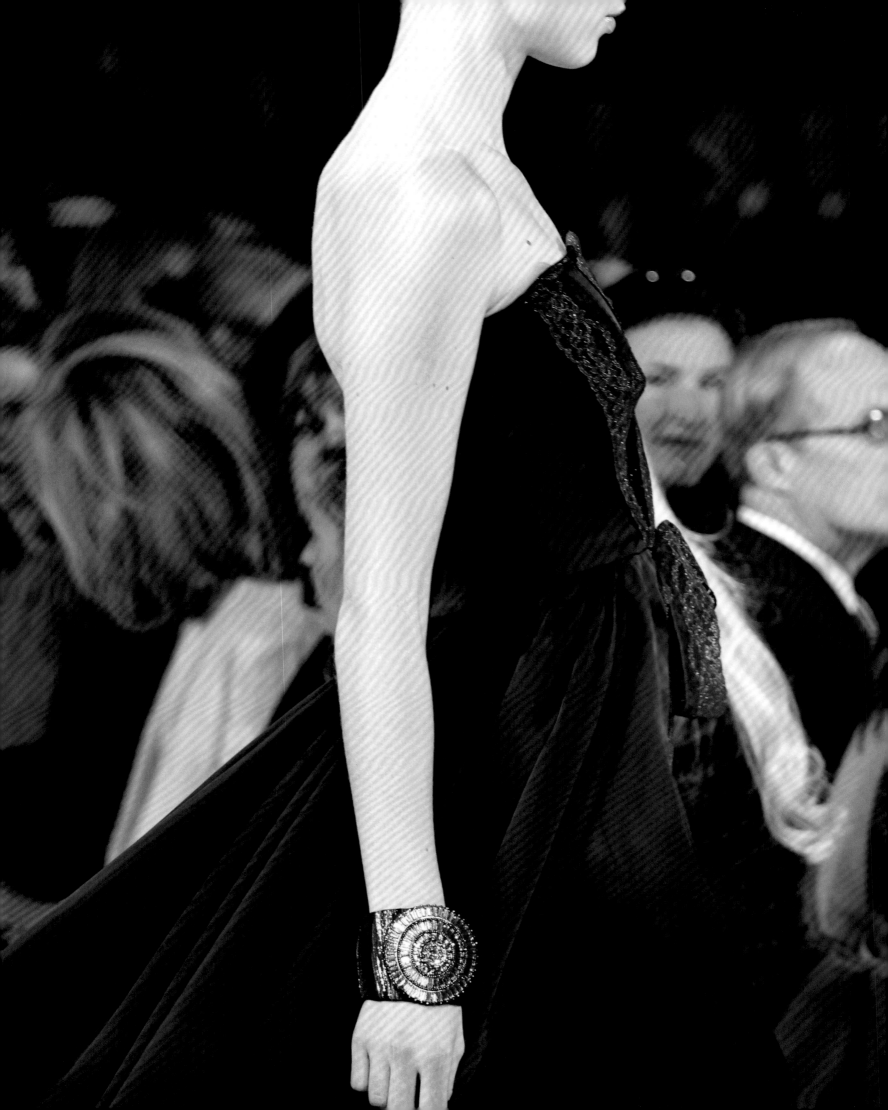

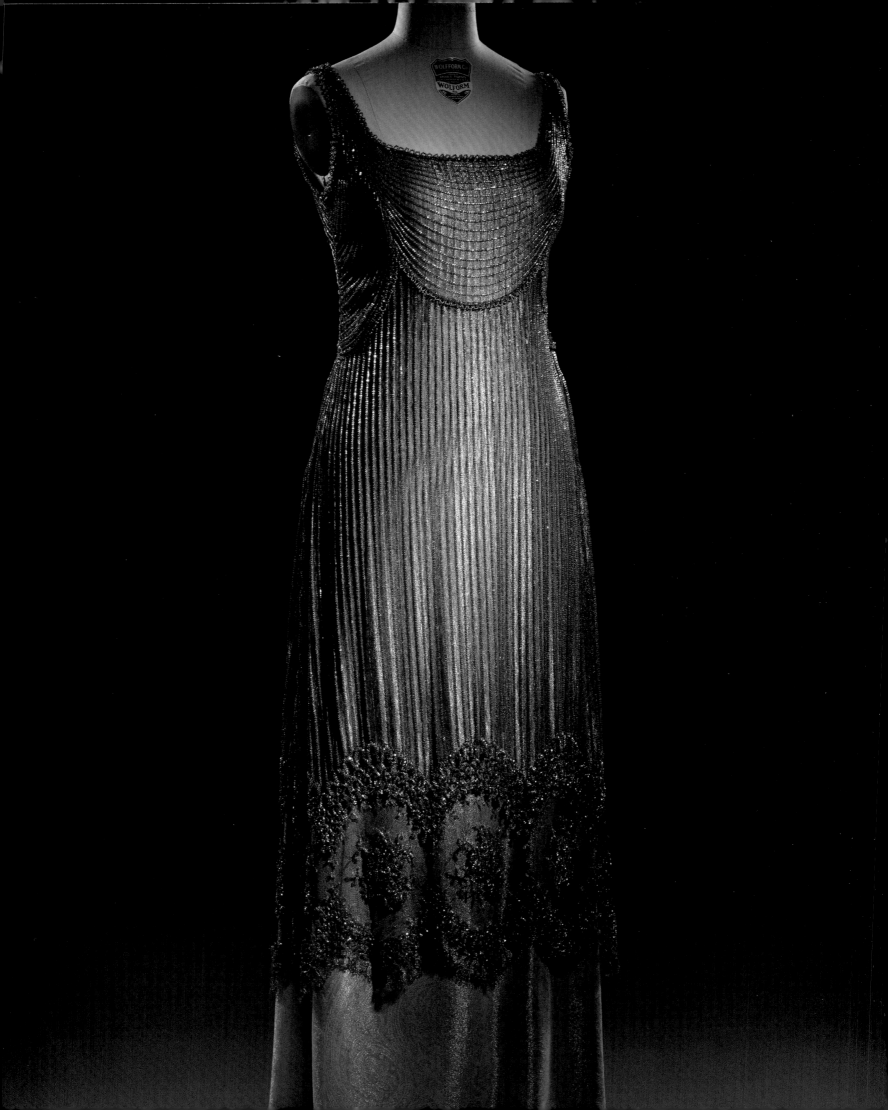

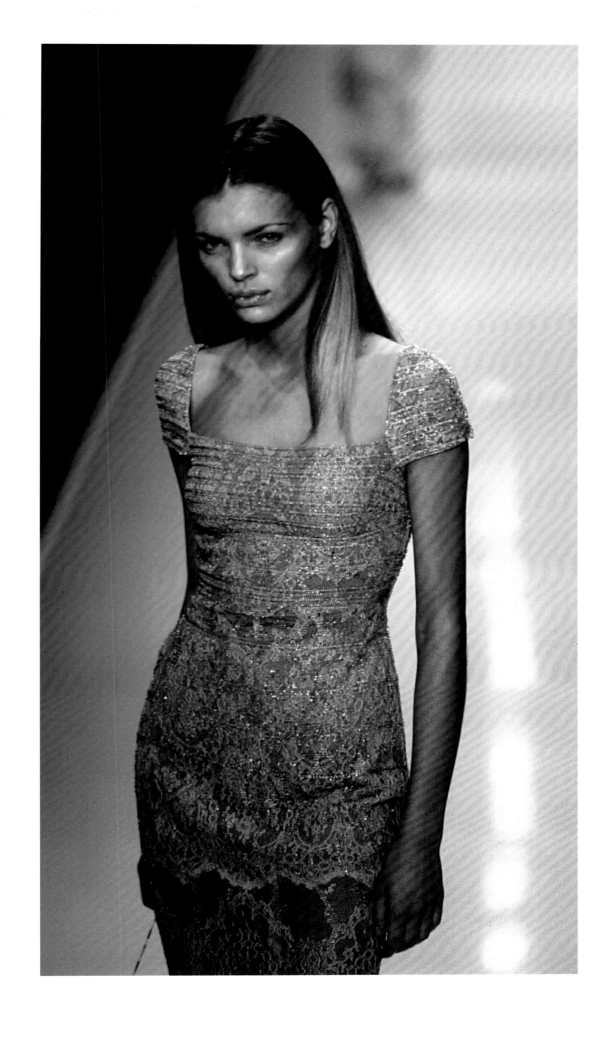

Early looks from the
Spring/Summer 1995
(left) and 1998 (right)
collections.

A dress of maille with a
train of tulle (Fall/Winter
2013 collection).

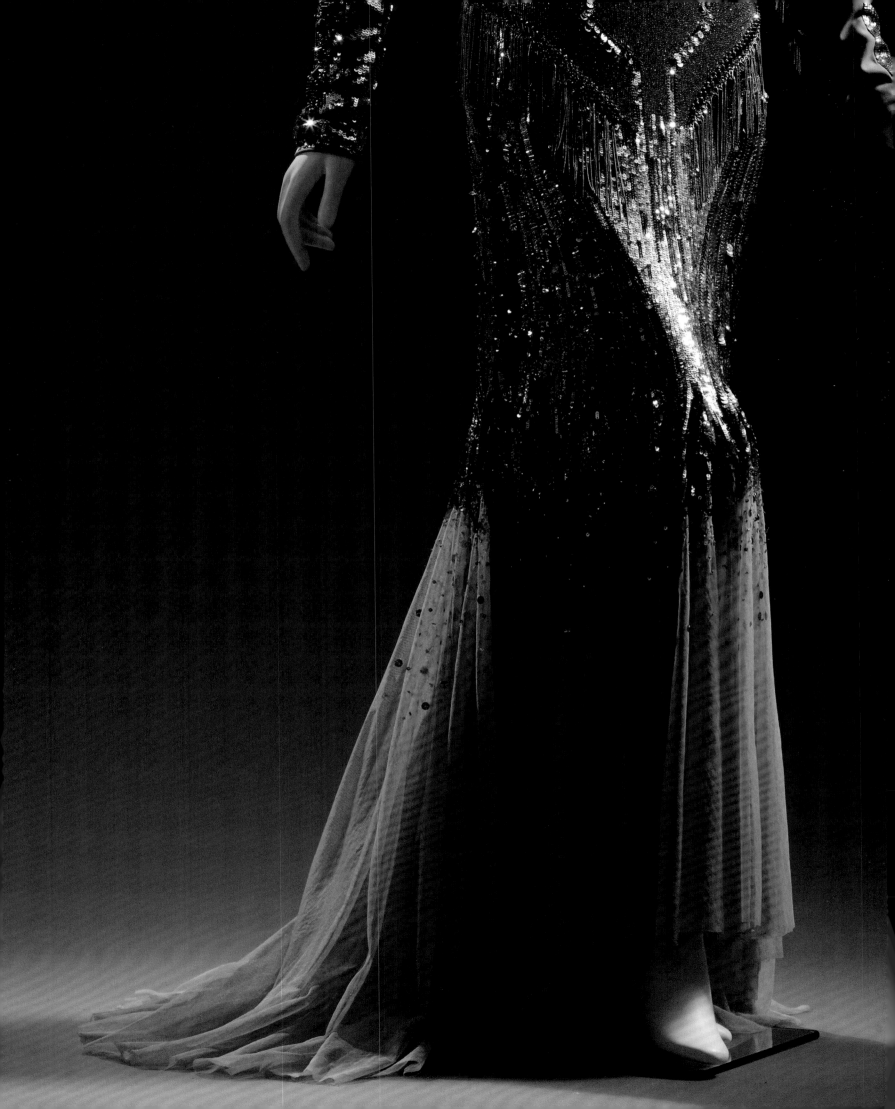

Opposite One-shoulder glamour (Fall/Winter 2015 collection).
Following pages An intricate collage of chantilly lace, metallic boullian, and crystals.

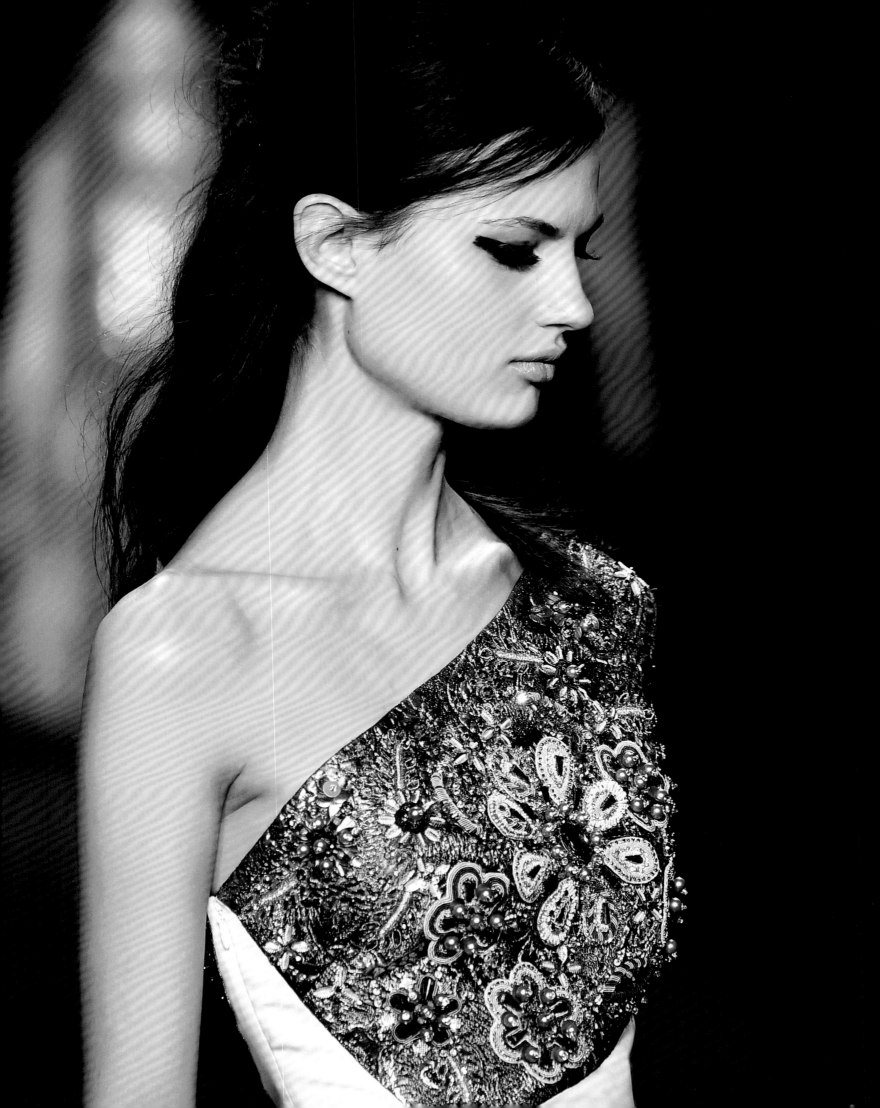

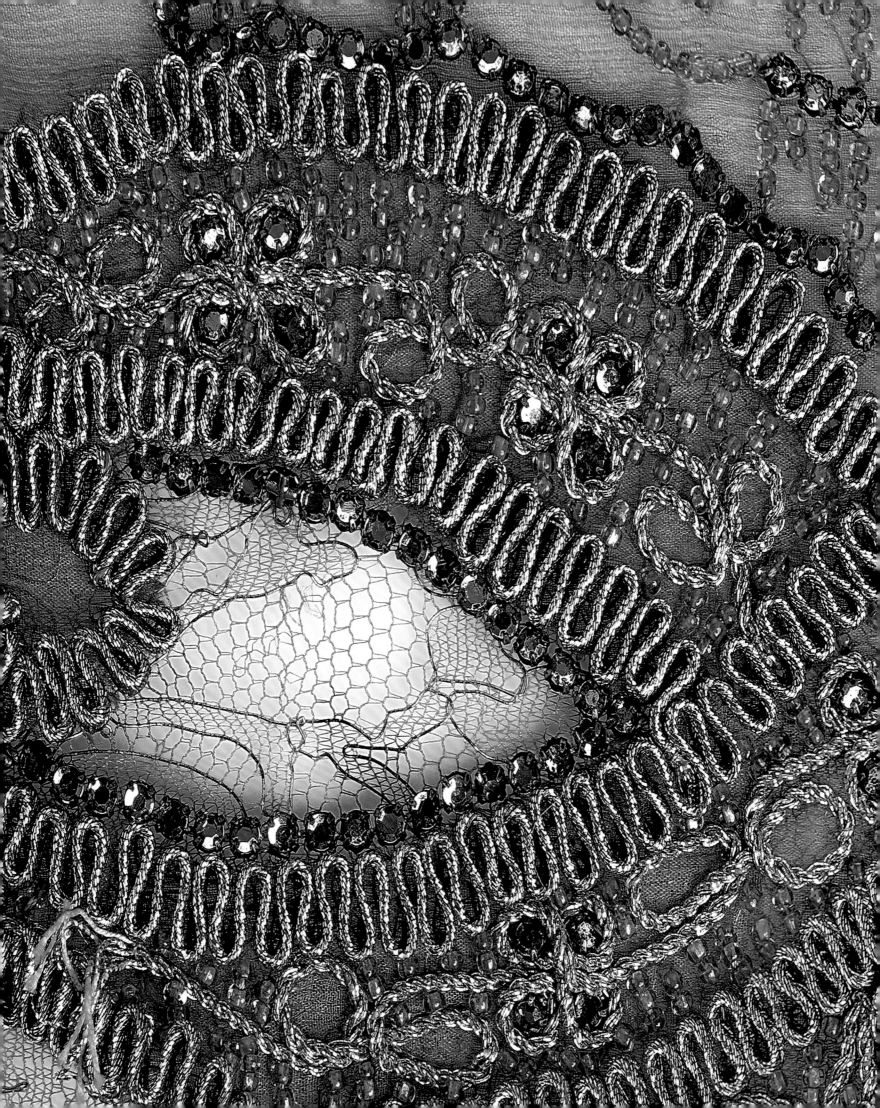

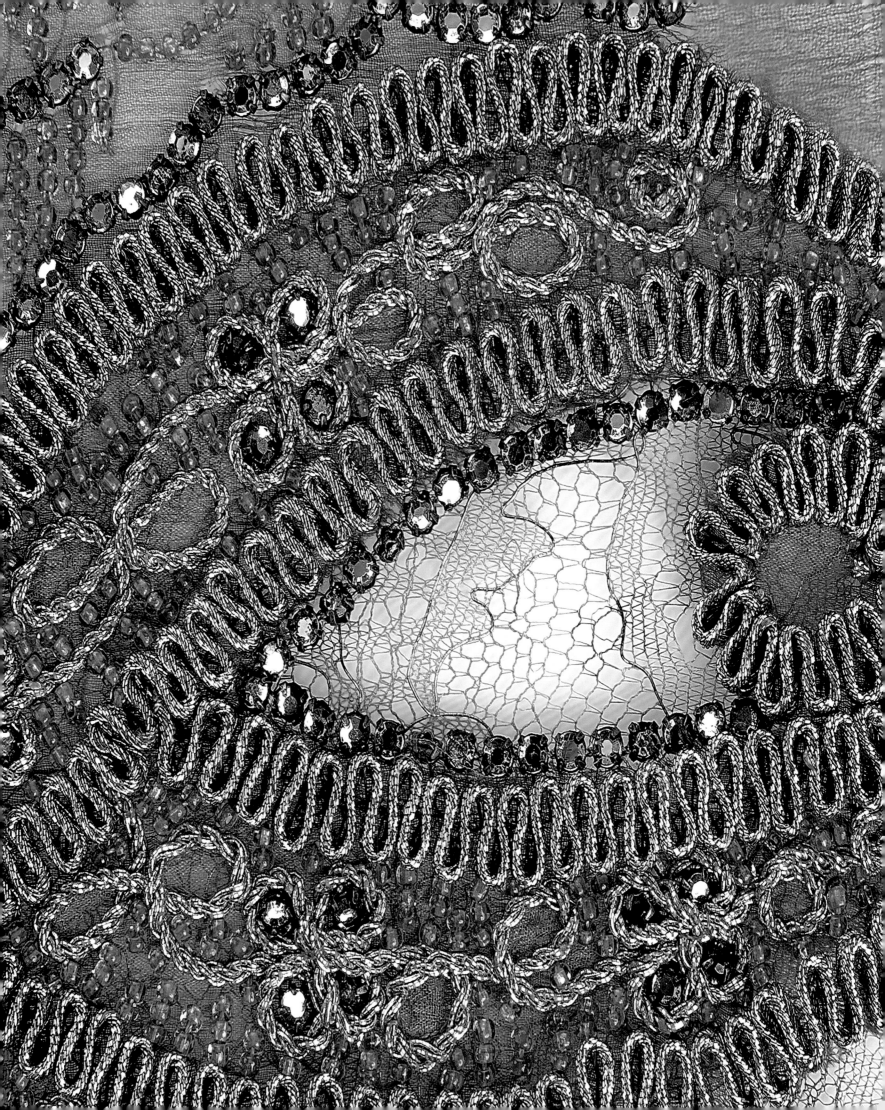

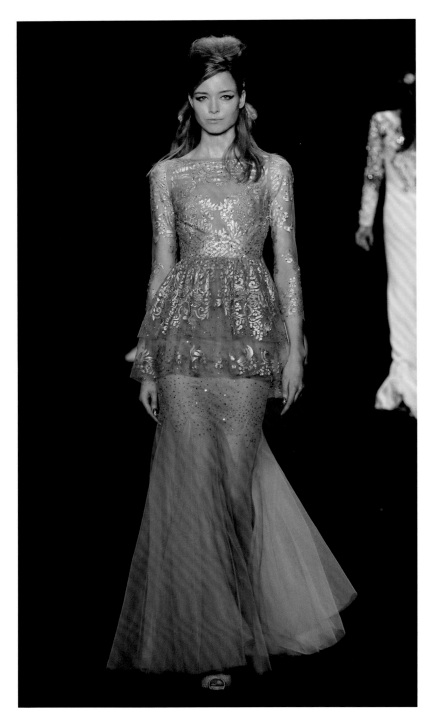

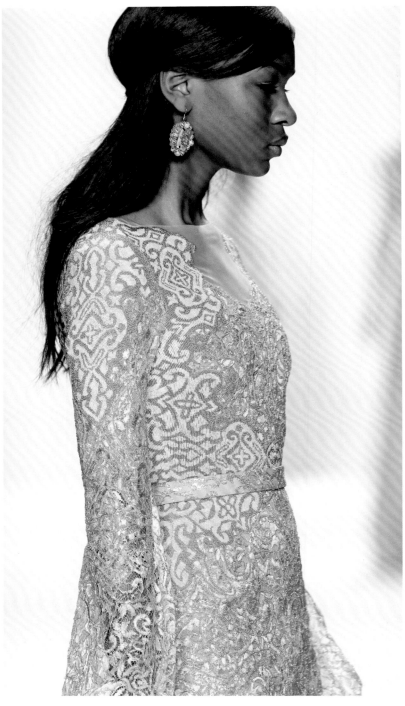

Above and opposite Classic body-hugging, long-sleeve silhouettes from the Fall/Winter 2014 and 2015 and Spring/Summer 2015 collections. *Following pages* A lace gown of subtle perfection with a tantalizing row of crystal buttons that traces the sensuous line from the neck down (Spring/Summer 2013 collection).

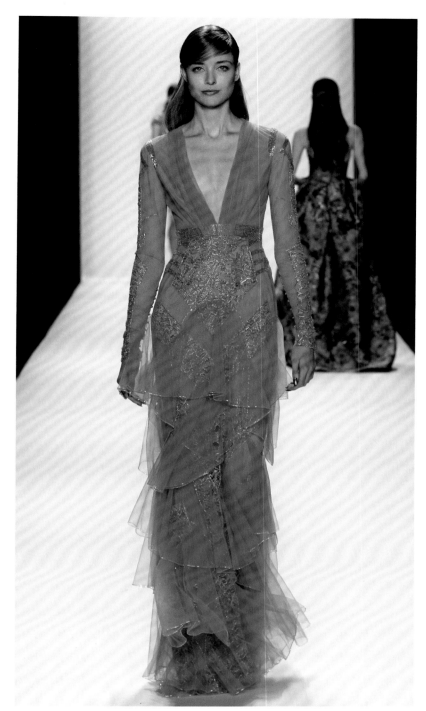

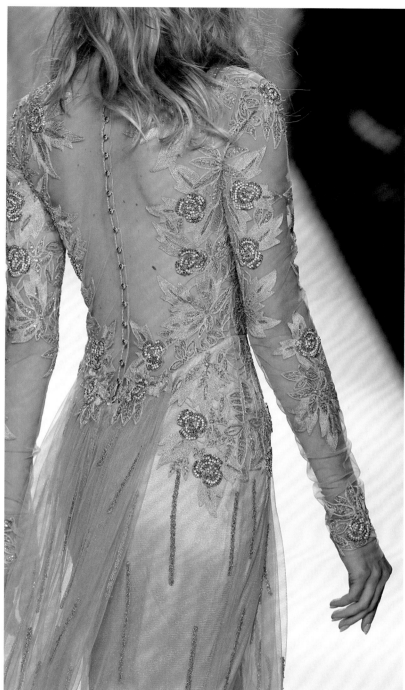

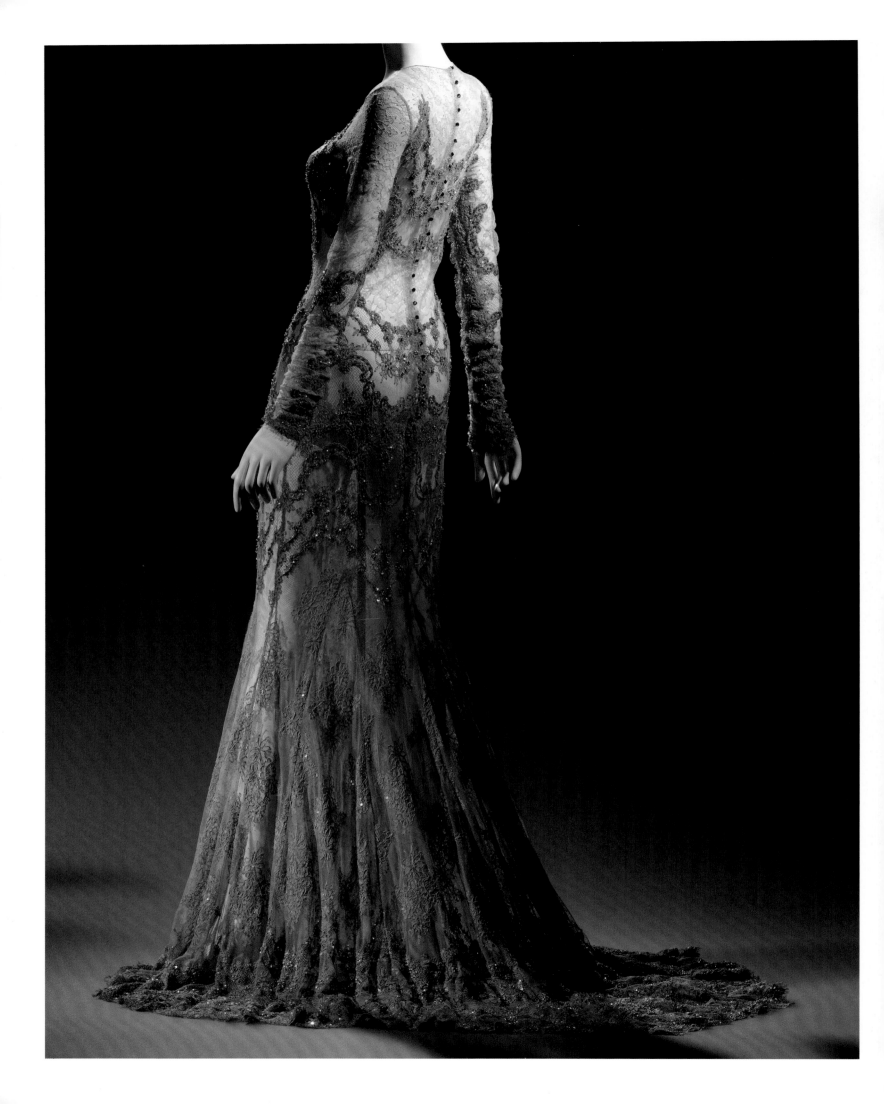

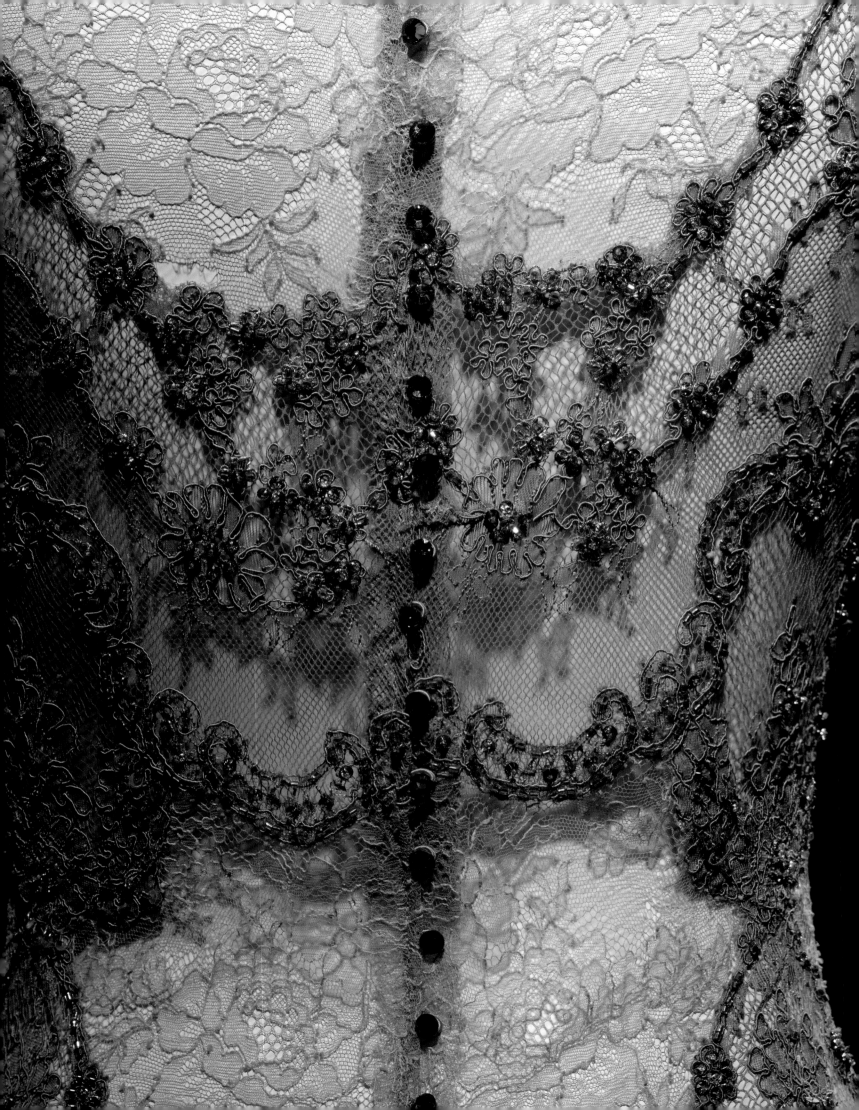

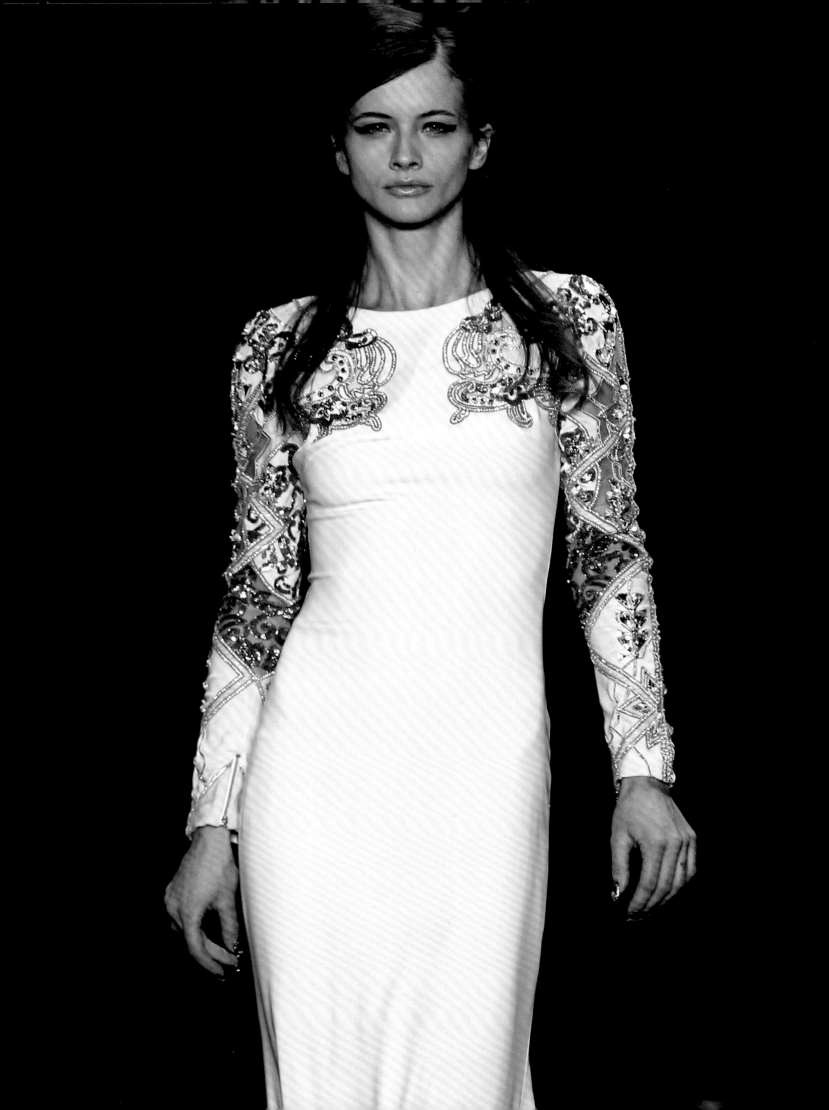

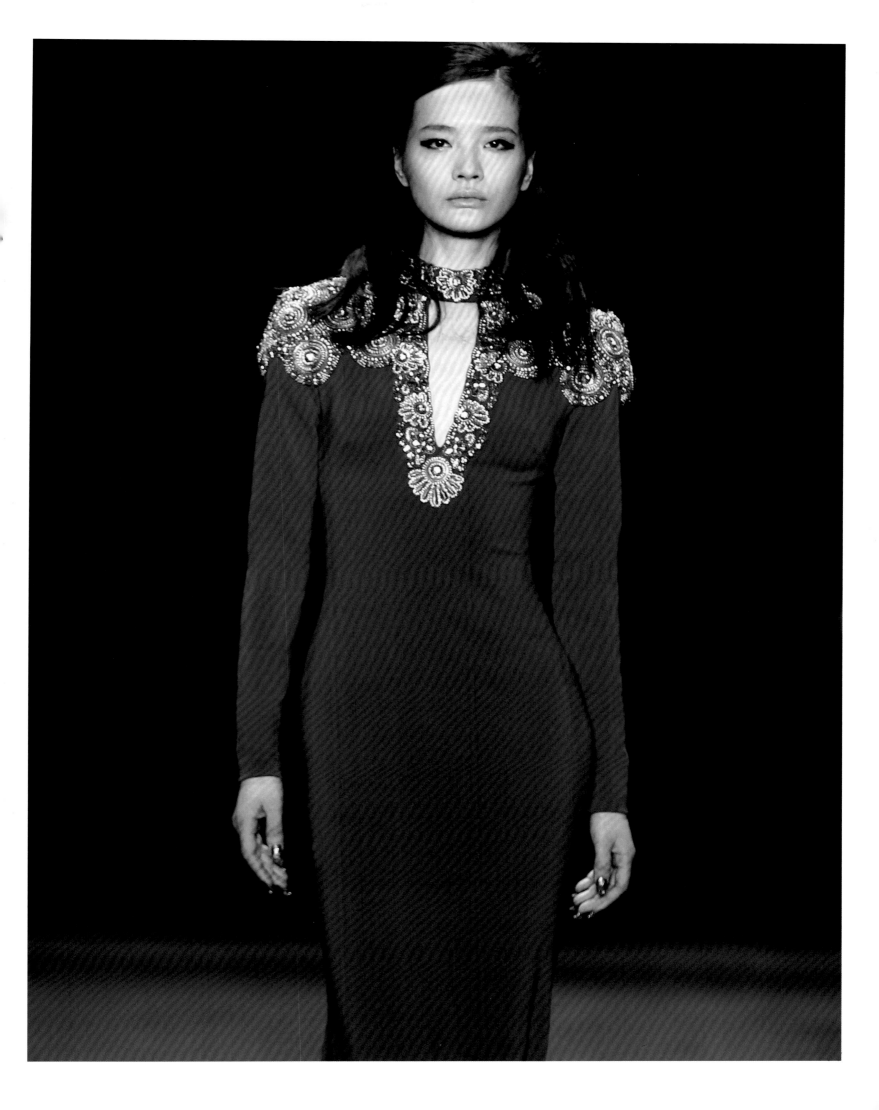

Opposite Taking a page
from old Hollywood, an
overlay of black tulle
softens a starry night
of sequins (Fall/Winter
2009 collection). *Previous
pages* Sleek, long-sleeve
silhouettes (Fall/Win-
ter 2015 collection).
Following pages, left Fall/
Winter 2009 collection.
Following pages, right
From the frames of Alfred
Hitchcock, a moody finale
gown from the Fall/
Winter 2013 collection.

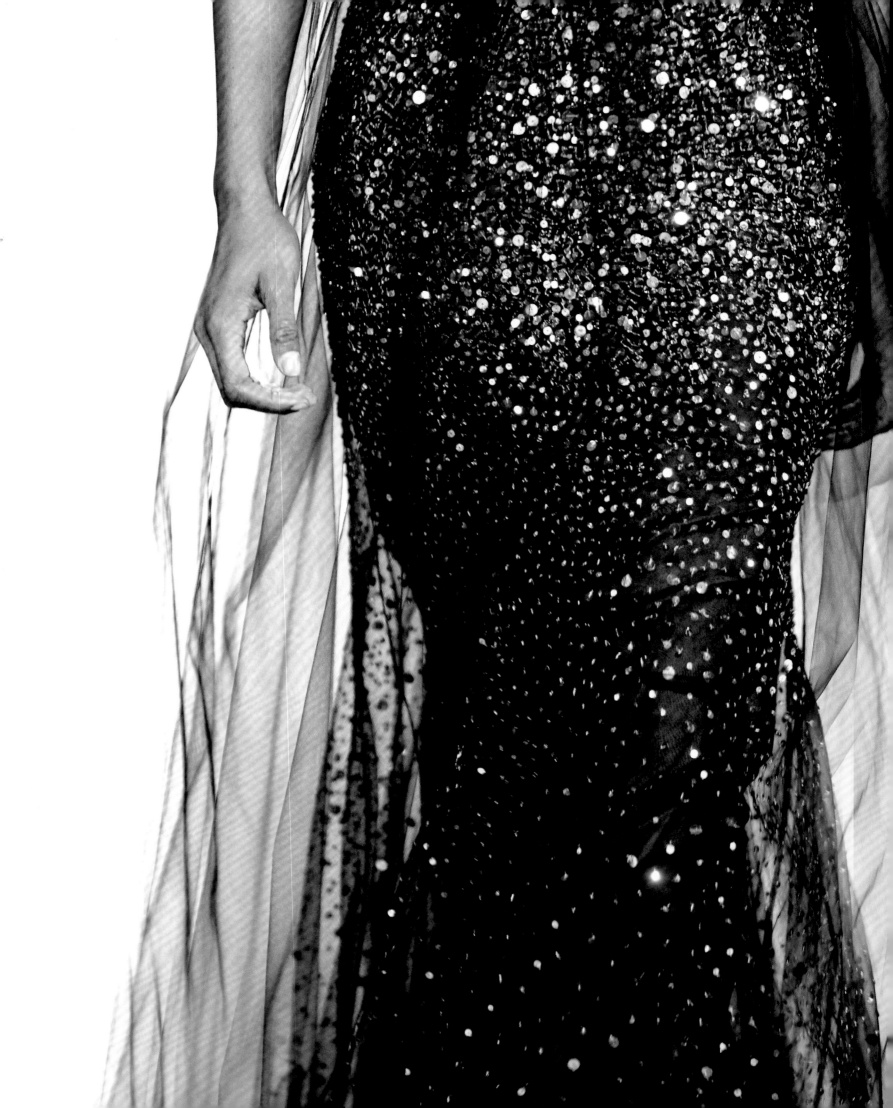

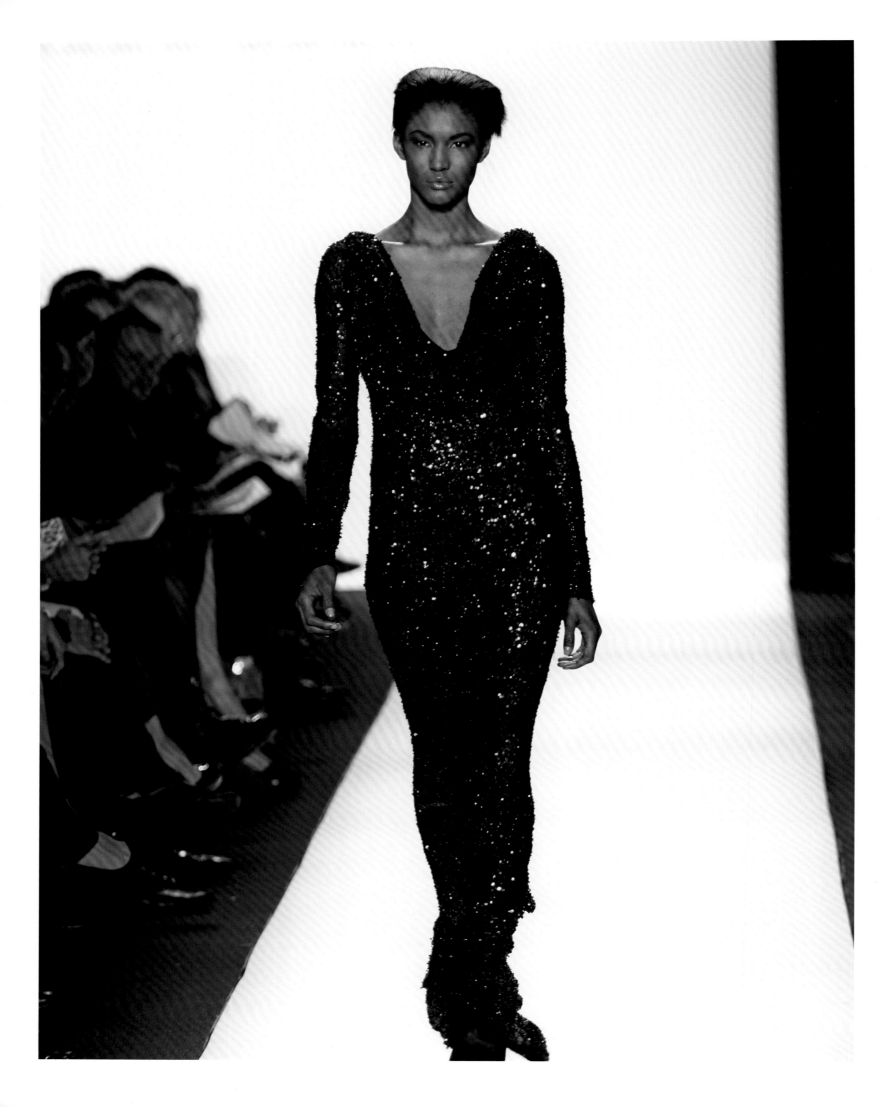

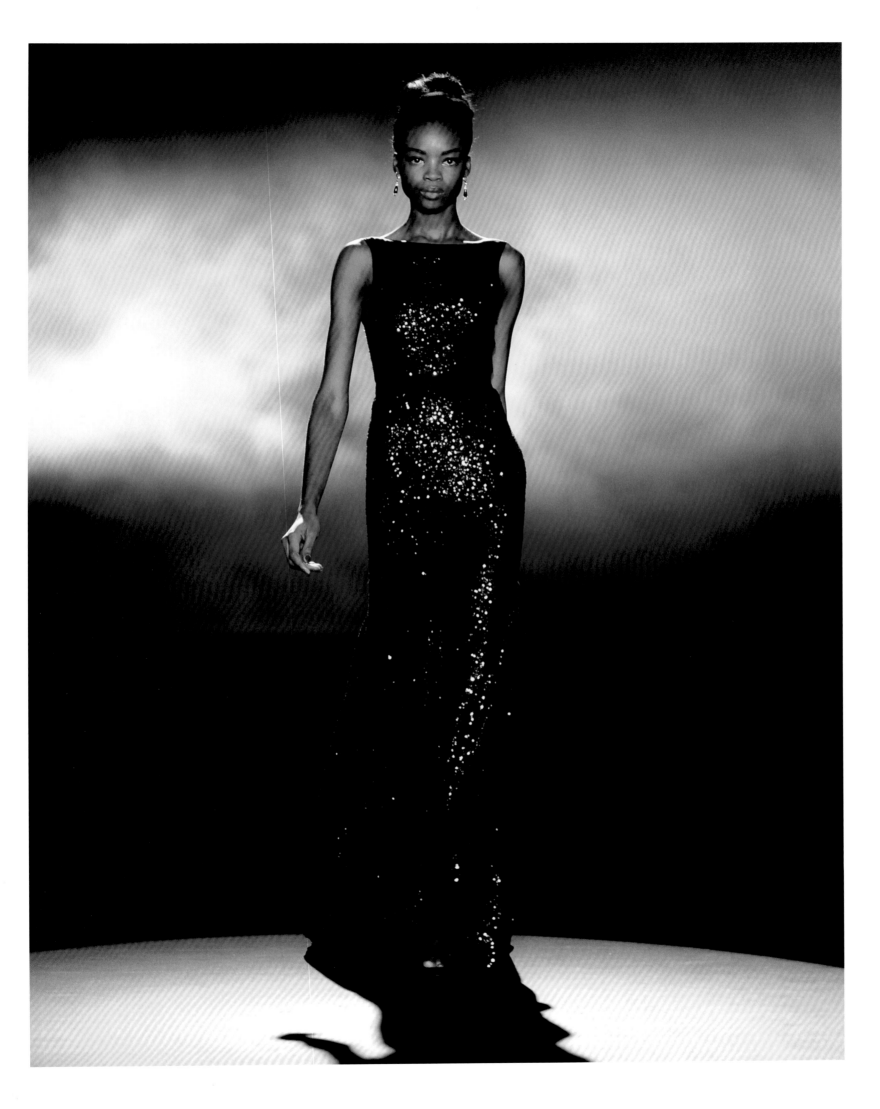

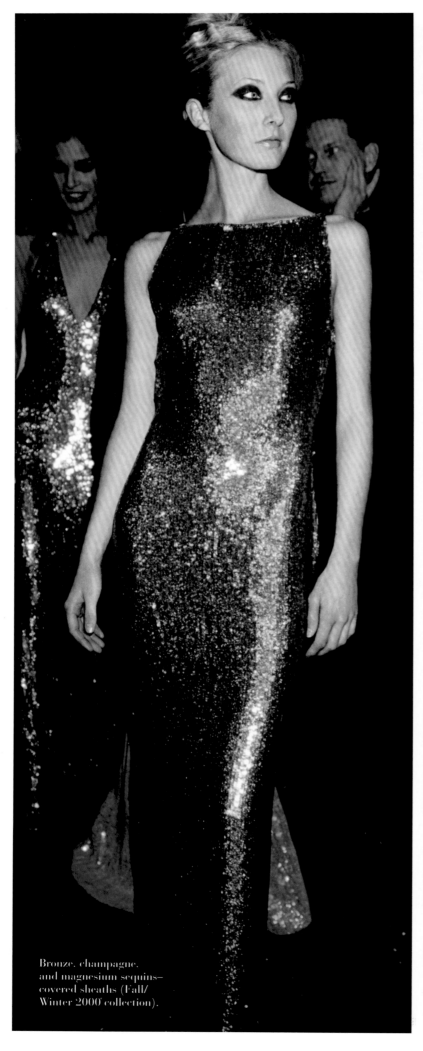

Bronze, champagne, and magnesium sequins-covered sheaths (Fall/Winter 2000 collection).

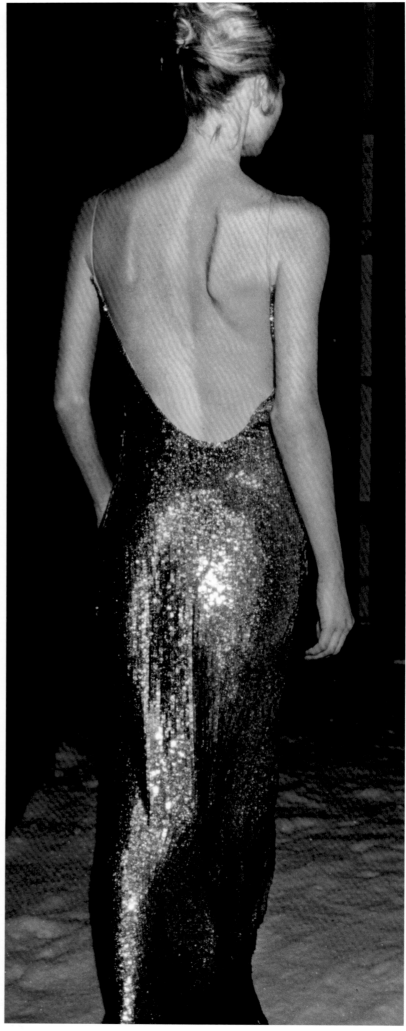

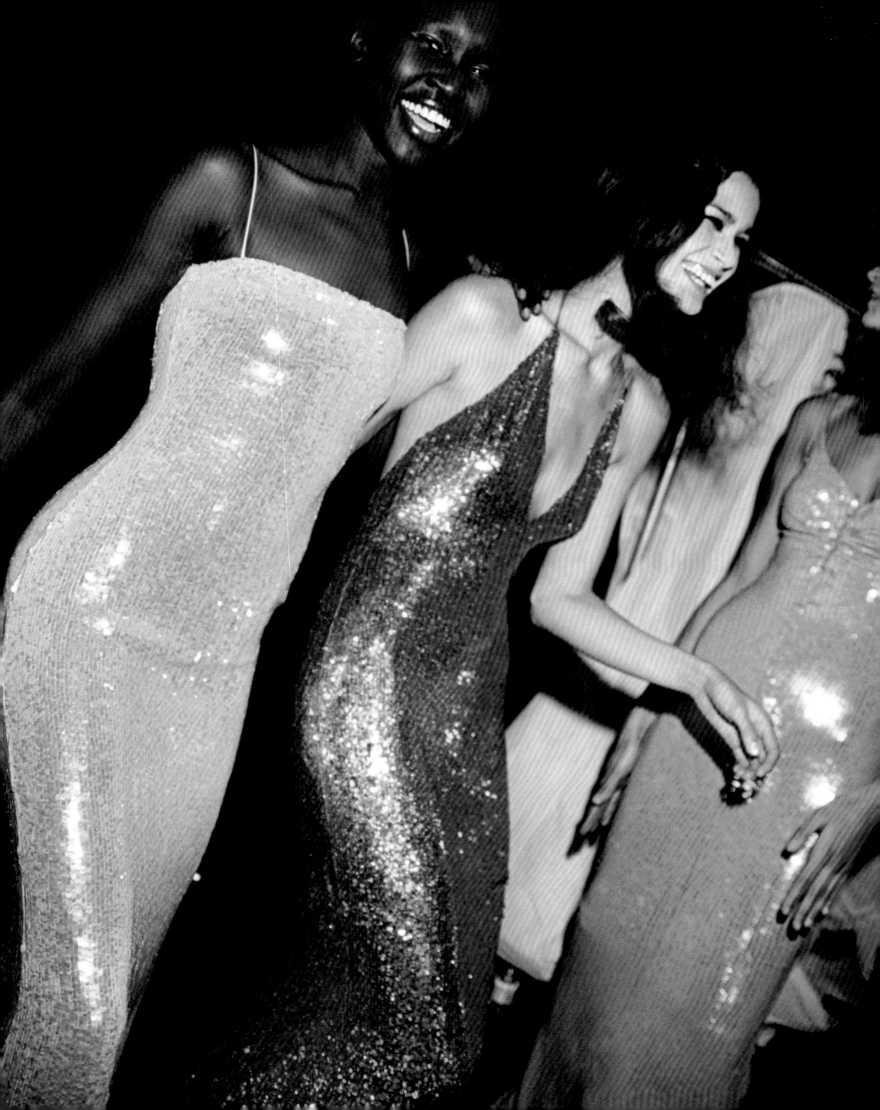

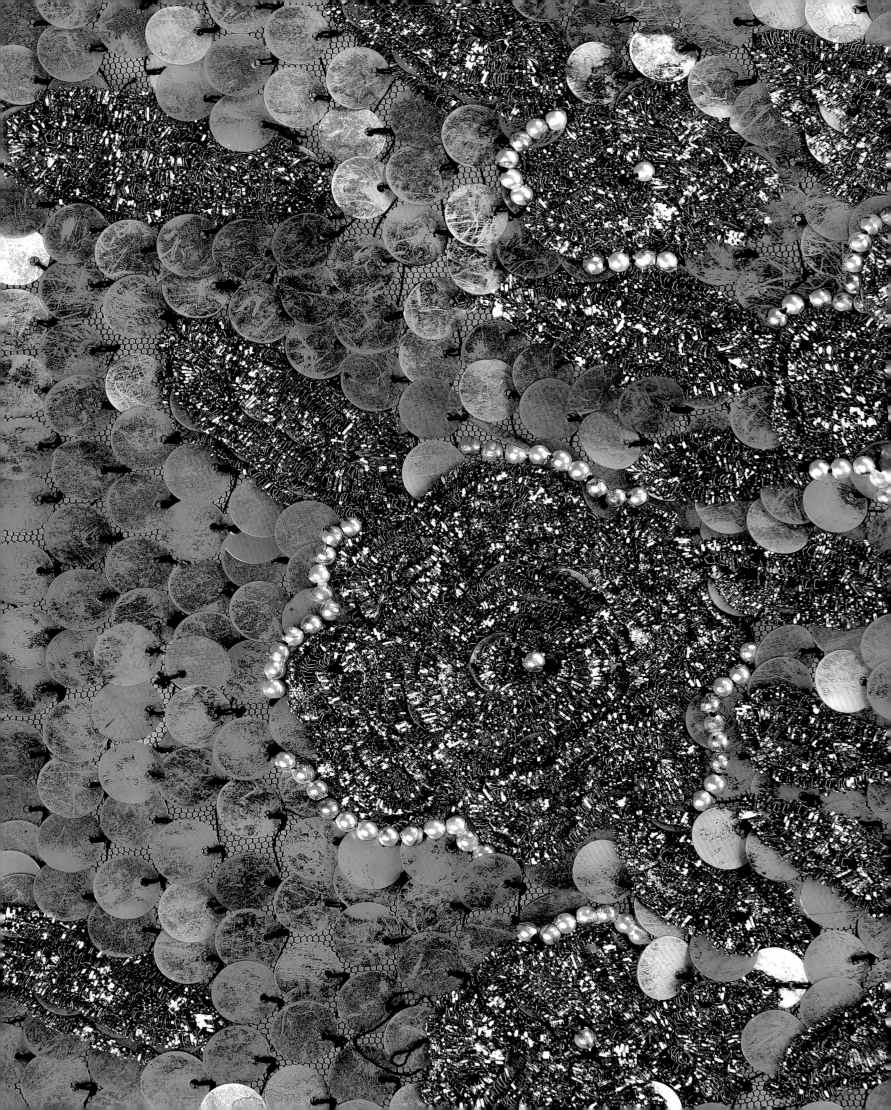

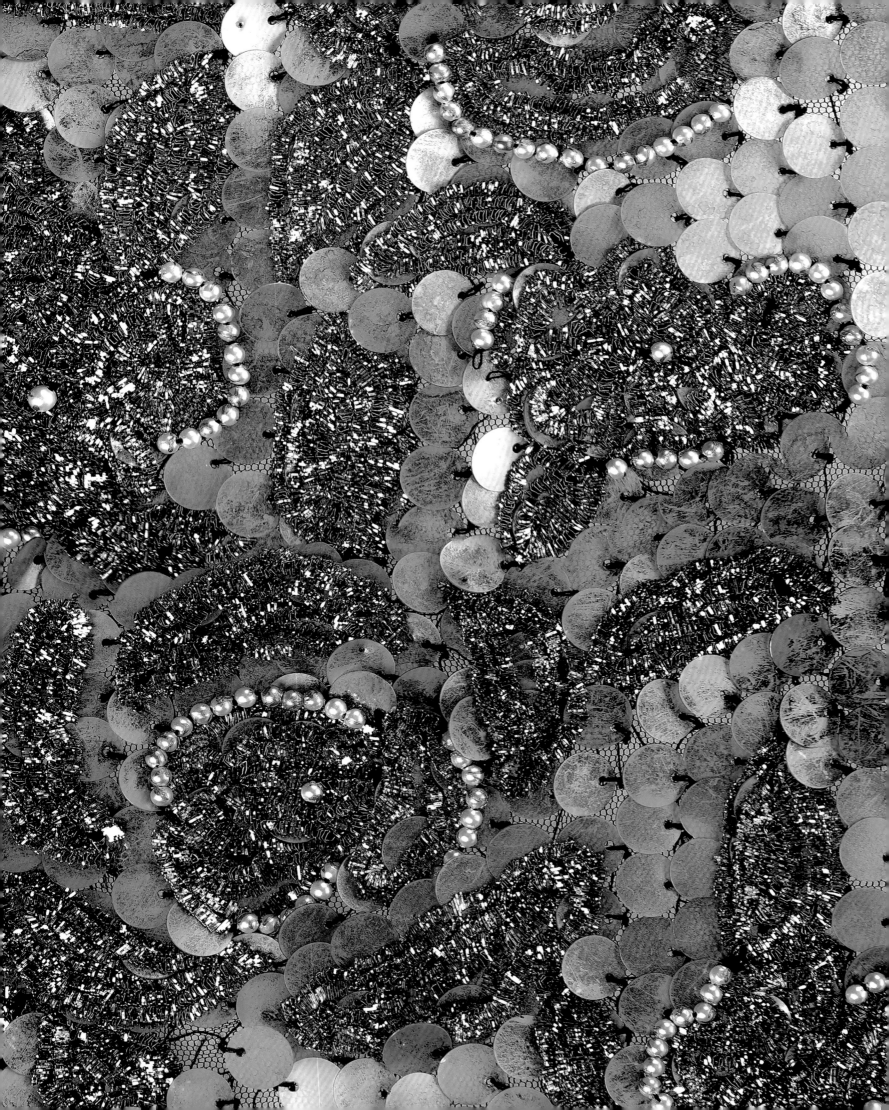

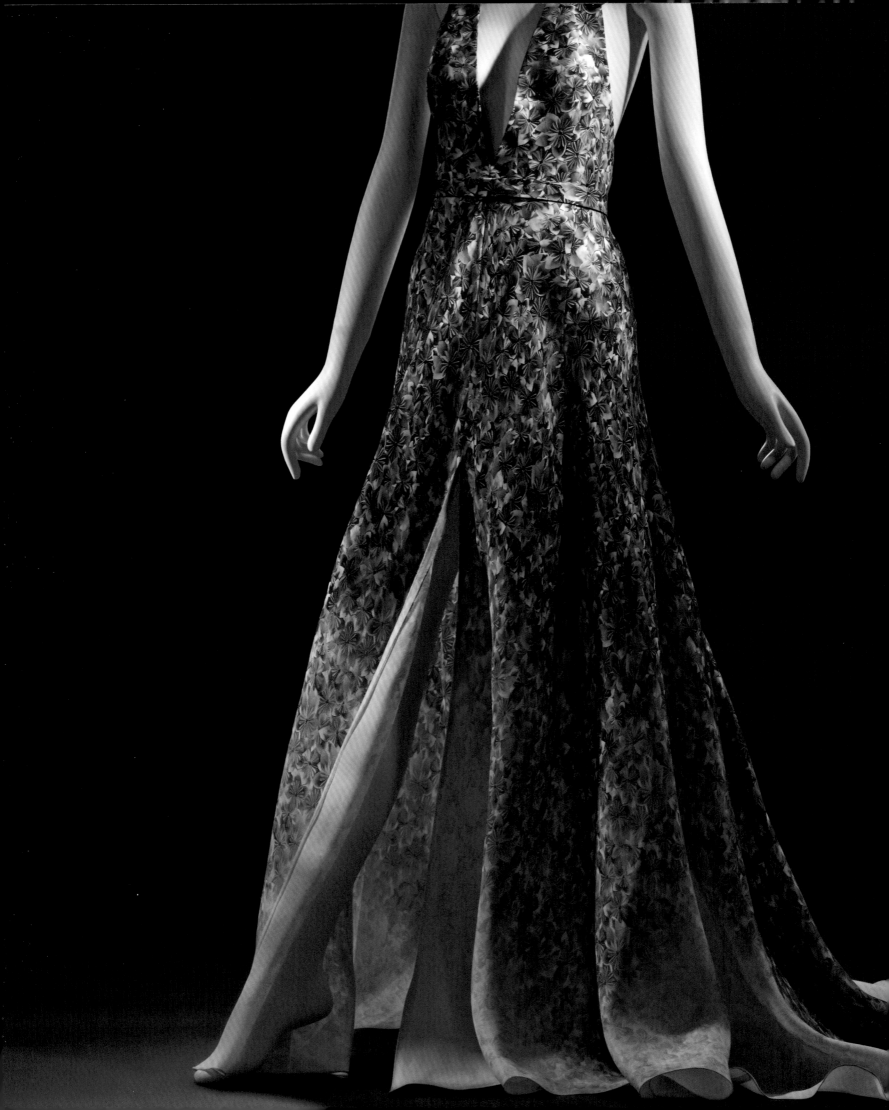

Opposite Custom-printed, feather-light organza flows along with the evening's fantasy (25th Anniversary collection, Spring/Summer 2015). *Previous pages* Smoked pailletes, gunmetal chenille, and antique pearls.

Opposite Fall/Winter
2010 collection. *Following
pages* Fall/Winter 2015
collection.

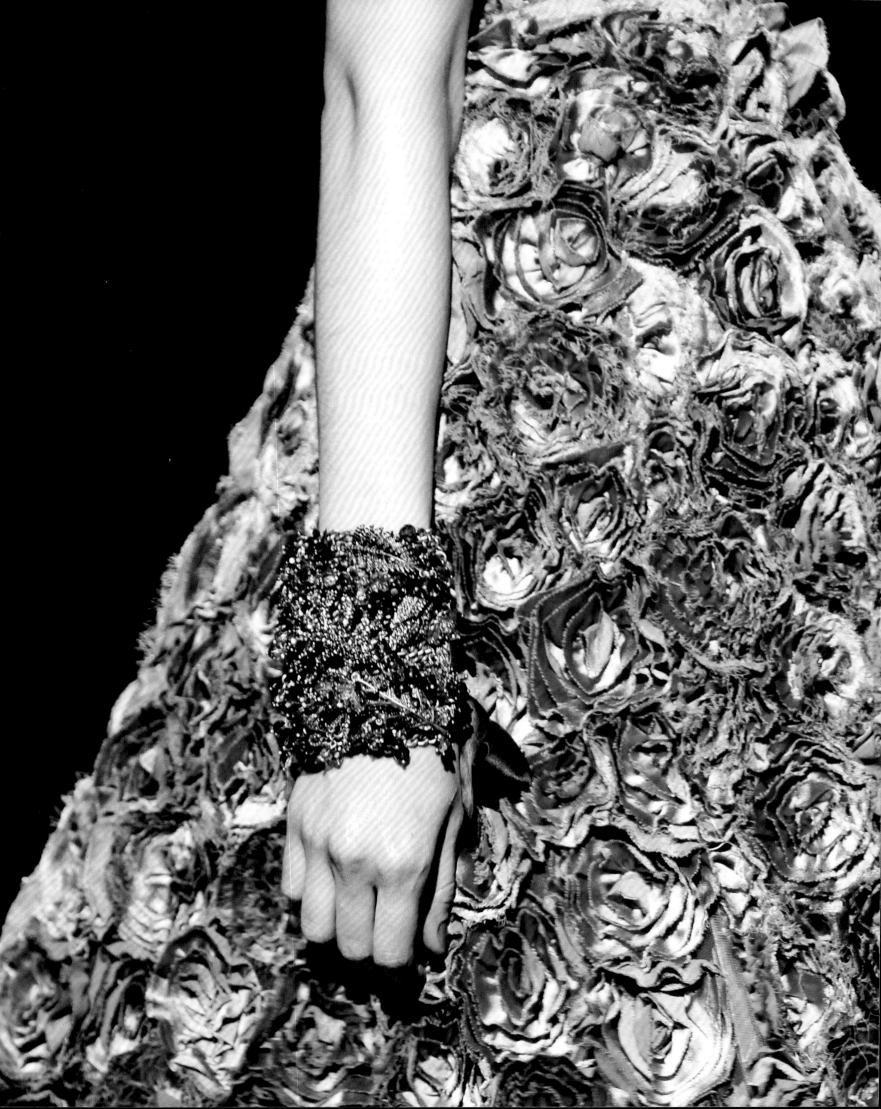

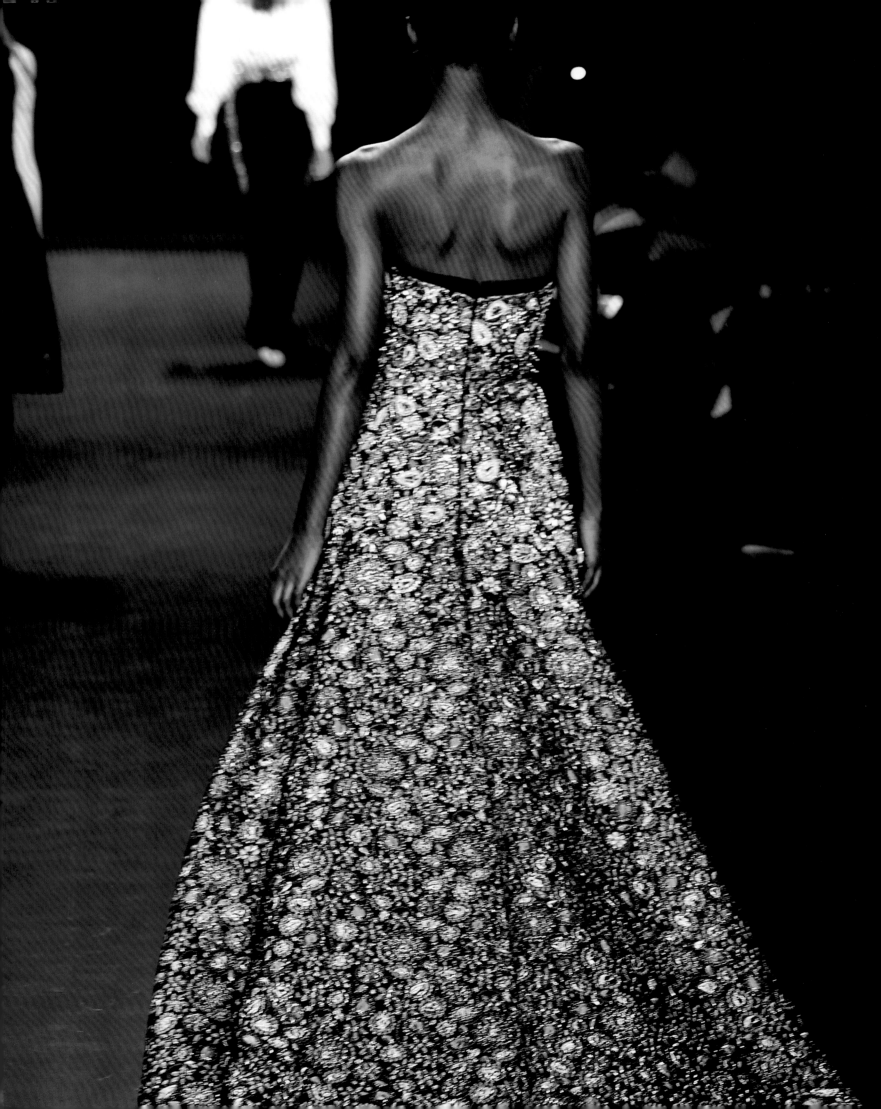

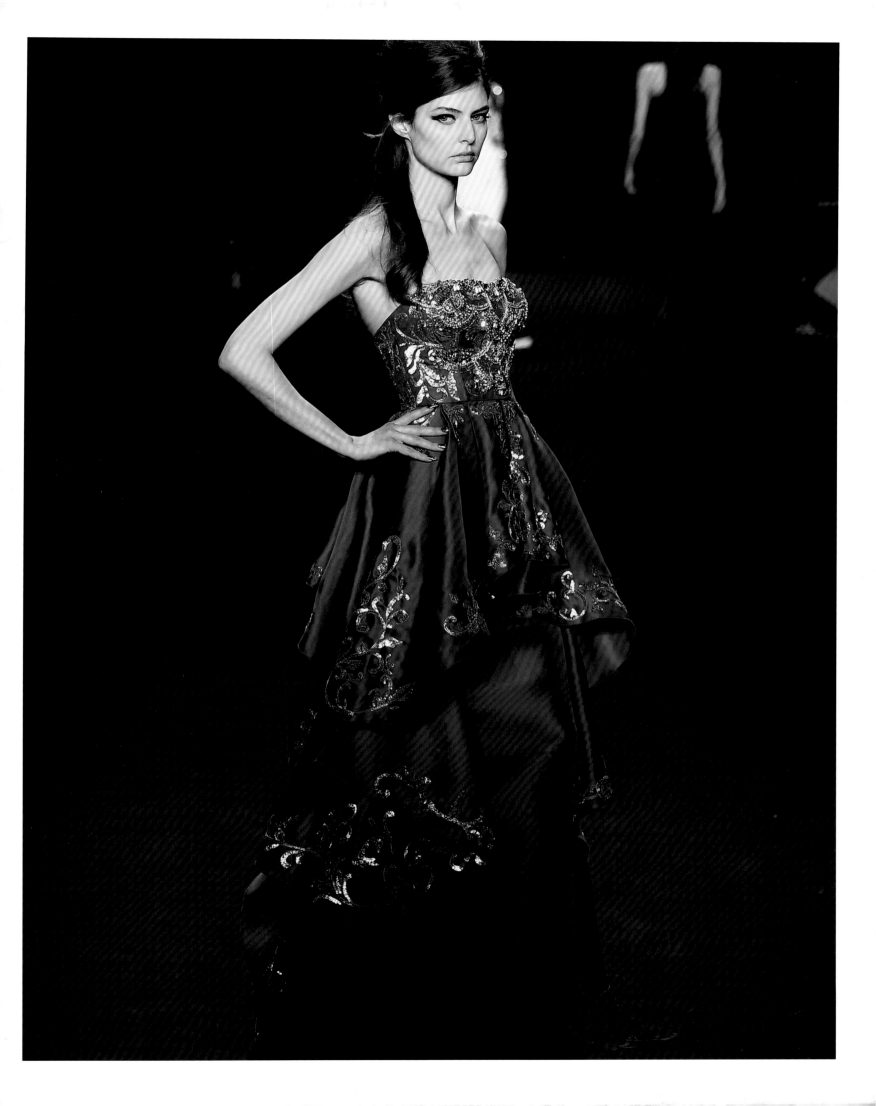

Opposite Fall/Winter
2015 collection.
Following pages Two
details from the Spring/
Summer 2015 collec-
tion. The blur of where
the fabric begins and
the embroidery ends
gives Badgley Mischka
gowns their unique
essence and character.

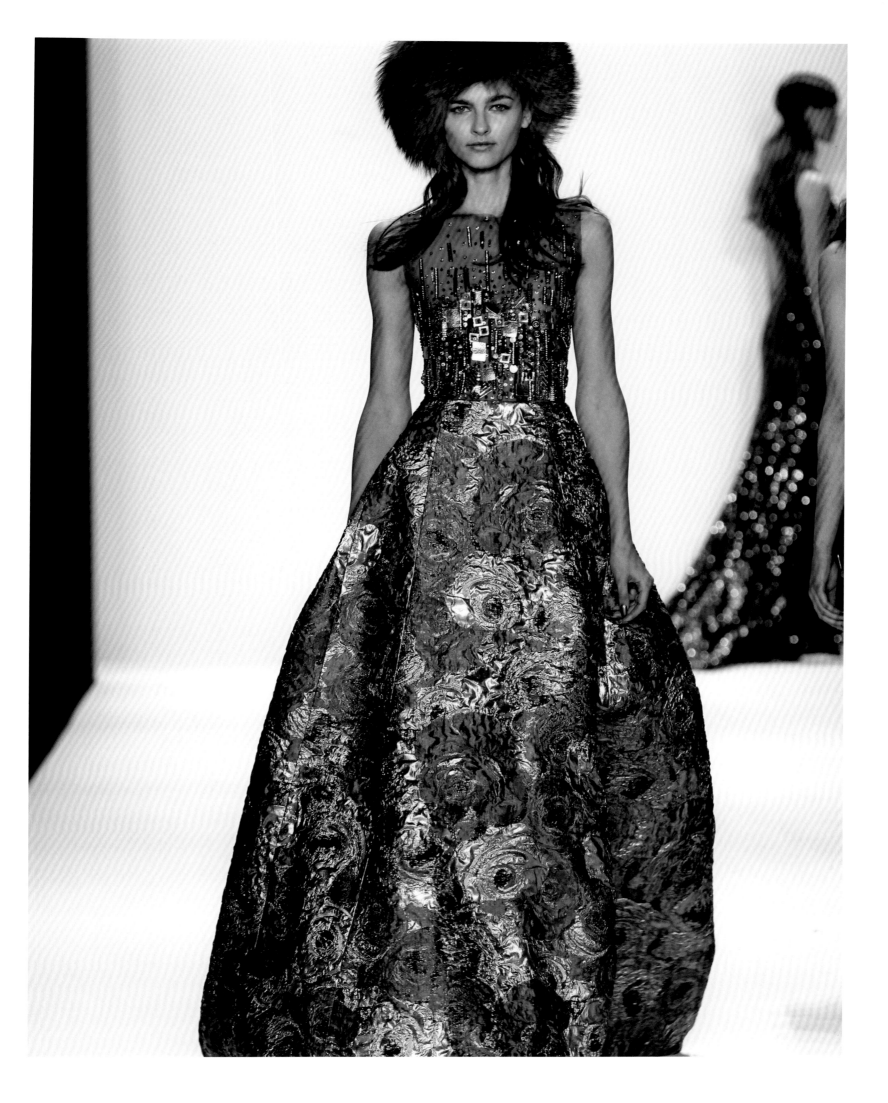

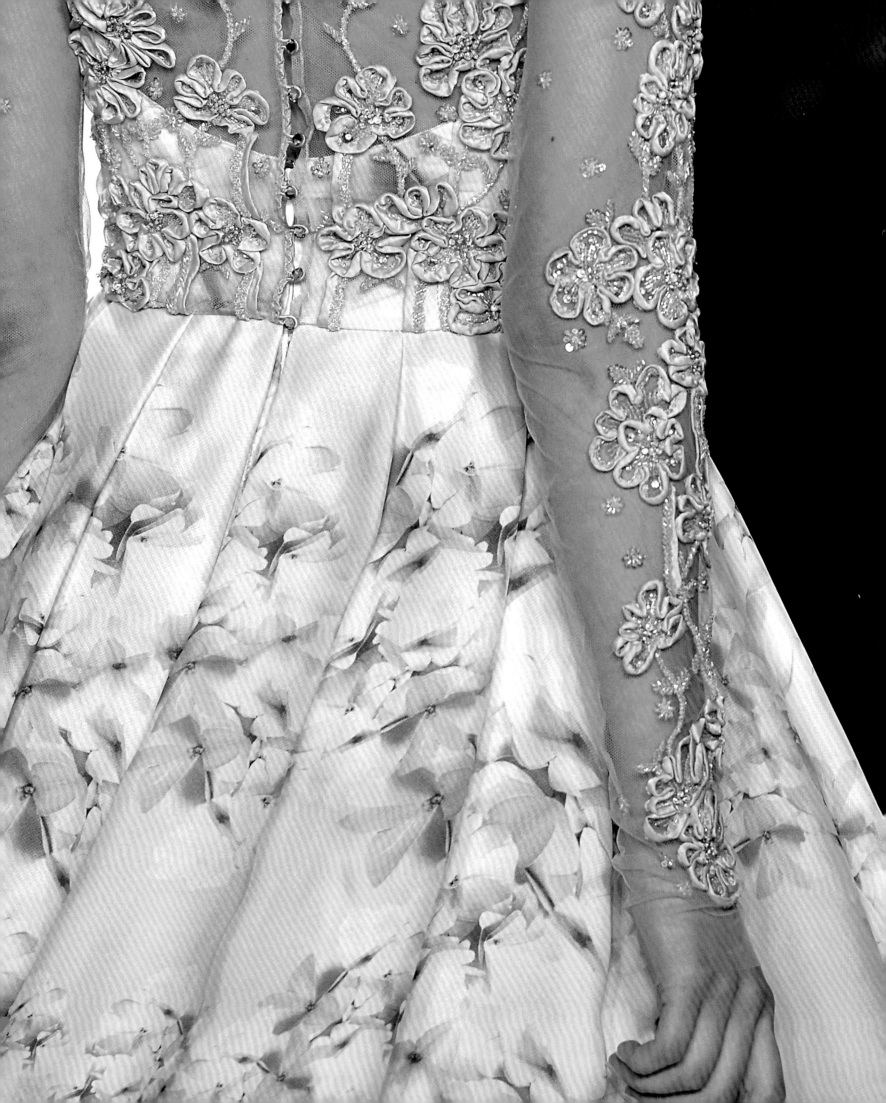

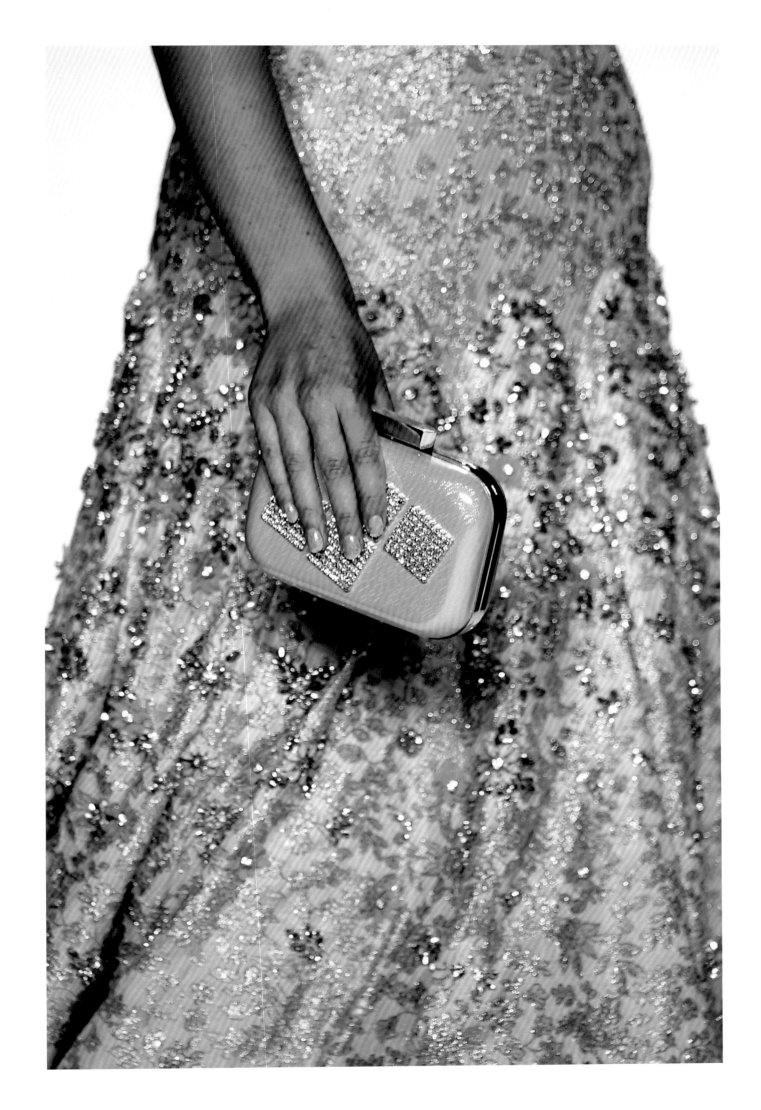

Opposite Finale gown
from Fall/Winter 2010
collection. *Following
pages* Antique gold seed
beads on tulle mended
to lace encrusted with
aurora borealis sequins
and pearls.

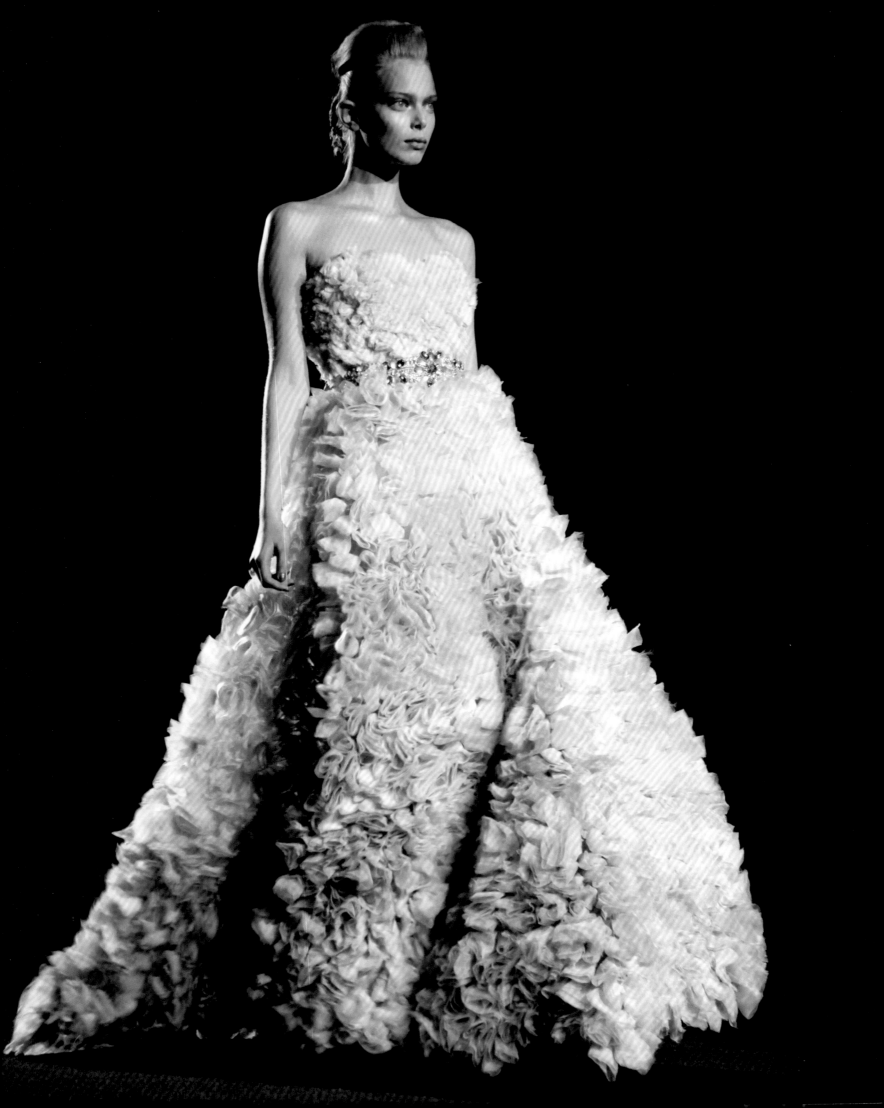

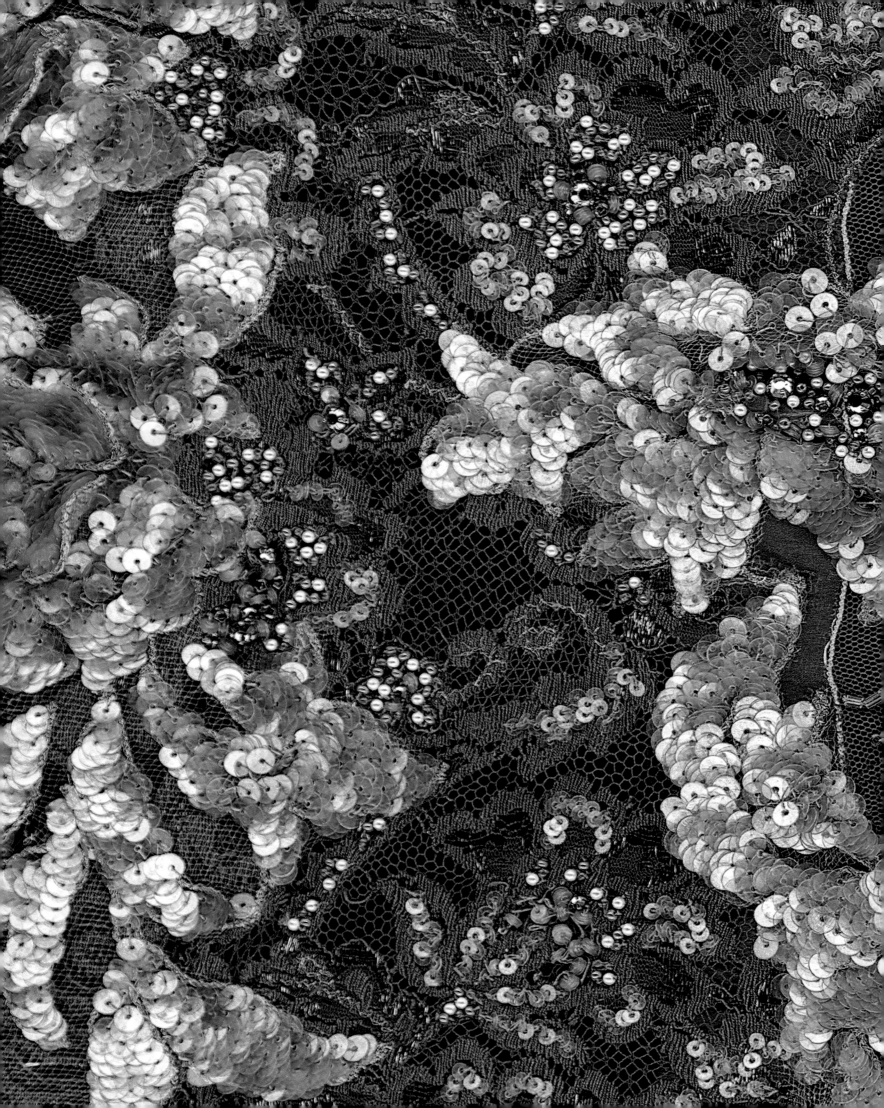

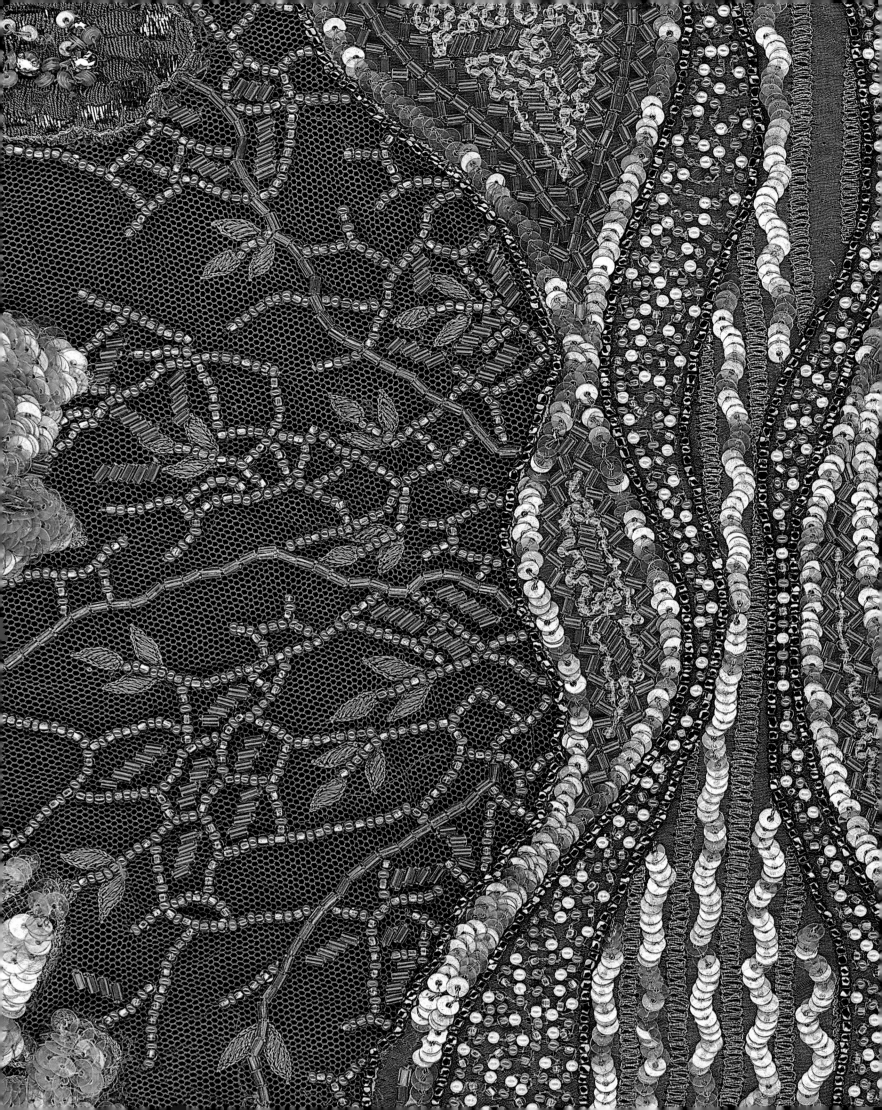

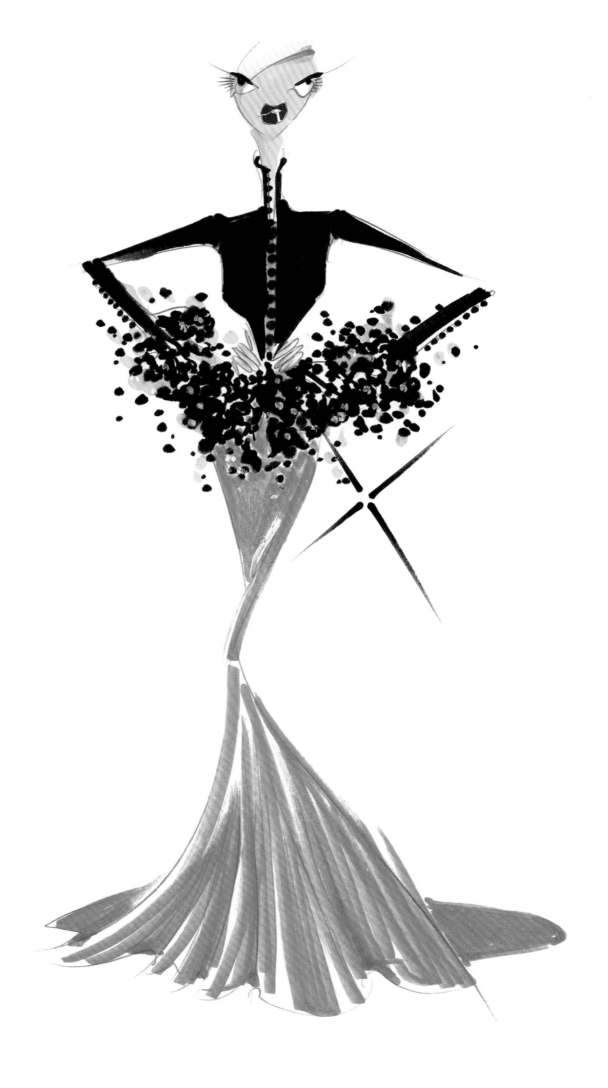

PHOTO CREDITS

ACKNOWLEDGMENTS

Badgley Mischka has been a collaboration from the beginning, from when we started with the two of us and one wonderful seamstress (Gladys, bless her). We have always counted ourselves lucky to be surrounded with gifted and generous souls. We thank our incredible team who make our dreams into concepts and then into clothes.

We have many co-conspirators on this book, as we have on every collection. We are giving you a very short list.

This book would not have happened without three people: Robert Caldwell, our longtime publicist and best friend; Deborah Moses, our other best friend and the art director of this book; and editor Allison Power, who somehow saw this project through. Their efforts were beyond superhuman.

We are humbled by the book's foreword by André Leon Talley, and in love with Hal Rubenstein's essay, and we thank them both. Thank you to Dennita Sewell for the overview of Badgley Mischka and her scholarly view on a very non-scholarly subject.

Our most treasured relationships are with the women we are lucky enough to work with, and we appreciate their kind words for this book. Oprah, Angelica, Helen, Ashley, Carrie, Brooke, Heidi—we thank you for your thoughts, and you grace us with your beauty.

We get dizzy thinking of the people that helped show our clothes to the world, and can only start to thank the photographers and stylists that were integral to this book: Annie Leibovitz, Walter Chin, Ruven Afanador, Ellen von Unwerth, Roxanne Lowit, An Le, Freddie Leiba, and more. We have been so lucky to work with each of you.

Thank you.

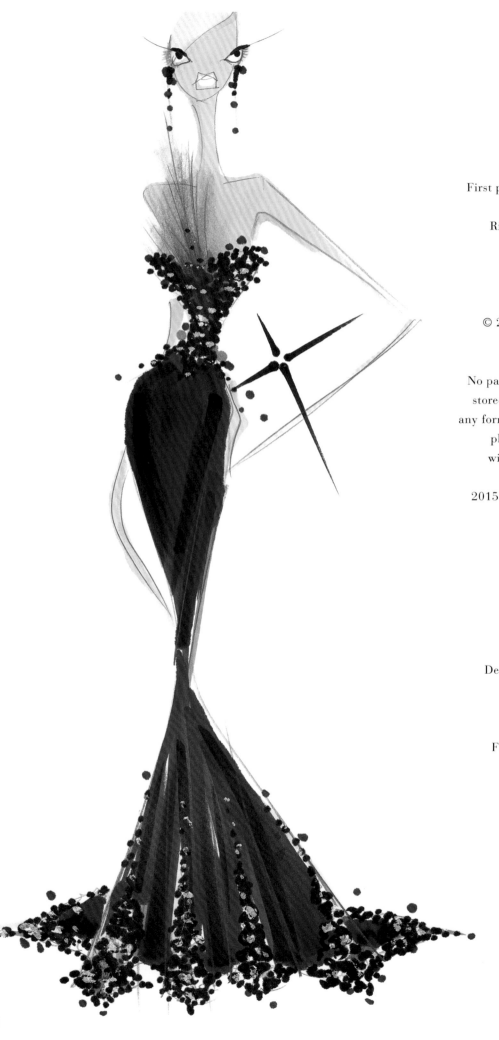

First published in the United States of America
in 2015 by
Rizzoli International Publications, Inc.
300 Park Avenue South
New York, NY 10010
www.rizzoliusa.com

2015 2016 2017 2018 / 10 9 8 7 6 5 4 3 2 1

Printed in China

ISBN: 978-0-8478-4601-6

Library of Congress Catalog
Control Number: 2015944332

Design Coordinator: Kayleigh Jankowski

Art Director: Deborah Moses

Front cover photo by Ruven Afanador

Back cover photo by Walter Chin